Happy Birthday!

Hope these pictures are enjoyable and we will see the real thing some day.

Love,
Chris

December 12, 2001

ARGENTINA
WILD SOUTH AMERICA

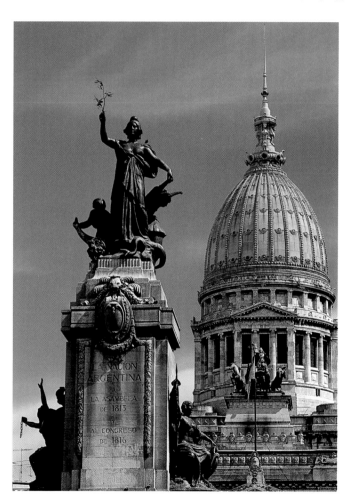

WHITE STAR PUBLISHERS

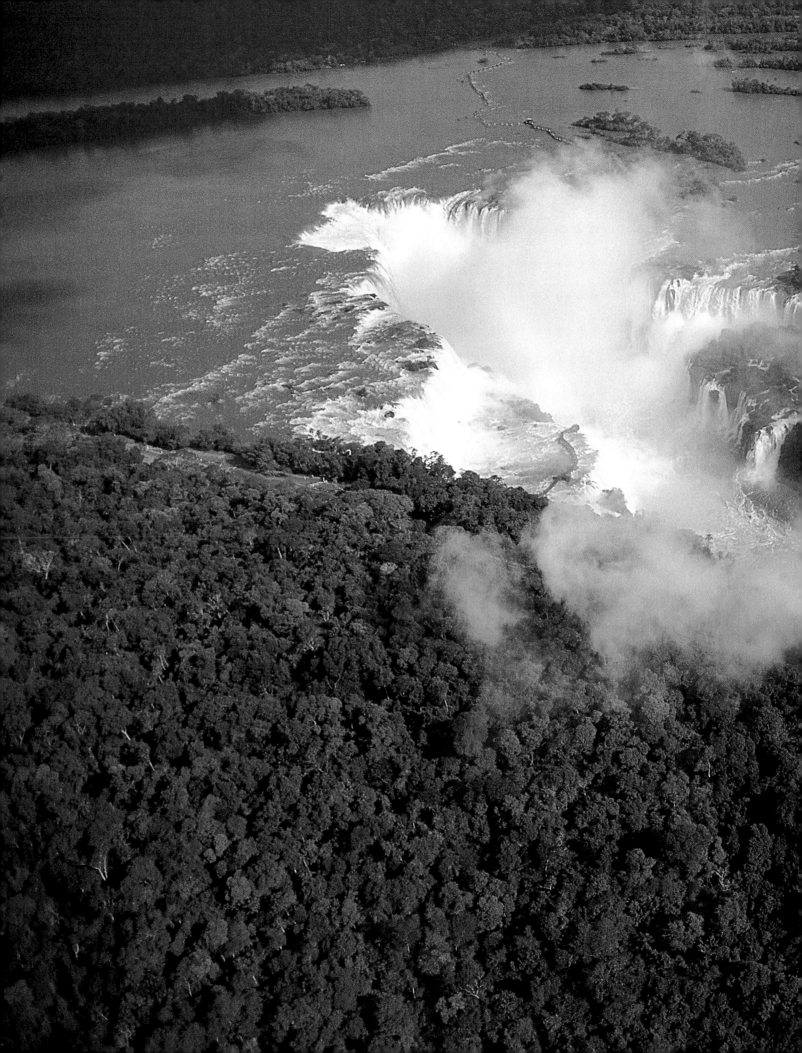

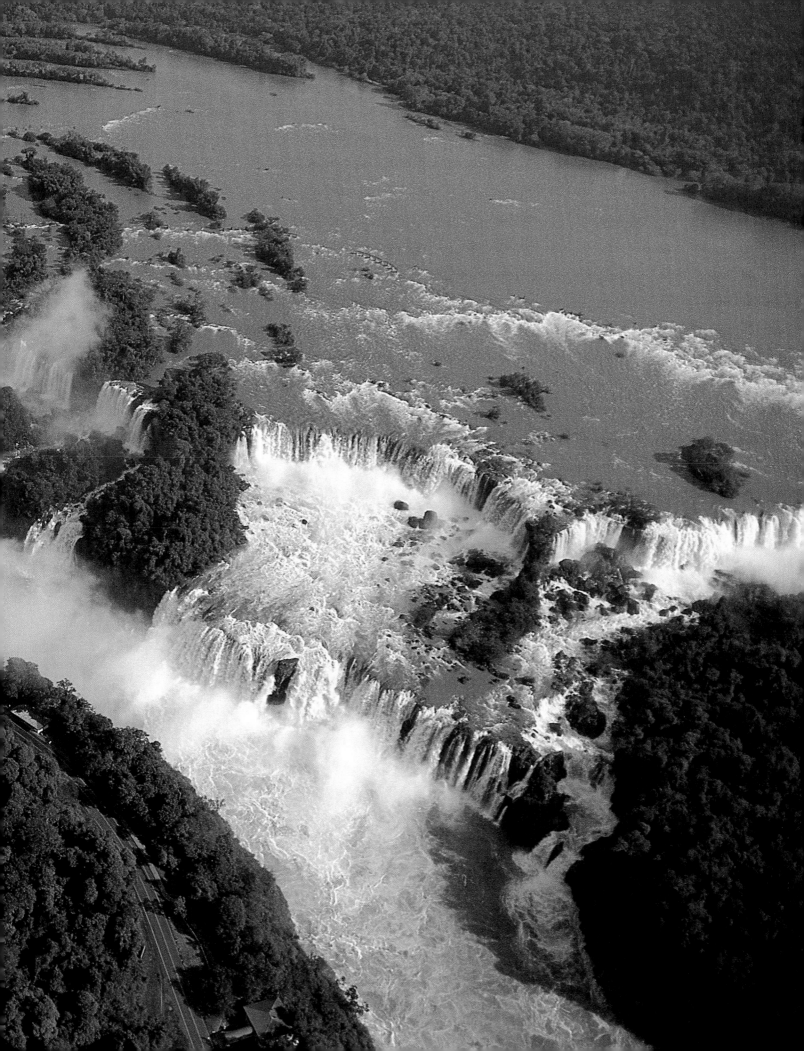

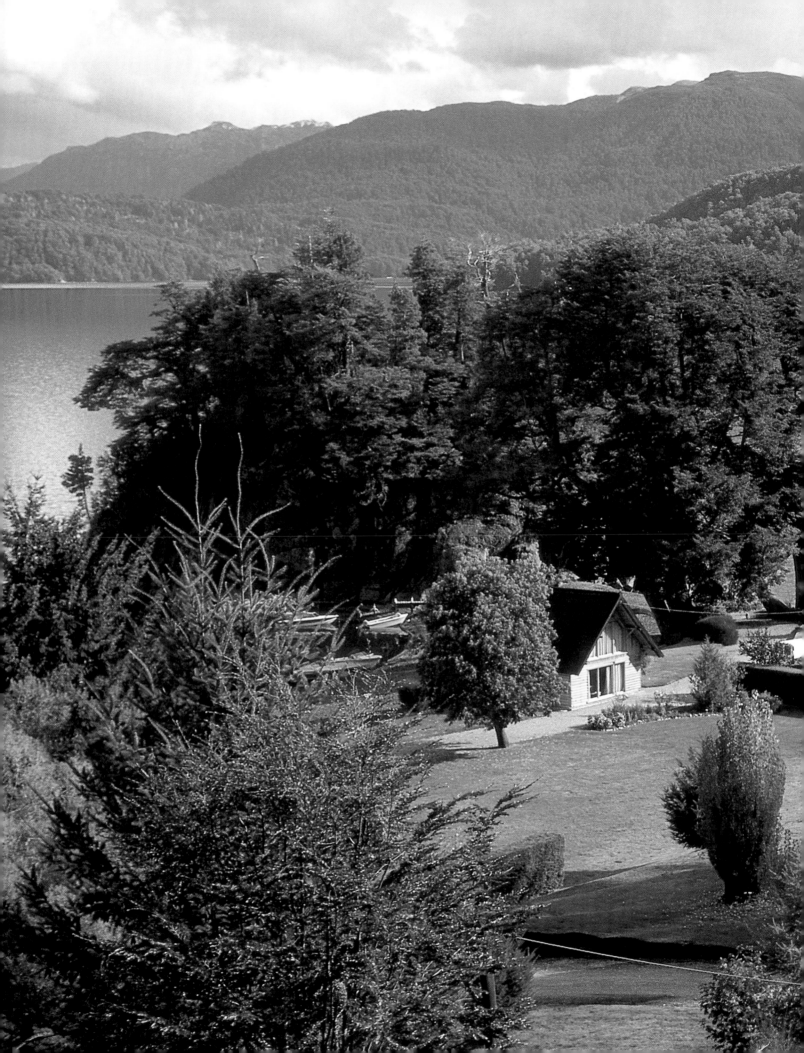

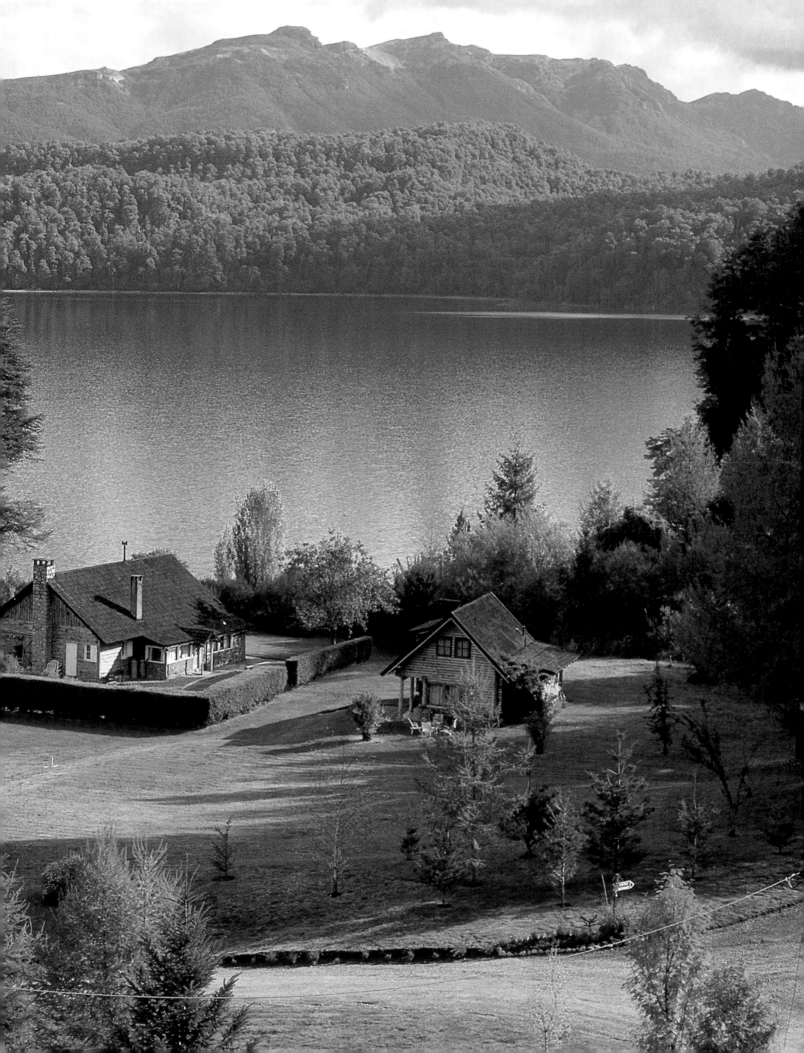

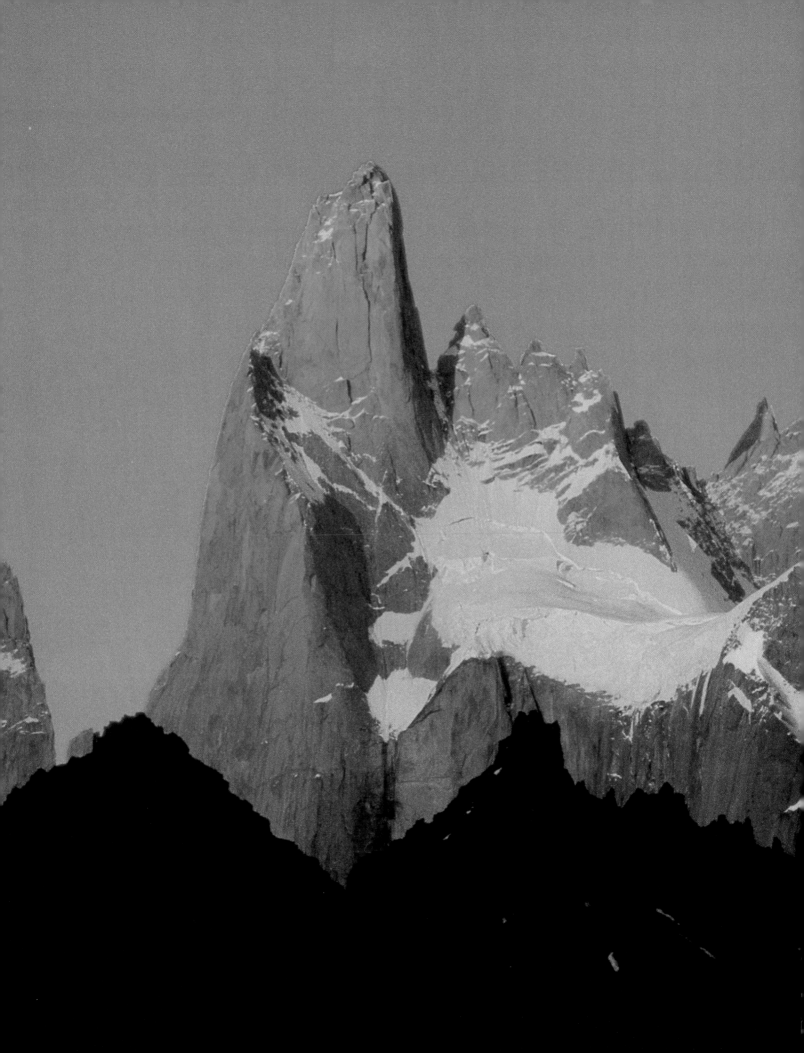

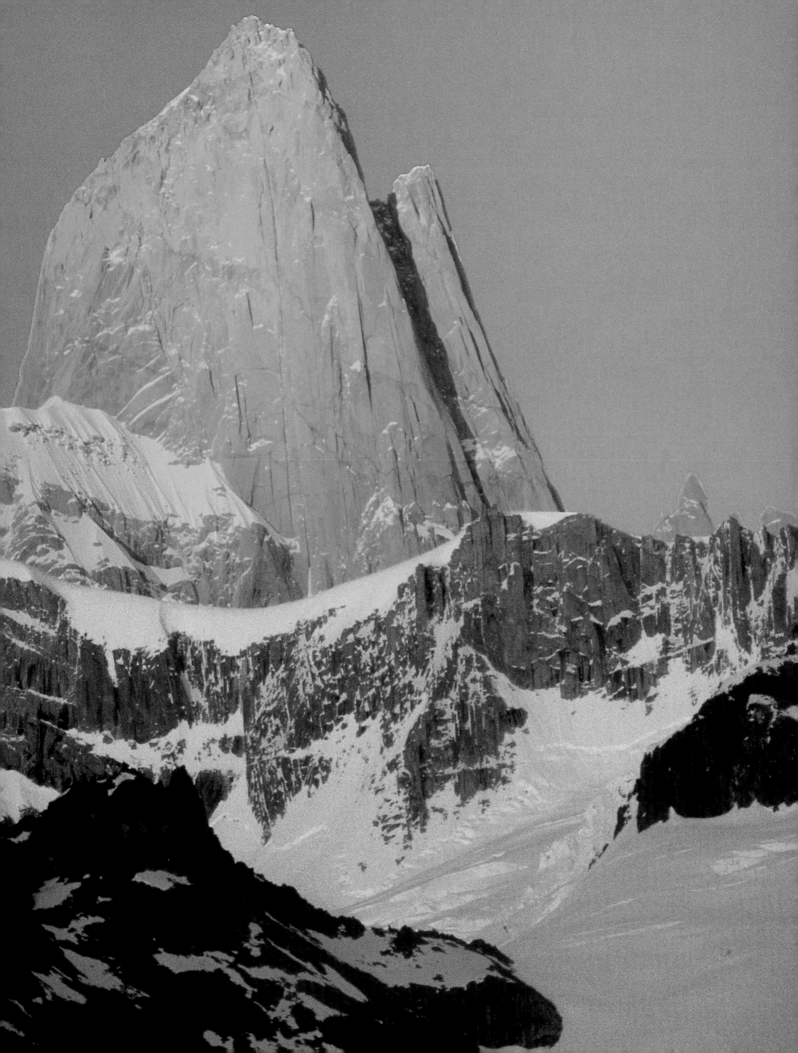

Text
Isabella Brega

Graphic design
Anna Galliani

Translation
Barbara Fisher

Contents

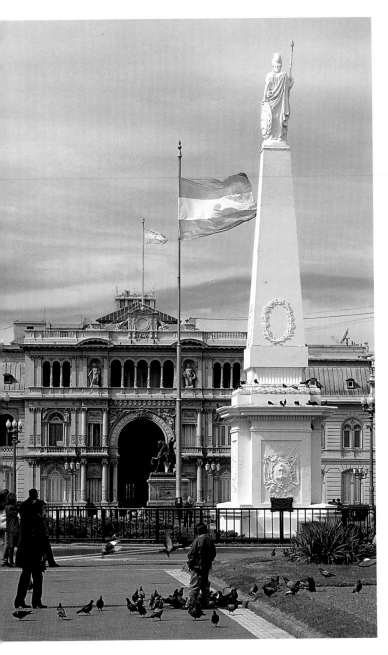

1 *The Palacio del Congreso in Buenos Aires. The Argentine capital, considered the most European of those in South America and the most American of the Latin ones, has 13 million inhabitants spread over an area of more than 77 square miles. Divided into 46 barrios (neighbourhoods), it is crossed from north-east to south-east by two large thoroughfares which also define the city center.*

2-3 *The majestic Iguazú Falls which give their name to the National Park around them. Situated in the marshy north-eastern region, amidst lush subtropical forestland, they number 275 different waterfalls, fed by the Iguazú river, and plunge from a height of more than 200 feet into the valley below before flowing on for nearly 560 miles.*

4-5 *Lake Nahuel Huapi, in the National Park of the same name, is in the lake district, in northern Patagonia. Considered one of the country's most beautiful lakes, in just a few years it has become a major tourist destination. On its banks stands the only real urban center of the area, the town of San Carlos de Bariloche, with European-style architecture.*

6-7 *An impressive view of Cerro Fitzroy, in the Los Glaciares National Park. This peak is known among enthusiasts for its extraordinary yellowish-pink hue in the first light of dawn. The ascent of the north-west glacier is particularly demanding.*

8 *The Casa Rosada, built in 1894 on Plaza de Mayo in Buenos Aires, is the official residence of the President of the Argentine Republic. Some say that the characteristic color, originally produced in 1873 by mixing chalk, blood and animal fat, was the result of a compromise between the two opposing parties at the time of President Sarmiento: the Federalists (red) and the Unitarists (white).*

9 *A beautiful view of the Calchaquíes valley, situated in north-west Argentina comprising the provinces of Jujuy, Salta, Tucumán, Santiago del Estero, Catamarca and La Rioja. Marked by the presence of the remains of ancient pre-Hispanic aboriginal settlements, the area has a tropical climate, with mild and usually sunny winters.*

© 1999 White Star s.p.a.
Via C. Sassone, 22/24
13100 Vercelli, Italy
www.whitestar.it

New updated edition in 2007

ISBN 978-88-544-0208-9

Reprints:
1 2 3 4 5 6 11 10 09 08 07

Printed in Singapore

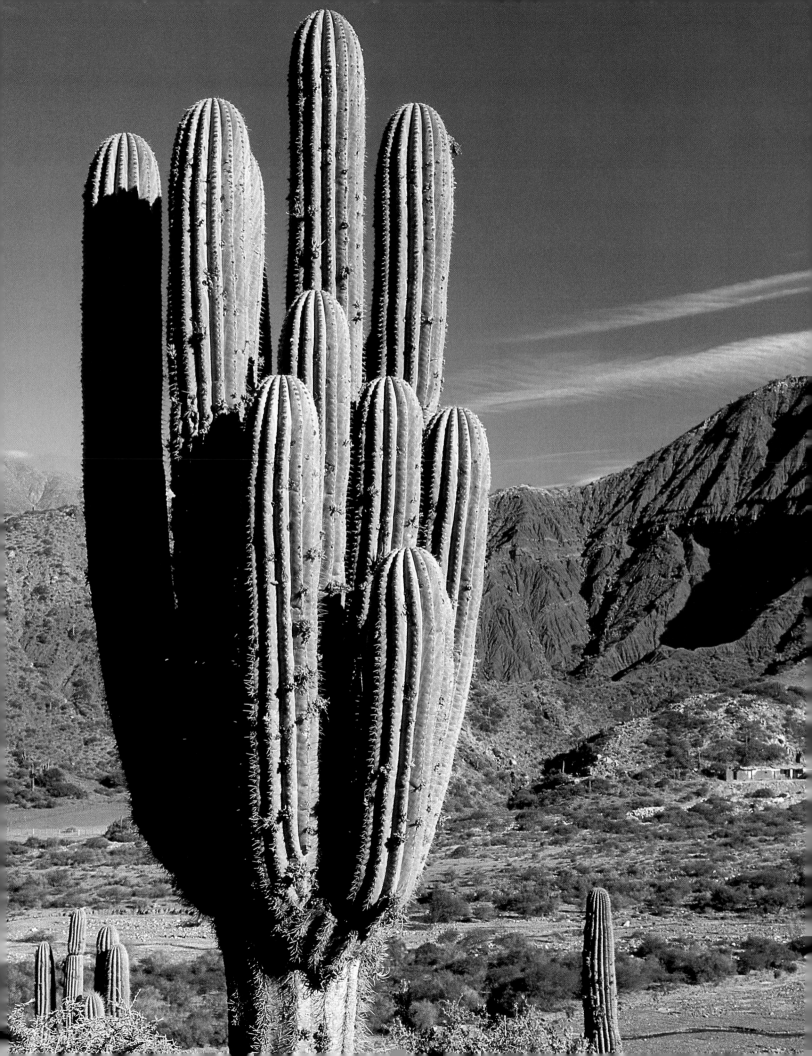

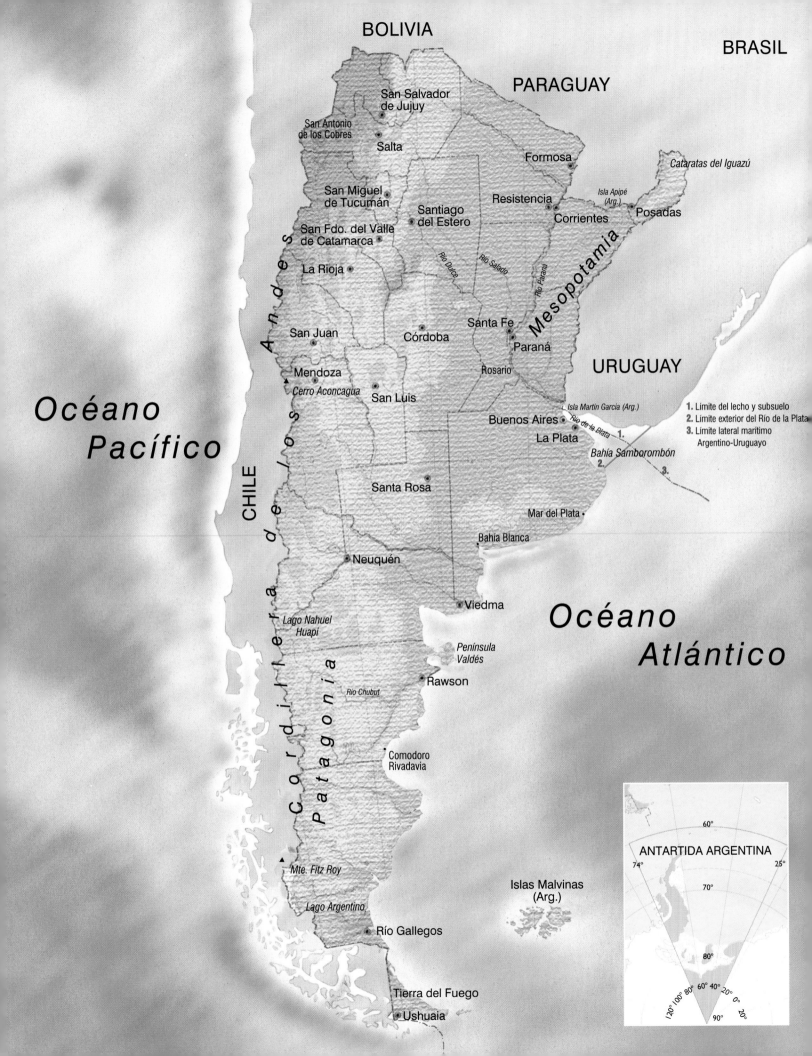

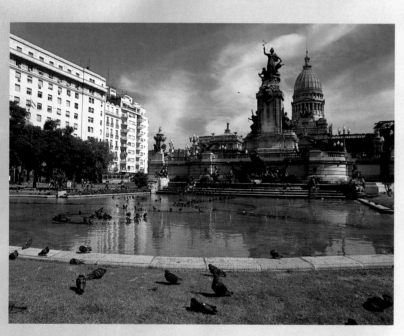

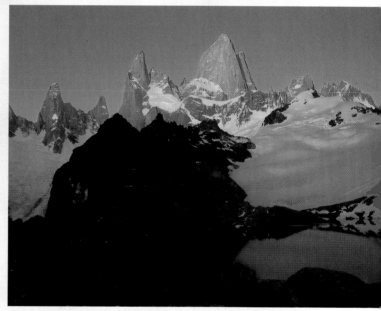

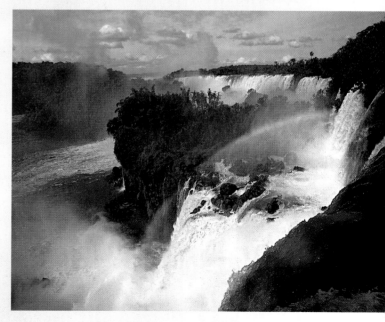

11 top *The Palacio del Congreso is situated on Plaza de los Dos Congresos in Buenos Aires. At the center of the square stands a fountain dedicated to the Congresses which abolished slavery and proclaimed national independence.*

11 bottom right *Situated on the border between Argentina and Brazil, the famous Iguazú falls were discovered in 1541 by the Spaniard Nuñez Cabeza de Vaca. The National Park they stand in, one of the country's most important, is home to more than 2,000 plant and 400 bird species and more than 100 different mammals. Particularly awesome is the central fall, known as the Devil's Throat.*

11 top right *The superb Cerro Fitzroy, 11,070 feet high, stands in the nature reserve of the Los Glaciares National Park, which extends over a surface area of 1,482,000 acres. The mountain, called El Chaltén (Blue Peak) by the natives, takes its* name from the legendary Fitzroy, captain of the Beagle, who with Charles Darwin made the first systematic chart of the Patagonian coast in 1836.

12-13 *An aerial view of Buenos Aires, the city which, according to one of the leading Argentine writers Borges "... does not look back. The conquistador and Indian do not concern him". The product of different cultures and worlds, the capital alternates futuristic skyscrapers with elegant neo-classical mansions, composed Spanish buildings and solid Art Deco constructions.*

14-15 *Most of the territory around Río Gallegos, in southern Patagonia, was populated towards the end of the 19th century by Irish and Welsh sheep-farmers, attracted by the offer of new lands made by the governor of Santa Cruz. In just a few years vast estancias grew up around the town and their activities made Argentina one of the world's leading wool-producers.*

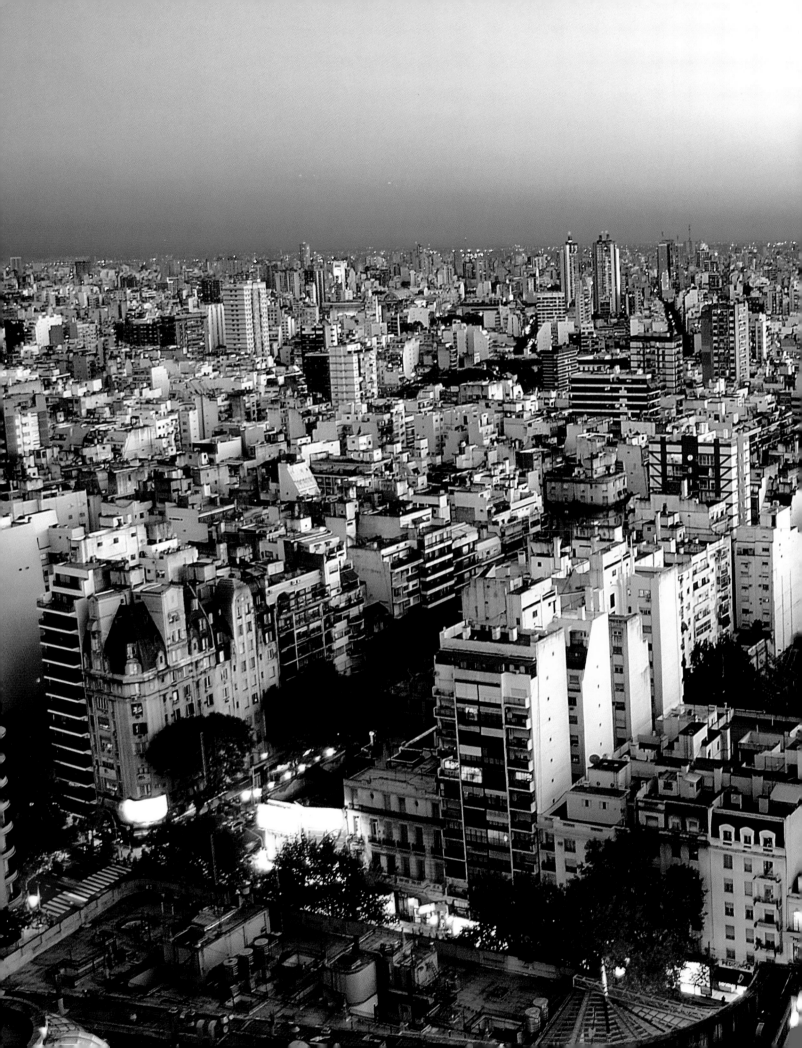

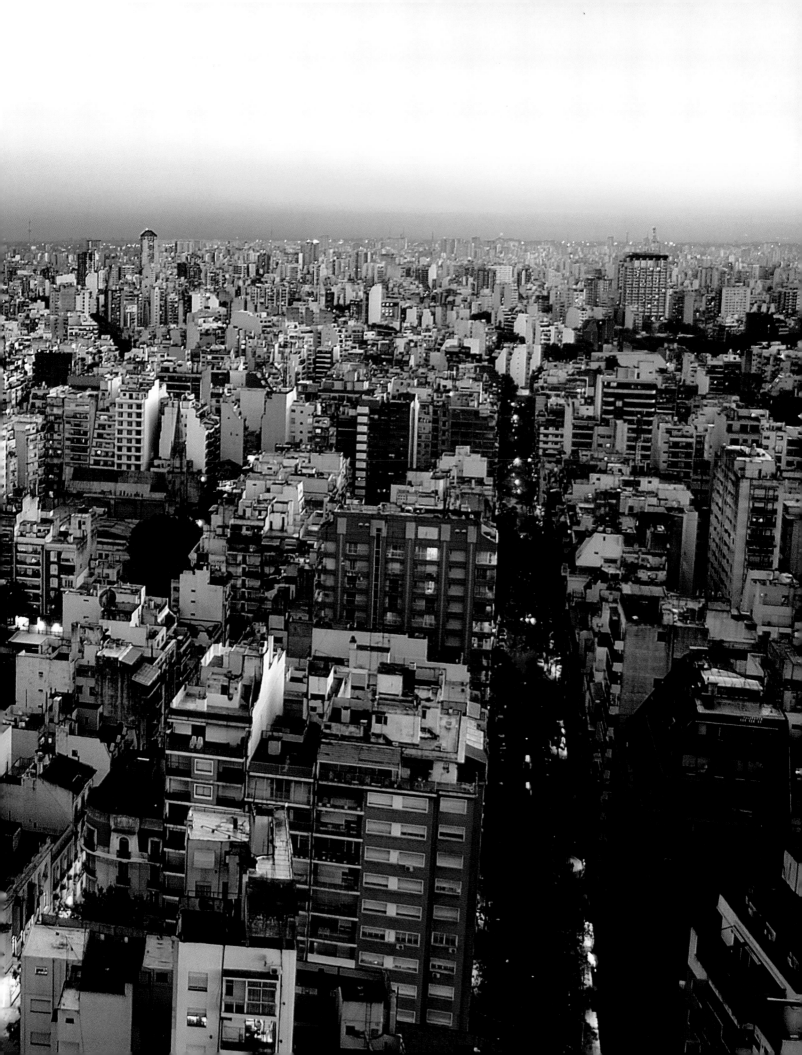

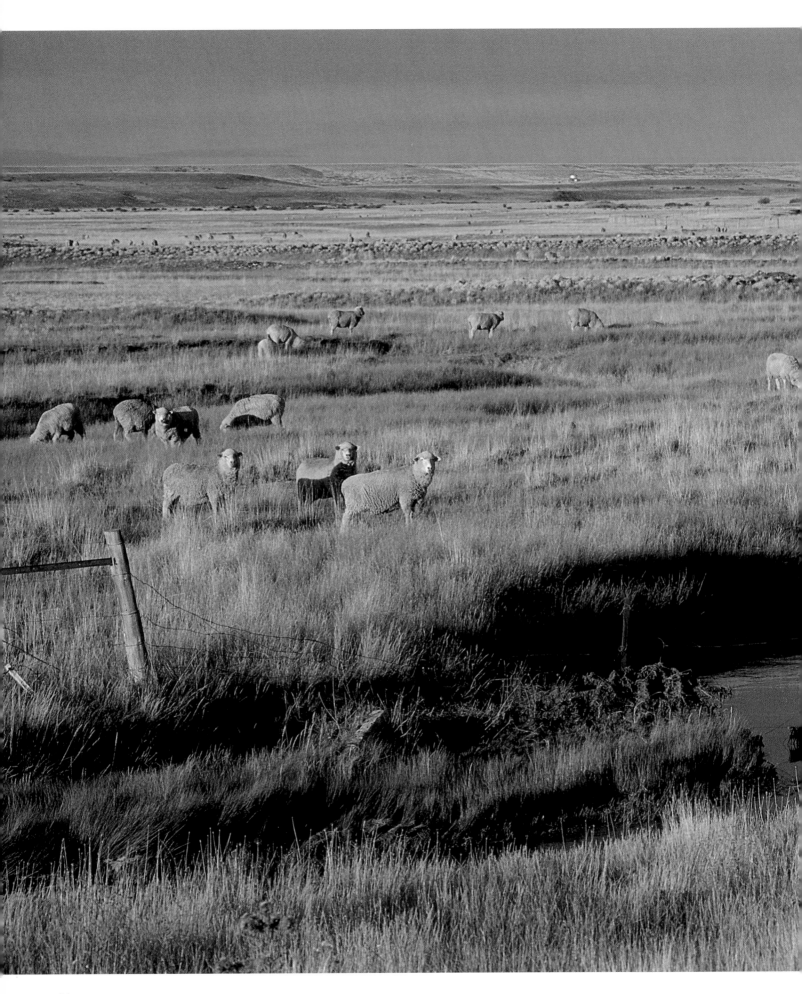

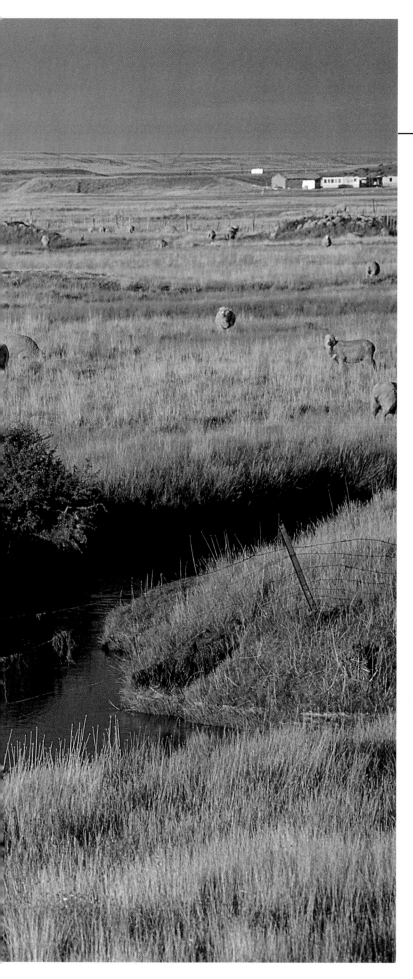

Introduction

Take lush nature, vast open spaces, fertile soil where a seed has only to fall to the ground to produce an abundant harvest; an interminable expanse on which herds of cattle and wild horses roam free and multiply beyond measure; endless woods, great raging rivers and lakes; a heart, the pampas, in which all is both elementary and incalculable and which, until it encounters plateaux, water-courses and mountains, is reflected in nothing. Add to this immensity - rich but devoid of boundaries and certainties - a man who still wonders who he is, born in this country but of Italian, Spanish, English, German, French, Polish or Jewish descent and you will see why it is not always easy to be the children of a land full of promise. Europe, for its inhabitants, is a state of fact for the Argentine, Argentina is a problem: that of knowing and defining oneself through one's own native race, which is the product of the coming together of several peoples — a race capable of expressing the essence of this fortunate land but in which the individual may sometimes lose his sense of identity, drowning in an abundance of land, in an excess of flocks and herds, in an intoxication of mountains, forests, prairies, glaciers and waters.

Immense size, a measureless void. This is Argentina's castigation, this its beauty, fortune and limitation. A huge country of nearly 1,076,000 square miles (plus 461,280 of disputed lands: the islands in the south Atlantic and the Antarctic territory), 3,000 miles long, 860 wide, inhabited by roughly 40 million people. A country that runs from the flat horizon of the pampas to the giddy height of Aconcagua (22,841 feet), the highest mountain in the western hemisphere, from the ferocious cordillera of the Andes to the ice of Tierra del Fuego, from the desolation of Patagonia to the barren upland plains of the north-west. According to Scalabrini Ortiz, one of the country's leading writers, because of the lack of what is the very essence of European life - the

15

continuity of tradition, a sense of belonging to a community - moving in this vastness is "a man alone and waiting", born in Argentina, although his origins are lost in a thousand rivulets of massive and confused immigration. A child not of his own parents, but of the land, of himself. No longer an heir of Europe but master of his own destiny and fortune. This explains the melancholy that marks the Argentines and the very nature of the most typical expression of their temperament, the tango, a reflection of the country, its crises, hopes, expectations and disappointments.

As Carlo Fuentes wrote: "The Mexicans descend from the Aztecs, the Peruvians from the Incas, the Argentines from the ships". The major problem of this vast nation, where meat was cheaper than bread and meat used to make broth was thrown away, has always been that of emigration. The remedy adopted was to favor immigration in all ways possible, such that article 25 of the 1853 Constitution even declared that "the Federal Government shall favor European immigration and shall not restrict, limit nor impose tax upon the entry to Argentine territory of foreigners intending to work the land, improve the manufacturing activities and introduce sciences and arts".

From the moment of independence, gained after three centuries of Spanish domination, foreigners accounted for a large percentage of the Argentine people and this caused problems. The number of inhabitants rose from 405,000 in 1810 to 1,300,000 in 1859 and, when unlimited entry was granted to immigrants, the population rose from 1,737,076 in 1870 to 7,885,237 in 1914 with the percentage of foreigners increasing from 13.8 in 1859 to 42.7 in 1914. More than half the immigrants returned home, but many decided to stay, especially among the Italians, who made up the largest part of the migratory surge, followed by the Spanish. In 1895 49 per cent of the inhabitants of Buenos Aires - the capital since 1880 - were of Italian origin and this percentage has remained unchanged.

Towards the mid-1870s this context favored the confused birth of the most typical Argentine symbol, the tango: a hybrid product of a hybrid country. Born and developed in the brothels of the Buenos Aires suburbs, the tango is the product of a male society. In the squalid taverns, in the ill-famed brothels of this city of unaccompanied men (between 1857 and 1924 70 per cent of immigrants were of male sex) the coming together of the Cuban habanera, the milonga (a popular dance), the African candombes (the first black slaves arrived in 1702), Andalusian tangos and, most of all, Italian melody gave rise to a restless and melancholic type of music. The tango, according to the famous definition by Enrique Santos Discepolo, who gave it a reflective and sceptical style, is basically "a sad thought danced". The immigrants made an enormous

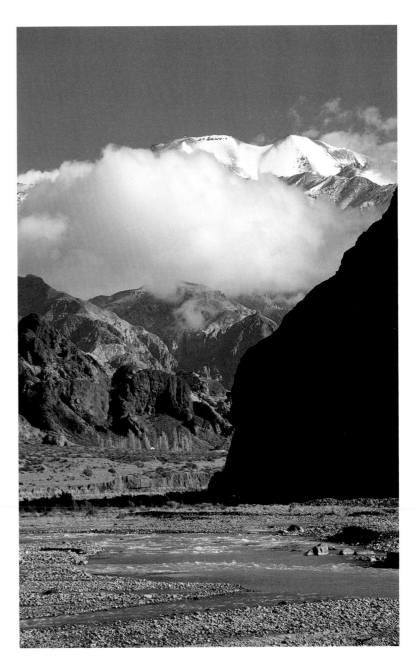

16 *The Río Mendoza, with the first spurs of the Andean Cordillera visible in the background, makes the green plain surrounding Mendoza fertile. The most important town in the Cuyo region was founded by Pedro de Castillo in 1561 and has since the mid-19th century produced the best Argentine wine - Merlot, Cabernet Sauvignon, Chardonnay, Chenin, Riesling and Pinot Noir.*

17 top *The wild peaks of the Aconcagua Provincial Park take their name from the great mountain that is, at 22,841 feet, considered the highest peak on the American continent. Mountain expeditions wishing to test themselves on this demanding peak must first obtain the necessary authorisation from the local Club Andinista.*

17 bottom *The Nahuel Huapi National Park is the oldest and largest in Argentina, with 40 lakes. The most striking is Lake Nahuel Huapi itself, supplied by the Río Negro and as large as Lake Geneva. On it banks stands, among others, the Hotel Llao Llao, one of the oldest in the area which takes its name from a yellowish pear-shaped mushroom that grows on the beech trees.*

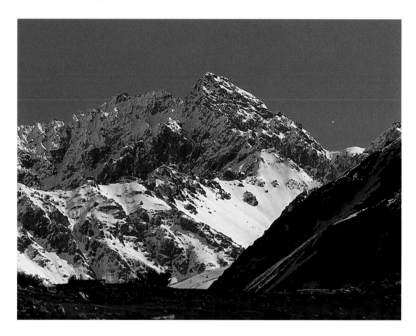

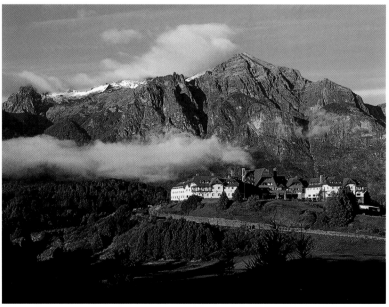

contribution to this dance, particularly so the Italians, the most numerous group which produced the first musicians, those who gave it that melancholic air, making it nostalgic and sorrowful, as bitter and sombre as the uprooting so typical of immigration. In fact nearly all the "old guard" of the tango, from Santos Discepolo to Juan Maglio, speak Italian. Forbidden in all public places, the tango had to wait a long time before being admitted to the family homes and bourgeois salons. It was the Paris of the Belle Époque, the center of the world and a point of reference for the Argentine aristocracy, which sanctioned first the legitimacy and then the triumph of the tango. Only once it had returned from Europe where, to the astonishment of the Argentines who spoke French and spent lavishly so as not to appear parvenu in the eyes of the Europeans - and who could not stand to be identified with a dance so inconceivable to the severe morals inherited from the Spanish - was it the object of a raging fashion and was eventually accepted in the salons. 1917 marked a turning point, Carlos Gardel sang *La mia triste serata* to music by Samuel Castriota. The words were written by Pascual Contursi, who was to turn the tango into an introvert genre, giving it real words, mostly sentimental and melancholic, linked to the theme of abandon and thus changing it from dance to song.

Carlos Gardel represents the legend par excellence, one fomented by an unknown place, origin and date of birth (probably Toulon, the illegitimate son of an ironer, between 1877 and 1890). Thanks to hundreds of records and films made for the Spanish-speaking market, by 1933 he was a celebrity conducting long tours in France and Spain and living in luxury in New York.

His death in 1935 in an aeroplane crash was to fix his youth and fame for ever, making him eternal together with his brillantine and the ever-present cigarette, which fans now leave between the fingers of the statue on his funeral monument. His tragic death allowed the Argentines, who snubbed him after accusing him of having failed to change with the times, to take him back and make him the first of the great national legends, to be followed by Evita, Manuel Fangio, son of an immigrant from the province of Chieti in Italy and winner of five world motor racing championships (1951 and 1954-57). Around them is consolidated that national identity so laboriously sought. The legend was born, the enthusiasts became devotees, admirers fanatics. Today Gardel is still in the hit parades and his tomb in the Chacarita cemetery is studded with plaques "for favors granted".

Fruit of Europe and of the New World, Argentina is somehow familiar yet new. As Borges sustains: "We are the true Europeans: children of Italians, Spaniards, French and Germans. All these cultures mix in our blood while the Italians are only

Italians, the Spanish only Spanish, the French French, the Germans German". This is also the impression given by Buenos Aires, the most European of the South American capitals, the most American of the Latin ones. A city that is insolently beautiful, elegantly retro, aggressively futuristic. It is European in the cafés with their mirrors and dark tables, exquisitely Argentine in the large squares and long, impressive avenues, as too in its 13 million inhabitants distributed over an area of more than 77 square miles. It is a city full of Art Nouveau memories, the period when Argentina was one of the richest nations in the world. Constructed to be grand, it was the capital of a country that lived "grandly" thanks to the sale of leather, meat, wool and wheat; a city grown quickly and not necessarily required to have beauty, harmony and style, but only to fill existential and physical voids, to be the reflection of the nation's great aspirations. Its 200,000 inhabitants of 1869 had by 1915 become two million, when it boasted 12,000 cars, more than all those in circulation in Italy, and 60,000 telephones, more than all those in France. Buenos Aires is a whole surrounded by the vast nothing of the pampas; a symbol, like its land, of great expectations and equally great frustration. It is a metropolis for its own sake, almost rent from the country, electrified by the life that flows along wide avenues that accentuate the aggressive vitality of a modern city.

Buenos Aires, the union of different worlds and cultures, can be French in the bohemian quarter of San Telmo, small restaurants and intellectuals; it has peaceful corners, exclusive clubs and quiet parks reminiscent of London. But it conjures up Italy in the classicism, the fashionable streets such as the Avenida Santa Fe and in the sumptuous Renaissance-style Colón theater.

Spain is reflected in the suspended patios and in the pompous and pretentious monumentality of the public buildings, before becoming once more a New World megalopolis in the difficult traffic, in its exaggerated and swollen proportions, in its regular chequered plan made of *quadras* (districts) 328 feet per side, in its total faith in the future, its forgetting the past. But also in the taste for excess, represented by Avenida 9 del Julio, "the largest street in the world" nearly 131 feet wide and the longest avenue, Rivadavia, 13 miles of mansions and shops.

It then turns into a South American capital in its love for football, demonstrated by 16 stadiums and 200 Sunday football tournaments, before declining dramatically in the shanty-towns of the suburbs, poverty that contrasts with the refined elegance of colonial villas, neo-classical buildings, avenues and parks in the residential districts of Palermo, Recoleta, Retiro and Belgrano (developed in the early 19th century as a holiday resort for the aristocracy and dedicated to the general of the same

18 *A myriad of hot peppers drying in the sun in the countryside around the town of Cachi, in north-west Argentina. The sale of hot peppers is one of the main sources of income in this mostly desert region. Near Cachi, the ancient aboriginal complex of Las Pailas boasts one of the most important archaeological museums in the country.*

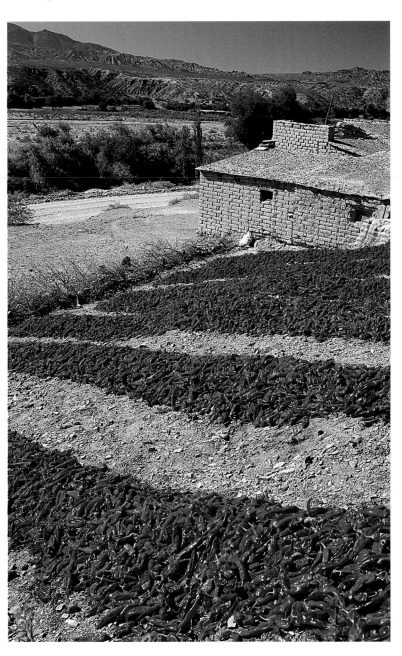

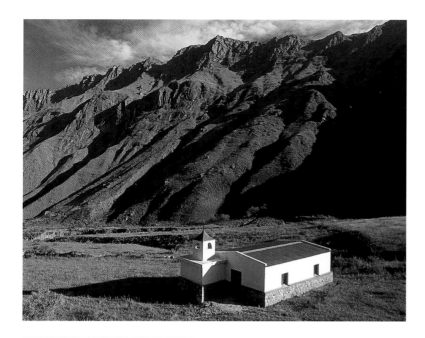

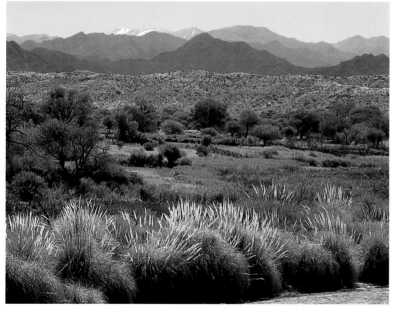

19 top *The Cuesta del Obispo leads to the pass of the same name, which divides Cachi from the town of Salta, with its many colonial buildings considered one of the most interesting centers in the Northwest. Communications in this area are not always easy and during the rainy season, from Christmas to Easter, landslides make many roads impassable.*

19 bottom *The countryside around the town of Molinos, in the Argentine Northwest. This small hamlet is marked by a colonial atmosphere; it takes its name from the old grain-mill still to be seen on the bank of the Calchaqui river.*

name of Italian - Ligurian - origin), with elegant shopping streets such as Avenida Florida and the glittering splendor of the Avenida Corrientes and Avenida Lavalle. Constantly torn between the search for the comforting and reassuring intimacy of small cafés fixed in the legend of good times lost - first and foremost the famous Tortoni, founded by the Italian Oreste Tortoni in 1858 - and the display of giddy heights and gigantic proportions, between an attachment to culture and tradition, symbolized by the great book-shops of Sarmiento, Santa Fe and Tucuman as indeed by the *tanguerias* of San Telmo and the frenetic pursuit of North American cultural models and novelty.

In the two cemeteries of Chacarita and Recoleta, Buenos Aires also gives the impression of a multiplicity that is resolved in a unity. Or rather, of a unity that does not cancel a plurality made of chapels, spires, pinnacles, temples and funeral constructions in all possible materials and styles. Architectural chaos, fruit of the competition between rich land owners who called artists from all over the world to make up for the Argentine sense of inferiority, to assure a burial worthy of the immense riches accumulated.

The stadium of the exclusive Palermo district is the temple of polo, the national sport that boasts the best players in the world, but the lively La Boca district, little houses built on piles by immigrants using sheet zinc brightly painted with the left-over colors of the ships (and with such a concentration of Genoese and Neapolitans that in 1882 it declared itself an independent republic, with Italian flag and laws), remembers the birth of the tango. As too it recalls the seafaring tradition of what was the country's largest port, big enough to receive more than 30,000 ships a year, and it brings to mind the images of Maradona, the champions of Boca Juniors and River Plate and the well-known Calle Caminito, the narrow street used for a famous piece by Juan de Dios Filiberto.

Plaza de Mayo contains the country and its contradictions. The neo-classical façade of the cathedral - in which is buried the champion of independence, San Martín - the solid and bourgeois Casa Rosada, the Spanish Cabildo, home of the City Council erected in 1608 with portico and central tower, summarize a history that is not linear but troubled, one of shocks and starts although not for this less generous: Spanish domination, the crazy years of wealth and extravagance, the Perón adventure, the military dictatorship, the Montonero terrorism, the Thursdays of numb tears wept by the mothers of the "Disappeared", the humiliation of the Falklands war, devastating inflation and the restoration of democracy. The fate of this country has been played out on this huge stage; here Maria Eva Duarte acted her best part before oceanic crowds; actress, lover, wife of colonel Juan Domingo Perón,

brought to power in 1946 by this woman who succeeded in turning one of the many South American coups into a true political movement. Daughter of the people, Evita was to live for the people and with the people, winning for them health care, paid holidays, state housing, salary bonuses and co-operatives. An illegitimate daughter, she was to become the mother of a nation of immigrants, children of themselves, scattered men. She was a legend, the projection of the desires and hopes of a country and its desire to grow. Comforter, goddess, advocate of the poor; for them she became blonde, elegant and refined and, clad in stylish clothes and draped in jewels, in 1947 she was the radiant ambassador of a country of descamisados visiting a Europe destroyed by war, meeting Franco, Pope Pius XII and the Foreign Ministers of France and Italy. Supporter of women's rights and in particular female suffrage, Evita founded the first solely female party (Partito Peronista Femminista) and her picture made the cover of the prestigious *Time* magazine.

She died on 26th July 1952 at the age of just 33, of a tumour of the womb; spared from old age and the judgement of those who followed her, she forcibly made her way onto the list of great national legends, the Argentine church being driven to request her beatification, already implemented in practice by the common people. Millions in tears followed her solemn funeral, for which three plane-loads of flowers were flown in from Chile.

Although immigration boosted the tango, it killed the other national myth, the *gaucho*, the king of the fertile alluvial lands that surround Buenos Aires. The pampas, miles upon miles always the same, where all seems to continue beyond, farther on, following the endless course of the railway tracks, constructed by the English, that seem to carry Argentine life and time along in an unstoppable flow. A monotonous void of unrelentingly flat scenery broken here and there by trees introduced by man to beat the monotony of a vegetation consisting almost exclusively in low bushes. Thanks to the tenacious work of several generations of pioneers, today this void constitutes one of the world's major granaries and possesses the main centers of beef production. It is here that Argentina is itself, in all its weakness, all its strength.

The pampas is no longer just that uniform land, "with no knots or poetry", the harsh monotony of which could test the will of even the strongest; it is no longer the poetic and mythical pampas, that nourished the dreams, spirit and poetry of an entire nation, busy adapting its life and hopes to the rhythms and hopes of the growing city. It is no longer the strong land "that as it grows so do the men it accommodates.

This immense plain has always been the domain of the *gauchos* (a word which in quechua means "without mother"), the legendary cowboys who have

20 top The cathedral of Córdoba is certainly one of the most distinctive pieces of architecture in the country and indeed all the colonial world. The town was founded in 1573 by Jerónimo Luis de Cabrera in the central Sierras and is rich in monuments, including a large number of religious buildings and the oldest university in Latin America, that of the Jesuits, inaugurated in 1621.

20 bottom Rosario's Parque de la Bandera, dedicated to one of the city's main monuments, that of the Flag, which consists in a flight of steps and an obelisk, adorned with statues and surrounded by arches in front of which burns an eternal flame. Formerly considered the country's second city, Rosario now has more than a million inhabitants.

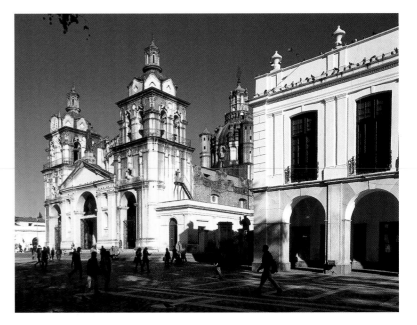

always seen the constant search for a limit to the boundless and oppressive horizons as a challenge and never a defeat.

The legend of these men was born when the Spanish, who had in 1536 founded the original center of what was to become Buenos Aires, withdrew, abandoning 76 horses and mares, 7 cattle and a bull; these scattered and multiplied on the great plains. Until the 17th century there was a population density of one family per 2,500 acres and the livestock of the pampas was free, unbranded and with no supervision and anyone could take advantage, seizing up to a maximum of 12,000 head although the Governor's permission had to be obtained for more. Tireless horsemen, the fruit of mixed blood, the gauchos came to the *estancias* (the territory occupied by the large farm estates) to do seasonal work such as branding, to earn some money before returning to the pampas. They led a solitary life but always in the company of their horse, hardly ever dismounting, and which allowed them to dominate a world that, on foot, would have condemned them to a sense of insignificance. Proud vagabonds of a perpetual border country, the gauchos with their knives and belts encrusted with silver, leather whips, baggy trousers, soleless boots made from the rear hoof of a colt, ponchos and the ever-present *boleadoras* (instruments used for hunting consisting of steel balls, bolas, and leather thongs) for capturing cattle and *nandu* – large flightless birds) took from nature only what was needed for immediate consumption. They killed a beast and took only a cut for their supper, when they cooked *asado con cuero* (meat cooked with the skin) or, when fuel was short, merely ate it after it had been left all day to "ripen" between the saddle and the horse's back, accompanying the whole with the ever-present mate, the national drink made from *Ilex paraguayensis* that compensated for an almost exclusively carnivorous diet.

They were the lords and the prisoners of the pampas until the end of the 19th century, when the European settlers, many from Piedmont, finally imposed discipline on that wild expanse, increasing the farmed surface area fifteen-fold but closing the horizon and above all the spirit, with a system of enclosures and fencing. When in 1872 Charles Tellier discovered how to produce artificial cold - eliminating the need for seasonal work and making it possible to export meat which before had only been salted and sold as food for slaves - and with the introduction in 1880 of barbed wire by the Prussian consul Franz Halbach, everything changed. The meat industry was born - the first frozen consignment left for Europe in 1877 - the cattle breed was improved with the introduction of some head imported from Europe and, in the same year, an army of 6,000 men gave settlers 50,000 miles of new land "cleansed" of Araucanos, Puelches and Querand Indians.

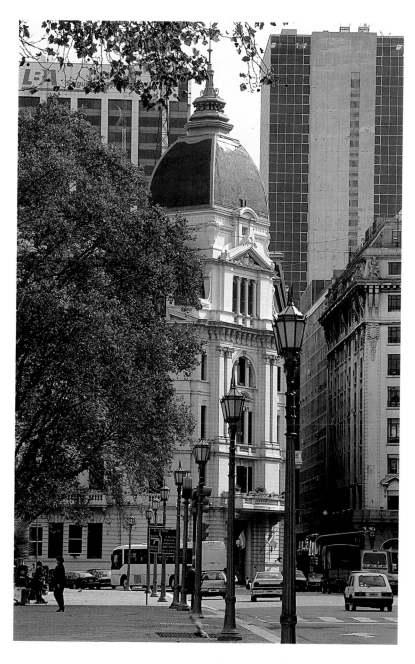

21 *A view of Plaza Mayor, in Buenos Aires, illustrates how the eclectic Argentine capital is the fruit of several architectural styles overlapped. The city center grew during the Belle Époque thanks to the huge riches accumulated by the owners of the immense* estancias *on the pampas from the hide and cereal trade.*

The end of the *gauchos* marked the birth of their cult. As the city grew and the world of the pampas started to decline, there was increasing Argentine nostalgia for the great open spaces, for the dying traditions, freedom, adventure, the chance for release and change offered by a lush and never truly tamed nature. This cult was fuelled by much literature, the bible of which remains the poem *Martín Fierro* by José Hernandez - the first true literary expression of Latin America, a book which the Argentines know by heart and that the descendants of the old immigrants gave to relatives come to visit them from abroad - in which the *gaucho* is immortalized in a number of fatalist, rough but courageous characters, who like the Argentines are torn between the desire for freedom and the need for reassurance, between submission and rebellion, between pride and self pity.

The men disappeared, their legend grew, encouraged by a local aristocracy that was afraid of losing its identity with the arrival of so many immigrants, and by the new arrivals, so anxious to be integrated in their new land as to be more Argentine than the natives themselves.

The old *gauchos* vanished in silence. The unyielding turned into horse or cattle thieves, the others integrated, moving to the towns or working the land. They did not die off completely nor could it be otherwise in a country that possesses nearly 60 million head of cattle, 40 of sheep, 3 of horses, where every head has nearly 36,000 square yards of grazing land and its inhabitants eat roughly 220 pounds of meat per year compared with the 35 of the United States, even with all its hot dogs and hamburgers.

The Argentine space is defined by the "presence of the horizon": the horizon created by the vast plain of the pampas that seems to occupy and expand the whole country and to find a limit to its expansionist drive only when it comes into contact with the ice of the South, the tropics of the north-east, the cordillera of the west, the jungles and woods of Chaco and Misiones and the Bolivian uplands of the north. This breathtaking natural world is symbolized by the famous Iguazú Falls, 275 different waterfalls plunging from a height of more than 200 feet, by the severe wind of the Andes; here as well as the nandu of the pampas there are the llama of the cordillera, the elephant and sea-lions, the penguins and whales of the Peninsula Valdés (one of the most important fauna reserves in the world), the pudú (the smallest deer in the world) of Patagonia, the silver foxes and the guanaco (related to the domesticated llama) of Tierra del Fuego.

The remains of the pre-Columbian civilisations entwine with the petroglyphs of the Talampaya canyon, the rock drawings of Cuevas de los Manos and the traces of the Chequa, Alacaluf, Yamana, Tehuelche and Ona Indians while the colonial buildings of San Fernando del Valle de Catamarca, Córdoba (with its ancient university and cathedral) and Acheral mix with the fossils of the Valles de la

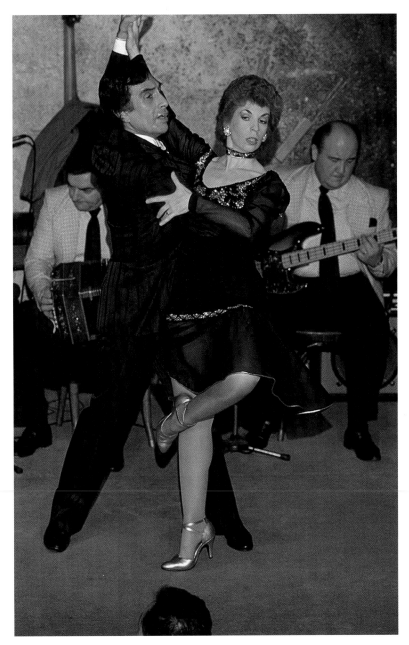

22 *Tango dancers at El Viejo Almacén, one of the best-known night-spots in Buenos Aires. According to the famous definition made by Enrique Santos Discépolo, one of its leading writers, this provocative and tormented dance is "a sad thought danced". Born in the brothels and tenements of the La Boca district, it is certainly one of the best-known expressions of the Argentine temperament.*

Luna and the remains of missionary villages founded by the Jesuits in the 17th century; added to the traditions of the Italian communities of Mendoza and San Juan (the main wine-making centers in the country which produce Cabernet and Pinot Noir) are the Welsh ones of Patagonia and Chubut (The Sundance Kid and Butch Cassidy settled here and bought an *estancia*) and the chocolate cakes and painted china of the Swiss and German communities of Bariloche.

If Argentina is synonymous with pampas it is by escaping the pampas that you come to that which still embodies the untamed spirit of this country, Patagonia. A vast area (a quarter of the entire national territory, from the 39th parallel to the Strait of Magellan, more than 294,000 square miles) marked by barren uplands which from the Patagonian Andes - embroidered with lakes, glaciers and forests in which grow various species of orchid, araucarie and alerce, a coniferous tree that grows to a height of 200 feet and 10 in diameter - descend towards the monotonous north-eastern steppe, destined to break on the rough Atlantic coast.

The pampas is the realm of cattle; Patagonia, with its desolate and monotonous plains covered with low grass and dotted with the bluish berries of the thorny Calafate (the wild barberry, emblem of local flora) and beaten by wind and rain, is the world of Australian Merinos sheep and Corriedales brought by the first settlers in the mid-19th century. Most of Argentina's 40 million sheep live in this region.

A catalyst of adventures and legends, this land of endless solitude, encountered at the gates to *estancias* often more than 60 miles from their farmhouses, takes its name from the huge "Patagoni", the native inhabitants mentioned by Antonio Pigafetta, the writer who accompanied Magellan here in the winter of 1520. This tough and hostile world enchanted Bruce Chatwin (*In Patagonia, Return to Patagonia*) as it did Paul Theroux (*The Old Patagonian Express*), Sepúlveda (*The World at the End of the World*) and Herman Melville, who rounded Cape Horn in 1843. Nor did its unsettling fascination, made of strength and desolation, fail to touch explorers such as Giacomo Bove or the Salesian Alberto Maria De Agostini, from Biella, Italy, adventurers such as Pasqualino Rispoli, missionaries such as Giuseppe Fagnano (the first who tried to oppose the extermination of the Indians in 1886), scientists such as Charles Darwin and even technical experts such as Fitzroy who must be credited with having made the first systematic survey of these coasts, or the legendary Francisco Pascascio Moreno, who followed the line of the watershed to mark the boundary between Argentina and Chile. This region, inhabited by only

23 top Tourists at Mar del Plata, the town founded at the end of the last century on the Atlantic coast which quickly became the favorite holiday resort of the cream of Buenos Aires, 250 miles away. Called the "pearl of the Atlantic", when its casino opened in the Thirties, it was considered the largest in the world.

23 bottom A young cowboy and his lady riding in traditional dress during a gaucho fiesta in the province of Salta, in Northwest Argentina. Gaucho horsemanship has been well known since the times of Darwin who himself praised their riding skills, observed as they hunted ostrich with boleadoras and captured cattle with a lasso.

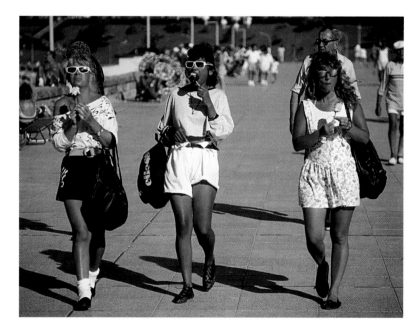

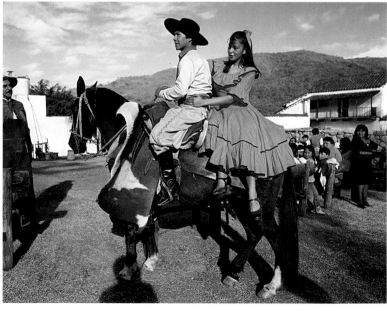

3.7 per cent of the entire Argentine population, has 40 nature reserves. One of the most important, the Nahuel Huapi national park, is the largest (3,021 square miles) and oldest of those in Argentina. This protected area was set up in 1922 around the vast lake of the same name, on the banks of which stands the resort of San Carlos de Bariloche and the Tronador peak (11,657 feet high) on land bequeathed to the state at the beginning of this century by the geographer Moreno (land given to him for his services to Argentina) because he wanted there to be "a public nature park to be enjoyed by generations present and future".

Commodoro Rivadavia grew following the discovery of petroleum fields in 1907 by Francesco Pietrobelli from Verona and is today one of the main centers helping to cover the country's energy needs; it is the most important town in Patagonia. West of Calafate, capital of the southern lake region, is the grand Los Glaciares national park, declared part of the "World's nature heritage" by UNESCO. This reserve of 1,482,000 acres rises to 11,070 feet at the splendid Fitzroy peak and freezes in the icebergs of Lake Argentino, the largest single body of water in the country, and in the Upsala, Spegazzini, Onelli and the majestic Moreno glaciers. The latter is 2.5 miles wide and almost 320 feet high, one of the few in the world still advancing thanks to moisture from the Pacific which, driven by steady winds, collides with the Andes and produces numerous snowfalls.

Beyond this is the extreme south. Between the Strait of Magellan and the Beagle Channel is the last frontier, "the uttermost part of the earth": Tierra del Fuego, in ancient times inhabited by the Alacaluf, Yahgan, Tehuelche and Ona natives, who built the bonfire sighted by the first explorers who gave a name to this strip of land. It consists of nearly 8,072 square miles of harsh mountains, dark and desolate bays: a dismal windy and cold environment. Tierra del Fuego presents an inhospitable and freezing nature but one rich in minerals and timber that long resisted the penetration of humans drawn by this wealth.

Ushuaia, the southernmost city of the entire planet, born in 1884 from a military prison, is now the home of industries linked to oil and natural gas drilling and an important scientific center. Where man has driven his heart and spirit, Tierra del Fuego, like Patagonia has silenced its wild hostility. It is thanks to this space yet to be conquered that Argentina has not stopped, contented but like its children is still seeking itself with courage and passion. Today the south is the ultimate Argentine bastion, the scene of the last effort, the land of the ultimate mystery and the emblem of the untamed spirit of a people and a nation. Here you can still believe in the future and confidently speak the word *tomorrow.* The challenge is still on.

24-25 Two placid sea-lions on a beach on the Península Valdés, a refuge for many marine animals such as seals, penguins and whales, who come here every year to mate and reproduce. Because of its great length, Argentina presents a great variety of climates and landscapes.

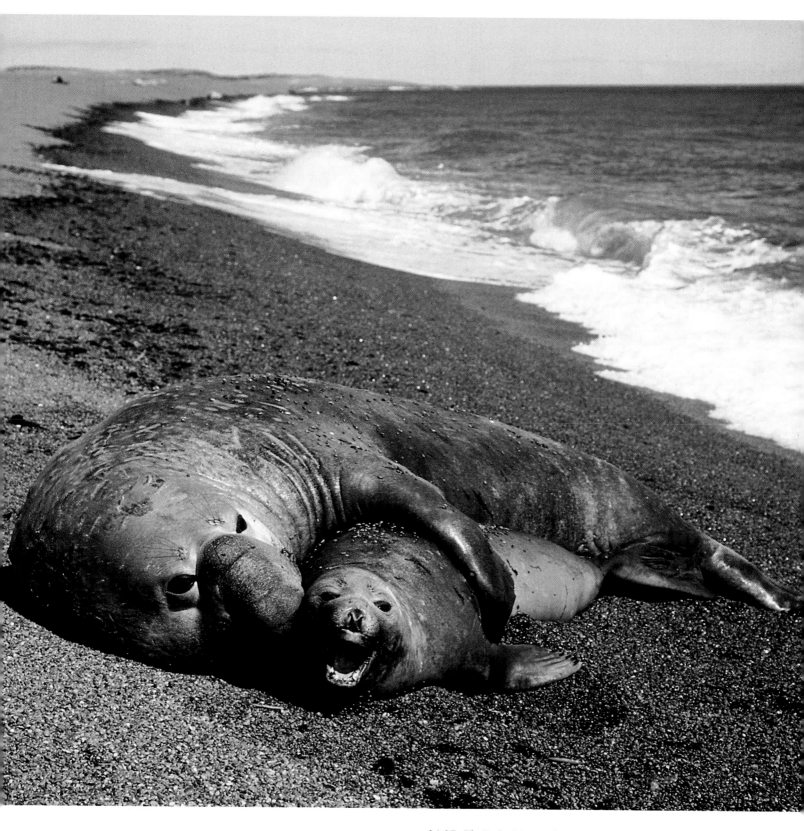

26-27 *The Perito Moreno glacier, visible on Lake Argentino after what is called the "curve of sighs", looks like a large expanse of ice columns and pinnacles which periodically plunge into the water. The myth of Patagonia as a metaphor for the utter limit has fascinated many writers, from Bruce Chatwin to Paul Theroux and Francisco Coloane.*

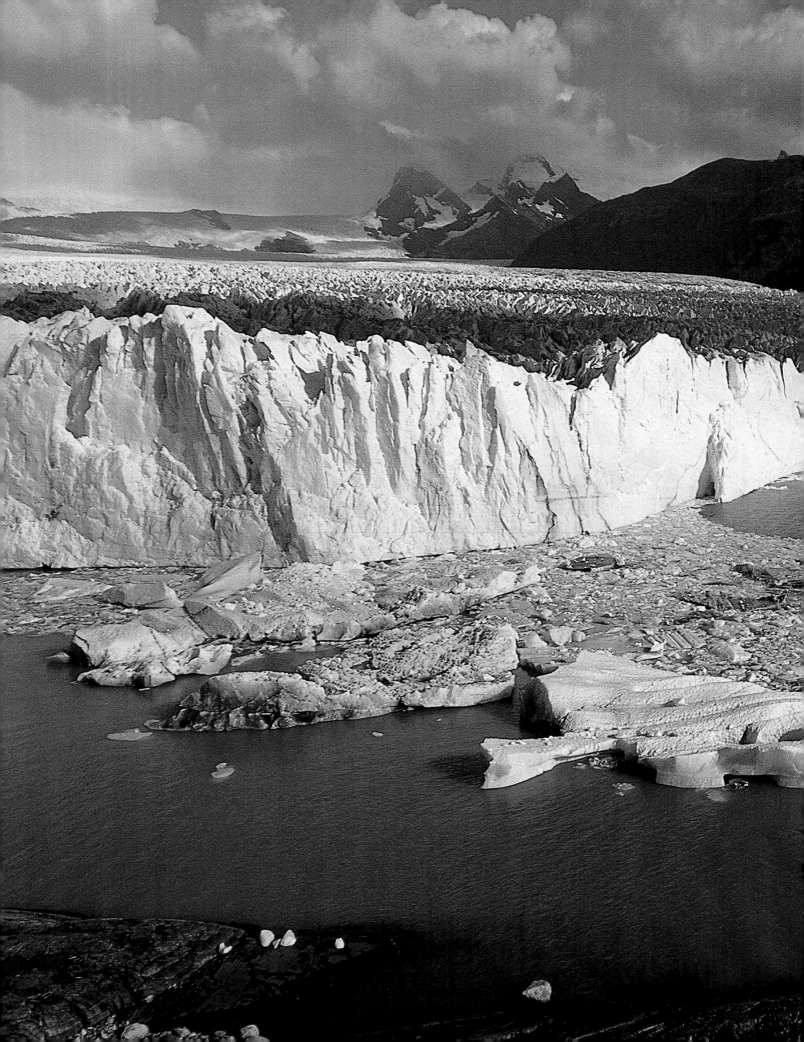

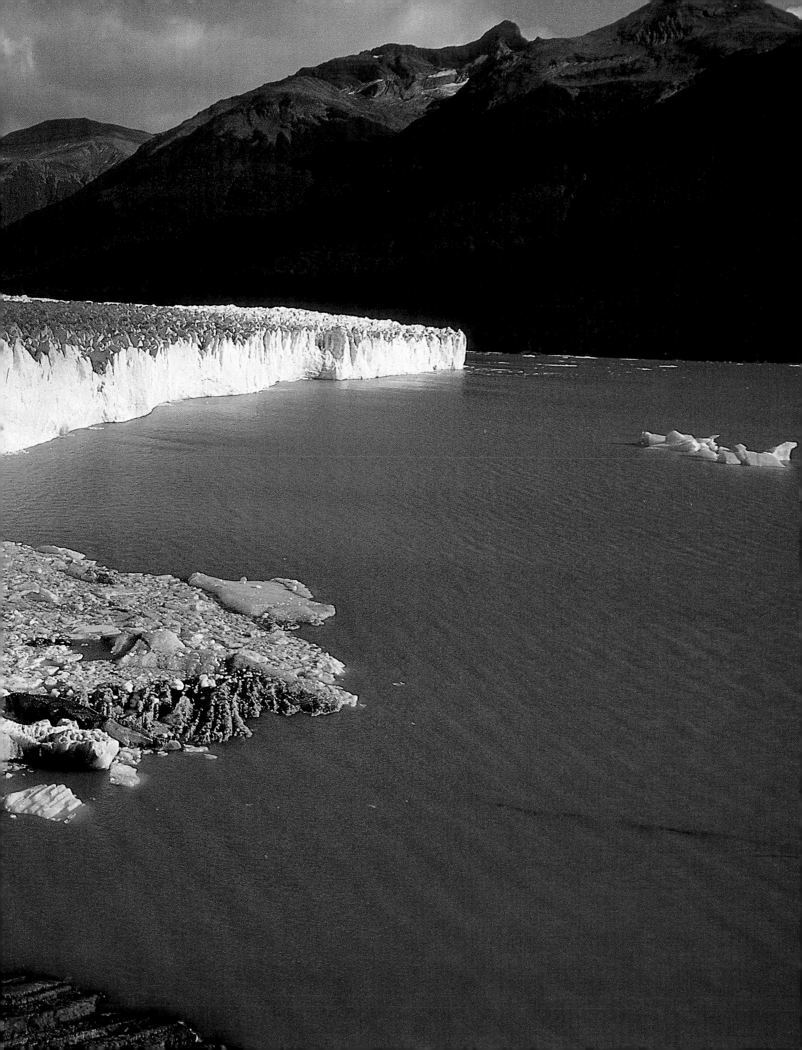

From forests to glaciers

28 top *Horses on the El Calafate plain, in the province of Santa Cruz. Argentina, which breeds the best polo horses, is also the home of the unusual Falabella, a special dwarf breed selected by a local breeder. The Falabella, whose illustrious admirers have included the Kennedys and King Carlos of Spain, are still raised on the El Peludo estancia, 40 miles from Buenos Aires.*

28 bottom *A small cemetery lies on a slope in the Calchaquí valley. This locality - not far from the town of Amaicha - "where the sun shines 360 days a year" is blessed with a favorable climate: indeed prior to Spanish penetration the Calchaquí valley was, along with Santa María, one of the most densely inhabited parts of Argentina.*

29 *The rocky Quebrada de Cafayate, in the south of Salta province. The action of wind and water have eroded the rocks in this canyon, considered one of the most important valleys in Calchaquí.*

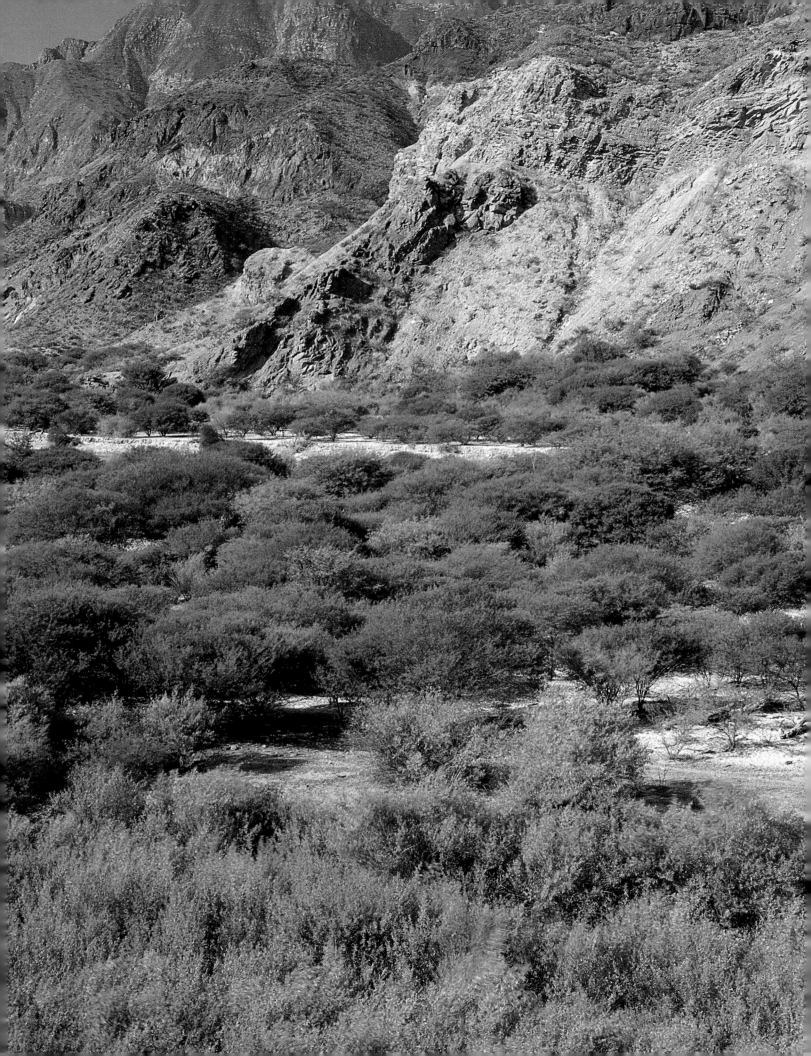

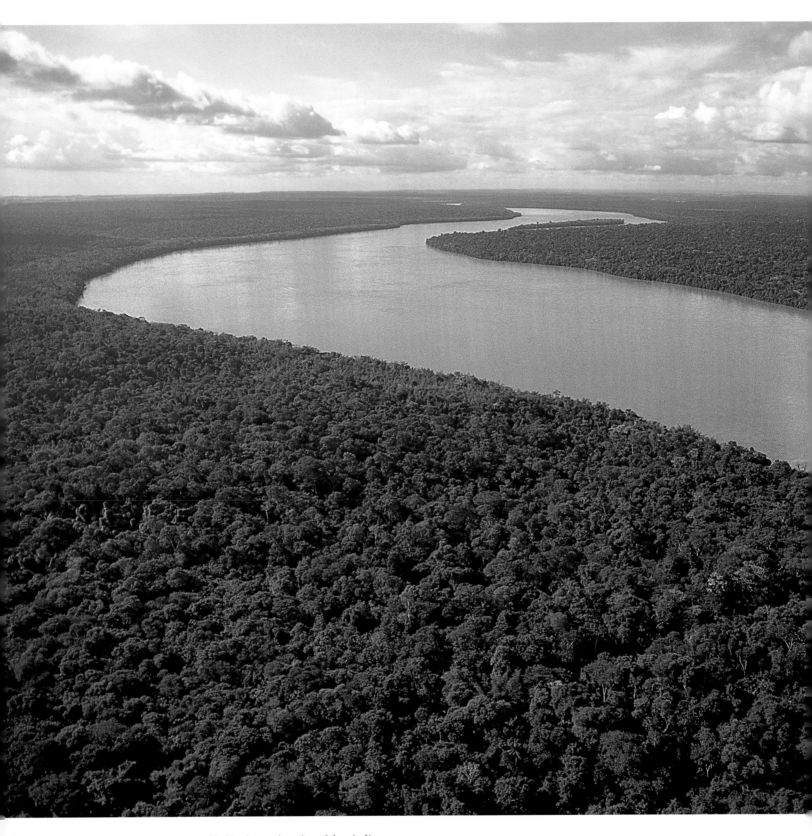

30-31 *A sweeping view of the winding Río Paranà which, together with the Uruguay and Paraguay rivers, is one of the main tributaries of the Río de la Plata. The Uruguay and Paranà are the limits of east Argentina, known as Mesopotamia, and help to make this a marshy land full of pools.*

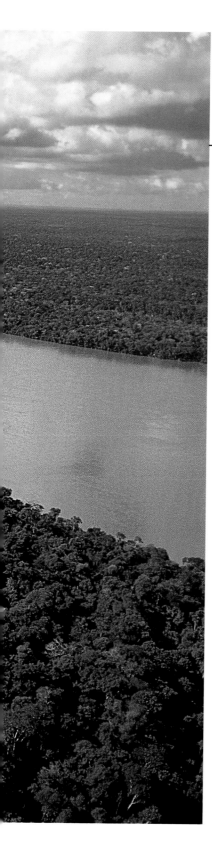

The jungles and the rivers of the north

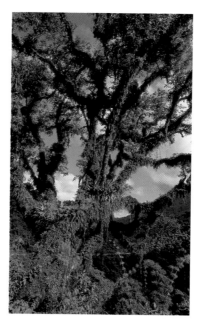

31 top and center *The luxuriant forest of the Río de Los Sosas valley, along the road to Tafí del Valle. The subtropical climate, featuring heavy rainfall and high temperatures with mean temperatures of 30°C in summer and 13°C in winter, produces lush vegetation.*

31 bottom *The Iguazú falls, in the north-east region of Mesopotamia, take their name from the river, known in Guaraní as Y-Guazú, which means "great water". Considered one of the most complex waterfall systems in the world, with falls arranged in a semi-circle 2 miles long, the spectacle offered is truly unique.*

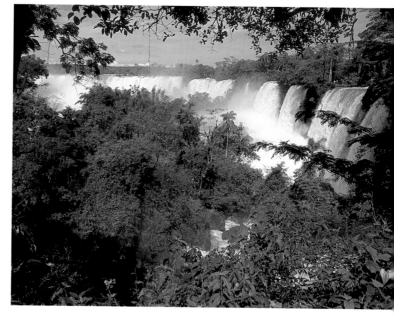

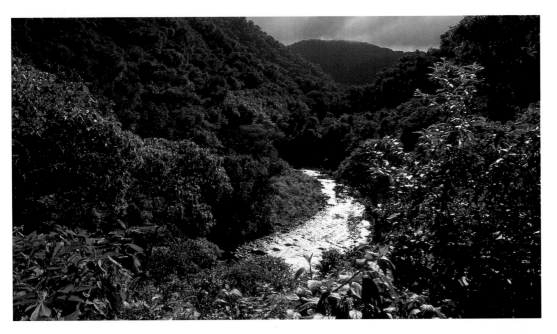

32 top *The thick forest that lines the Río de Los Sosas is an example of what the nature of the Northwest has to offer: in just a few miles you pass from desert to high mountains and gorges such as this where the humidity favors the growth of lush vegetation.*

32 center and left *The 135,000 acres of the National Park surrounding the Iguazú Falls are home among others to the shy coatimundi (Nasua nasua). The reserve, which is one of the best examples of subtropical jungle in Argentina, is situated approximately 25 miles from the center of Puerto Iguazú, a town of 15,000 inhabitants on the banks of the Río Paranà. The natural waterfall area has been declared a world heritage site.*

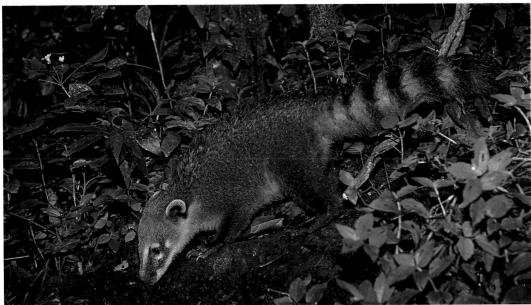

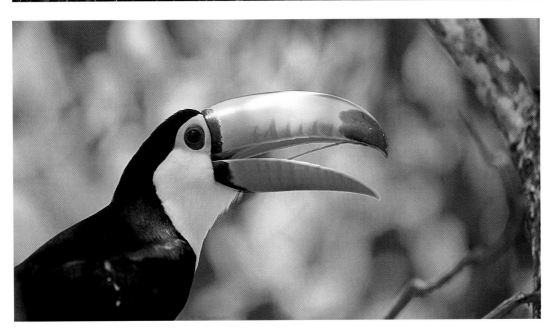

32 center right and 33 *The Río de Los Sosas valley is on a popular tour that visits the towns of Salta, Tucumán and San Salvador de Jujuy. The attractions are the natural beauties (the paths of the Los Sosas gorge are regularly trod by bird-watchers) and the pre-Hispanic settlements, symbolized by this monument to the Indians.*

32 bottom *The toucan is one of the most common birds in the south American jungle. With a large distinctive orange beak and shrill cry it is present in various species, the most important and common being the so-called Toco. Many of these birds are found in the Iguazú National Park, which also houses nearly 2,000 species of butterfly.*

Pre-Hispanic nostalgia

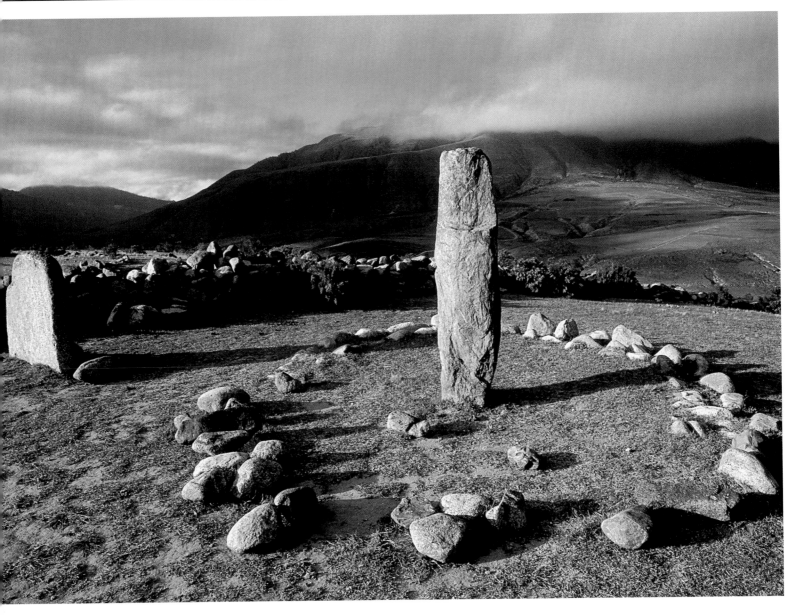

34 *The Parque de los Menhires,
situated at El Mollar, near the village
of Tafí del Valle. The park lies at a
height of 6,560 feet at the entrance to
the valley sacred to the Diaguita, an
ancient Indian civilisation which
flourished here between the 4th and 9th
centuries; the ruins of some dwellings
and a number of stones set in a circle
remain. Inserted vertically into the soil,
these monoliths rise up to 6 feet.*

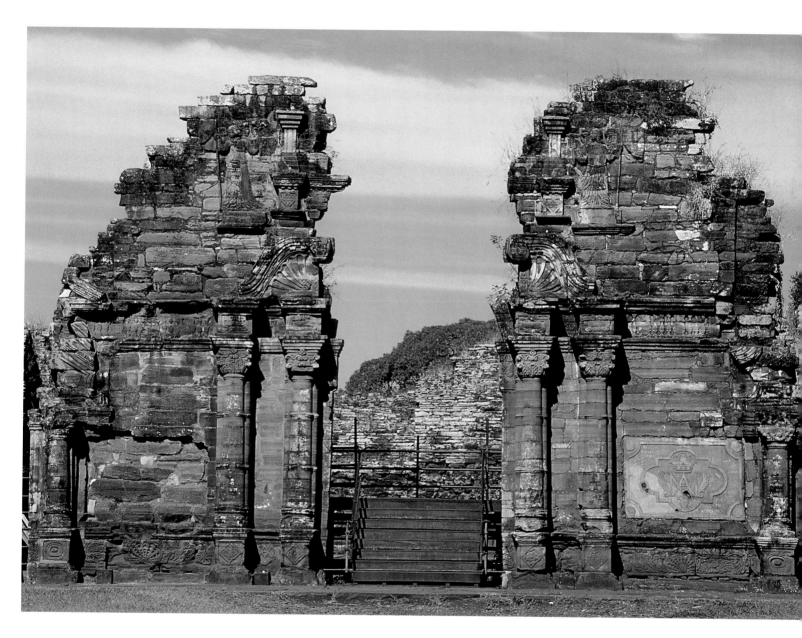

35 The ruins of San Ignacio Miní,
near Posadas, considered the most
important of the twelve missions
founded by the Jesuits in the first half of
the 17th century in the province of
Misiones. Inhabited by more than 4,000
people the complex consisted of the
church of 1724 - the photograph shows a
detail of its façade - stores, workshops
and dwellings. The Jesuit Order
conducted a major work of conversion
and defence of the Indians against the
slave merchants but was expelled in
1767.

Northwest, a magical land of contrasts

36 *The countryside of El Carmen, in the province of Salta. The Argentine Northwest regions feature sedimentary terrain, covered with a fertile humus which has favored the development of a vegetation that consists in undergrowth alternated with vast savannahs of Gramineae. The plateaux, influenced by the nearby Andes, have a high altitude tropical climate.*

36-37 *Some vine-yards in the Calchaquí valley. Since the 19th century, Argentina has boasted a good wine production which, with an average of 21 million hectolitres per year, makes it the fifth largest wine producer.*

37 top *Sugar-cane plantations around Tucumán, capital of the province of the same name and known for the large agricultural production of its plains, favored by plentiful rainfall.*

37 bottom *The characteristic rock formations of Quebrada de la Flecha, in the province of Salta, consist in a number of sandstone pinnacles and columns in the most bizarre forms, sculpted by wind and water.*

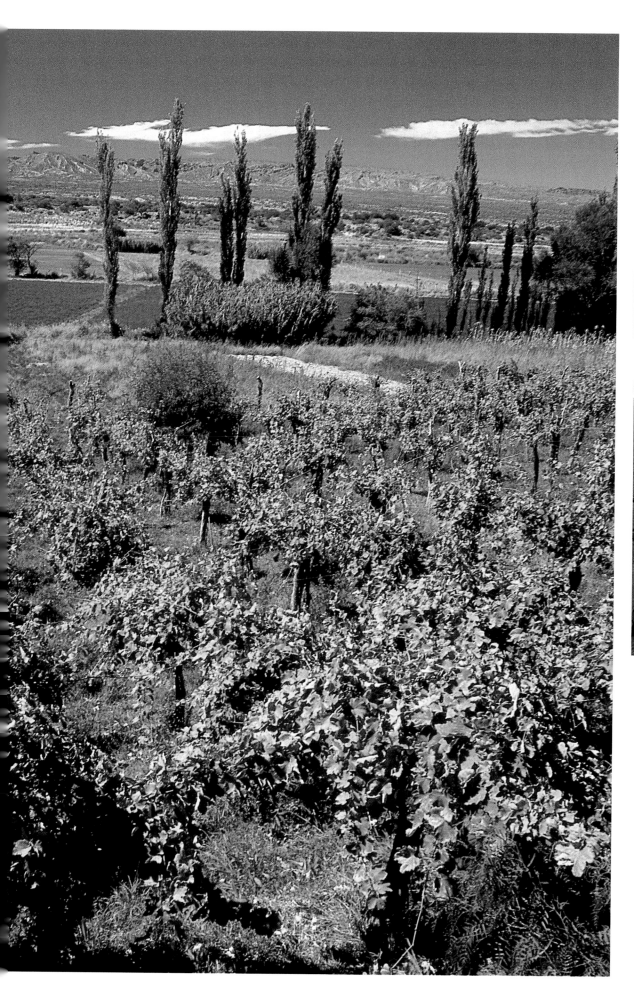

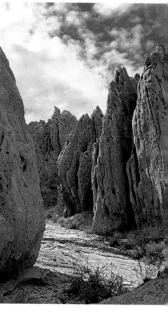

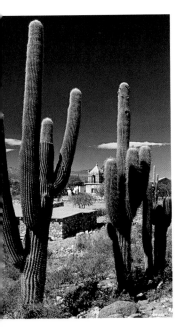

38 top and 38-39 *A striking presence in the Calchaquí valley, crossed by the river of the same name considered one of the longest in Argentina, is the unmistakable majestic* Cardón pasacana; *the stem of this large candelabra cactus grows up to 40 feet in height and the Los Cardones National Park was recently created here to protect it. This is mountain territory, barren plateaux that lie at up to 13,000 feet, stretching between Cafayate and Salta. Before the arrival of the Spanish, the Santa Maria and Calchaquí valleys were some of the most densely-inhabited regions in the country.*

38 bottom *The ruins of Quilmes stand 6,560 feet above sea level. An ancient pre-Hispanic stronghold, it conserves the remains of stone houses inhabited in ancient times by members of the*

Quilmes tribe, not subjugated until 1665, after a 35-year war. Their disappearance is linked to the decision of the then governor of Tucumán, Don Alonso de Mercado y Villacorta, to send them to the mouth of the Río de la Plata, more than 620 miles away, where they died of hunger and exhaustion.

40-41 *The mountains around the Calchaquí valley, which takes its name from a legendary Indian chief. Along the road crossing it are many small villages featuring buildings that date from the Spanish period. Churches, convents and mansions are reminders, in a minor tone compared with those of the motherland, of the splendor of Spanish Baroque style.*

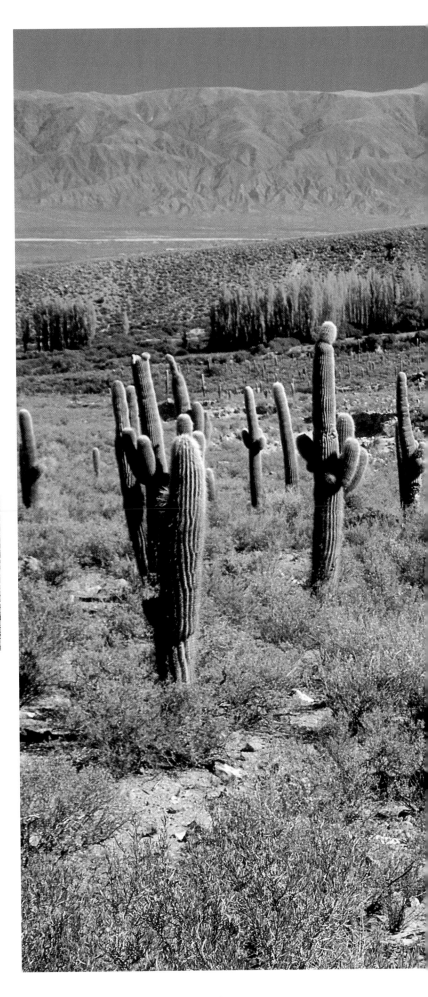

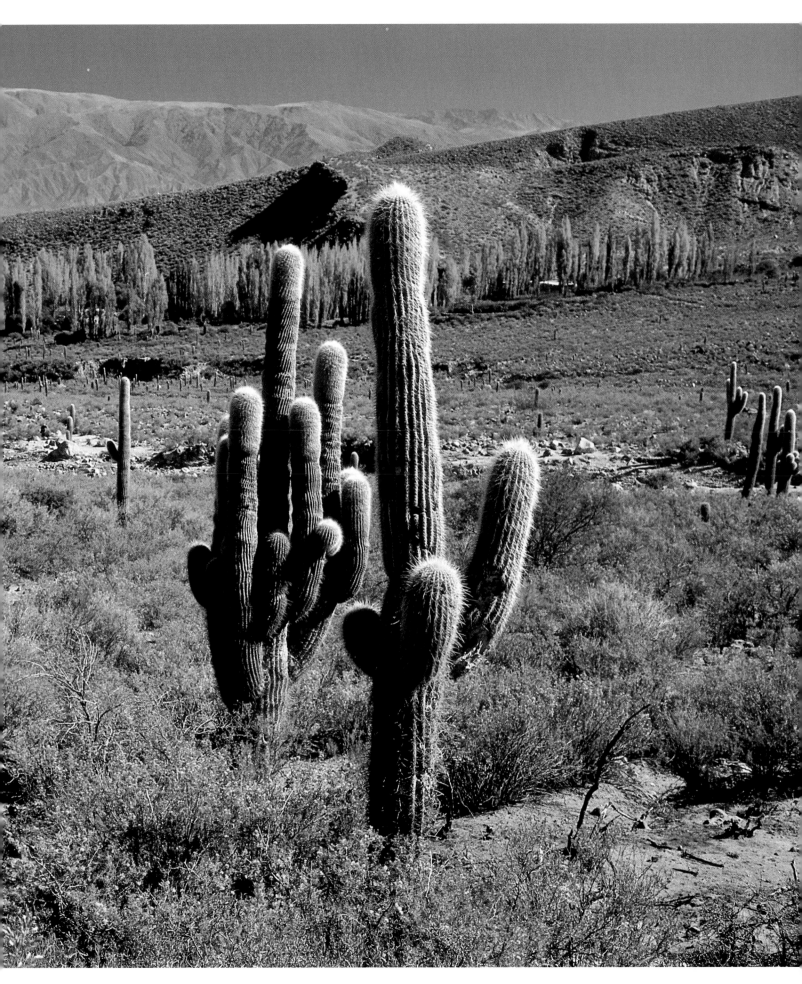

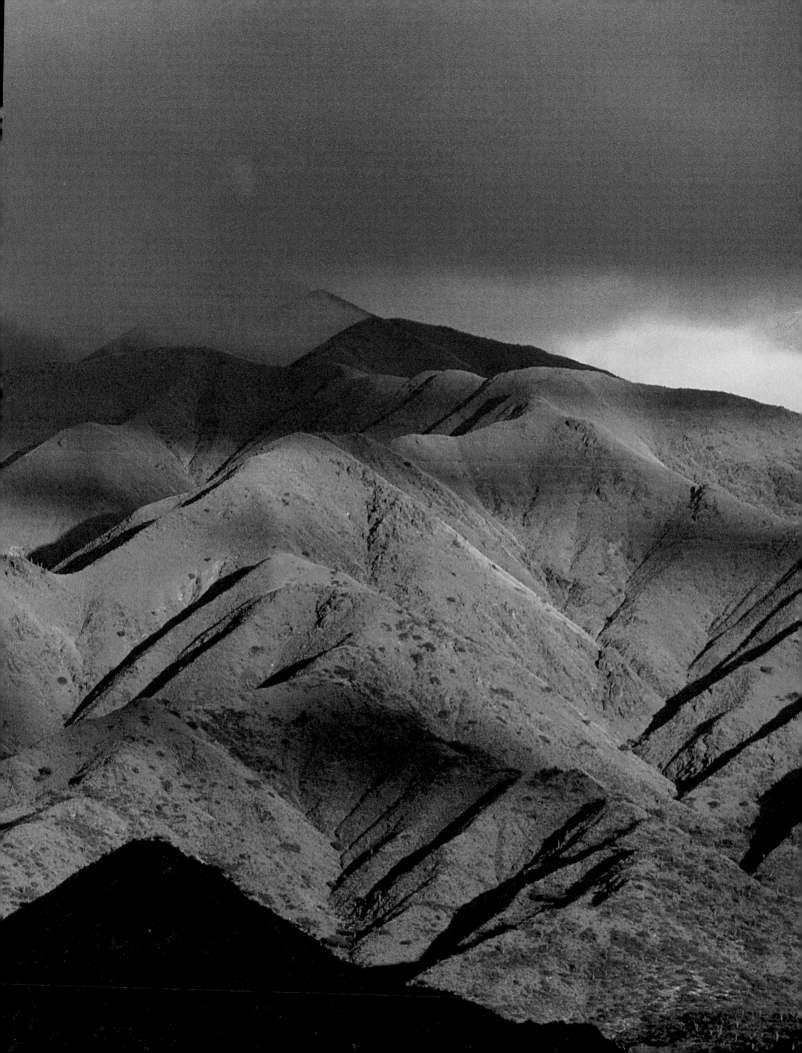

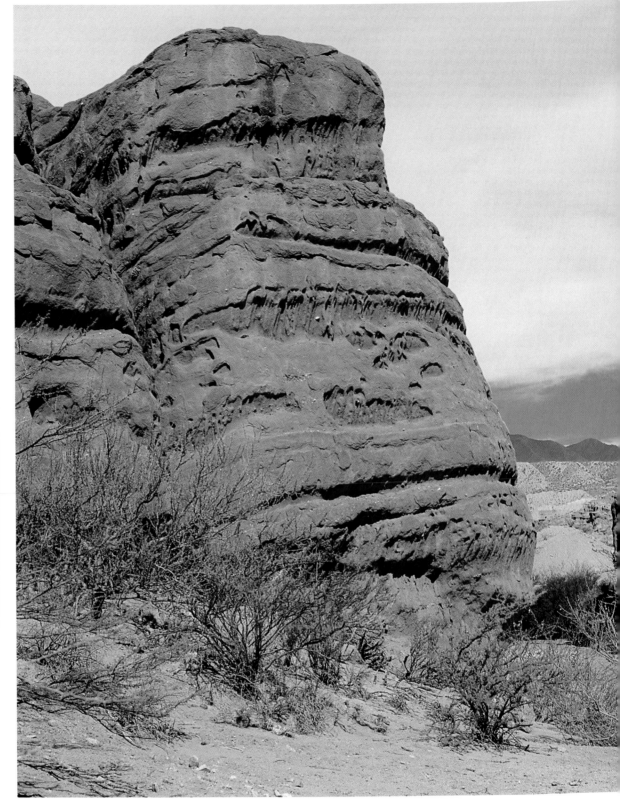

42 and 42-43 bottom *The impressive Talampaya canyon in the Argentine Northwest, along the road between Patquía and Villa Union, is a deep gorge with reddish rock faces rising to 475 feet. Inhabited in ancient times by pre-Hispanic peoples, it conserves numerous paintings and drawings, which make it one of the most interesting petroglyph sites on the whole American continent. Anthropomorphic figures, impressions including a drawing depicting a foot with six toes, spirals, pictures of pumas, llamas and guanaca cover the steep walls of the canyon which, because of the heavy rain, is not open to visitors from January to March.*

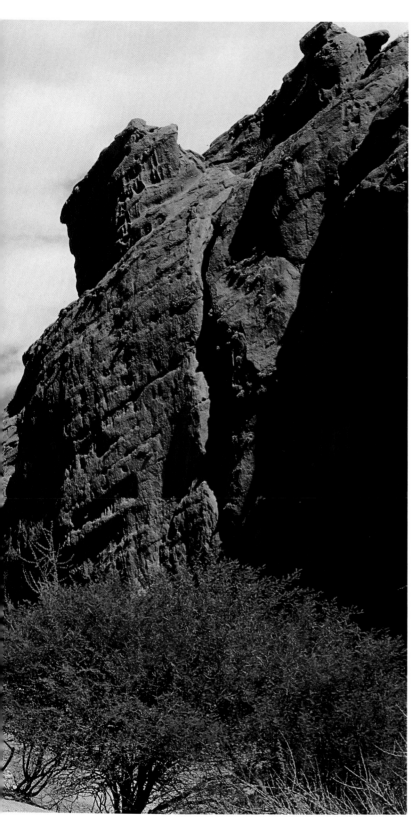

43 top *La Quebrada (which in local tongue indicates a deep enclosed valley) de Cafayate. Also known as Valle de Guachipas, is the most important of the Calchaquíes valleys. Situated nearly 160 miles from San Miguel de Tucumán, in Northwest Argentina, it features unusual rock sculptures in red sandstone, created over the millennia by the erosive action of water and wind.*

43 bottom *The Valle de la Luna, on the border between the provinces of La Rioja and San Juan. The erosive action of wind and water have fashioned the sandstone of this large depression in the Andean Precordillera, 4,100 feet above sea level, giving rise to strange rock formations, including a number of spheres formed by masses of mineral salts. Many fossils have also been found in this barren expanse 7.4 miles by 25.*

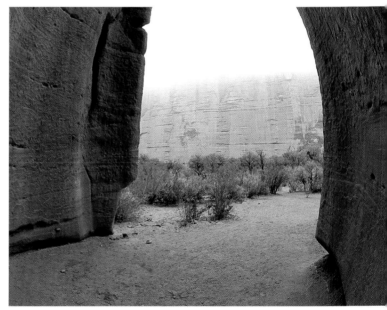

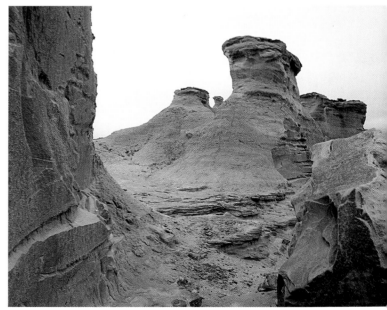

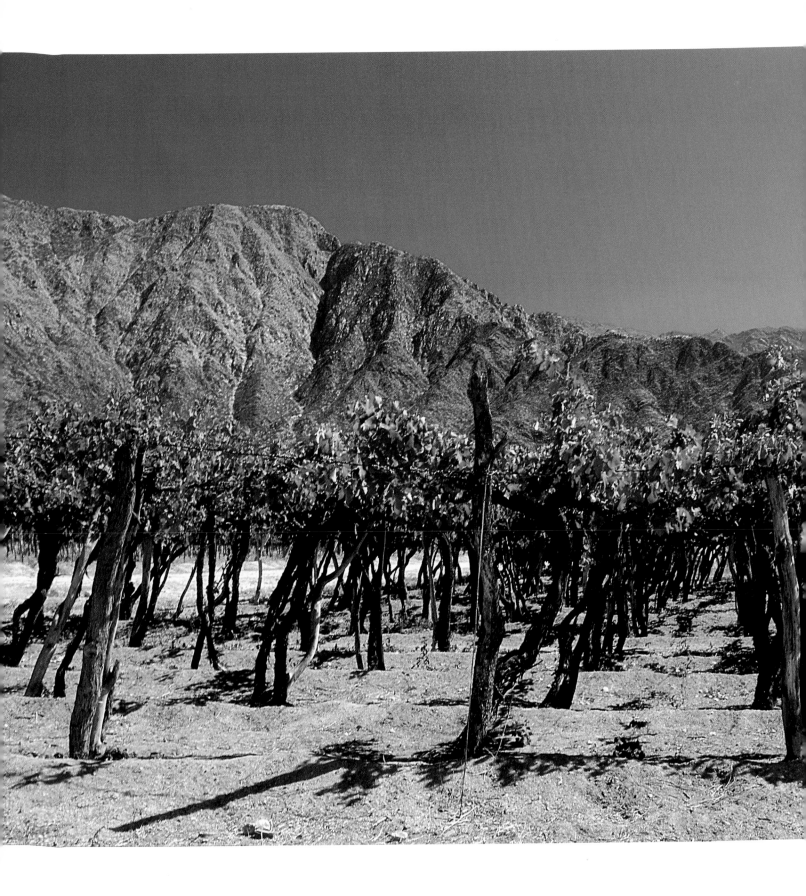

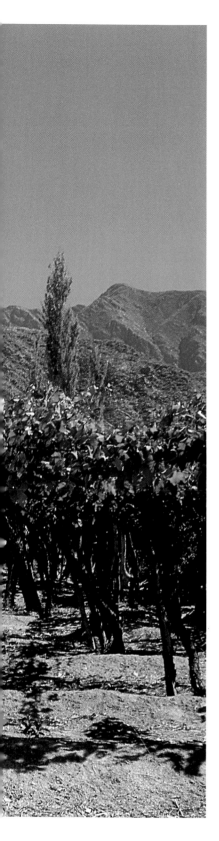

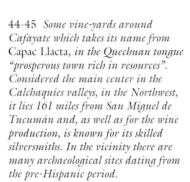

44-45 *Some vine-yards around Cafayate which takes its name from Capac Llacta, in the Quechuan tongue "prosperous town rich in resources". Considered the main center in the Calchaquíes valleys, in the Northwest, it lies 161 miles from San Miguel de Tucumán and, as well as for the wine production, is known for its skilled silversmiths. In the vicinity there are many archaeological sites dating from the pre-Hispanic period.*

45 top and bottom *Two views of some grape and wine farms in Cafayate, including that of Michel Torino who mainly produces white wines from Torrontes grapes. Although Argentina has some importance on the world wine-producing scene, only 7% of the produce of more than 2,000 national cavas is high quality. Regional and table wines are predominant with small quantities of sherry, port and vermouth. The local vines generally descend from European stock, some brought by the Spanish but most by Italian and French settlers.*

45 center *A small country church built just outside Cafayate. Standing at 5,248 feet, this town has a cathedral with an unusual five-aisle plan and a remarkable museum dedicated to the colonial period.*

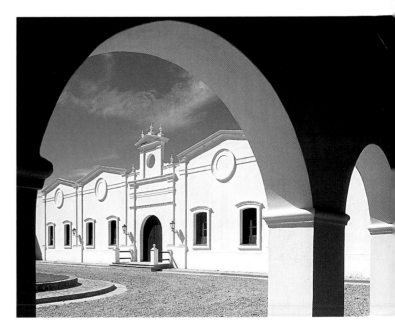

The Sierras, pampas and highlands

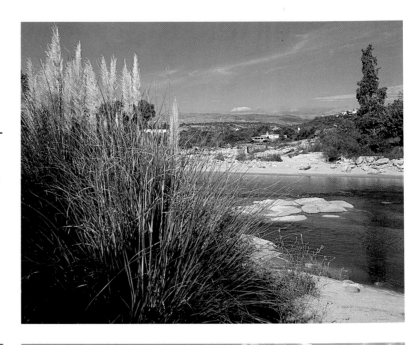

46 top left *One of the many craft shops in the central Sierras, halfway between the Andes, Buenos Aires and the Atlantic coast. As well as pottery and terracotta decorated with motifs based on those of the ancient pre-Hispanic and Andean cultures, Argentina's typical products include alpaca and* vicuña *jumpers and shawls, leather goods, brightly colored* ponchos *and fabrics.*

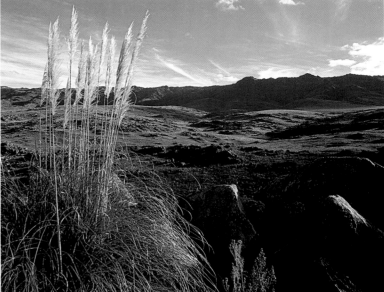

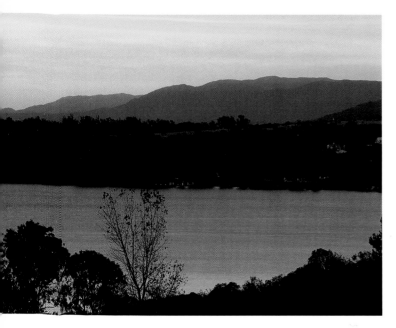

46 bottom left *Lake San Roque, in the province of Córdoba, lies along the so-called Camin de la Punilla, the road which leaves the capital and crosses a valley to head north, towards Cruz del Eje. On the banks of the lake stands the town of Villa Carlos Paz, known for its nightlife and the many sports that are practiced on this sheet of water.*

46 right *On the boundary between the vast flat pampas and the undulating sierras, the province of Córdoba has vegetation made of ferns, moss and plants particularly adaptable to stony terrain such as the* Plantago bismarkii. *Mount Champaquí is the highest peak in the province, rising to 9,500 feet. Surrounded to the north and east by a range of hills, the so-called Sierras Chicas, not as extensive nor as high as the chains to the east of the Andes, the countryside offers beautiful views.*

47 *A watercourse in the Sierras, near Córdoba. Here is the so-called Pampa de Achala, a refuge for many animal species, including the condor, still present in fair numbers in this country. Also living here are the guanaco, the* vicuña, *the shy and fast* nandú, *the ostrich, the deer and European boar.*

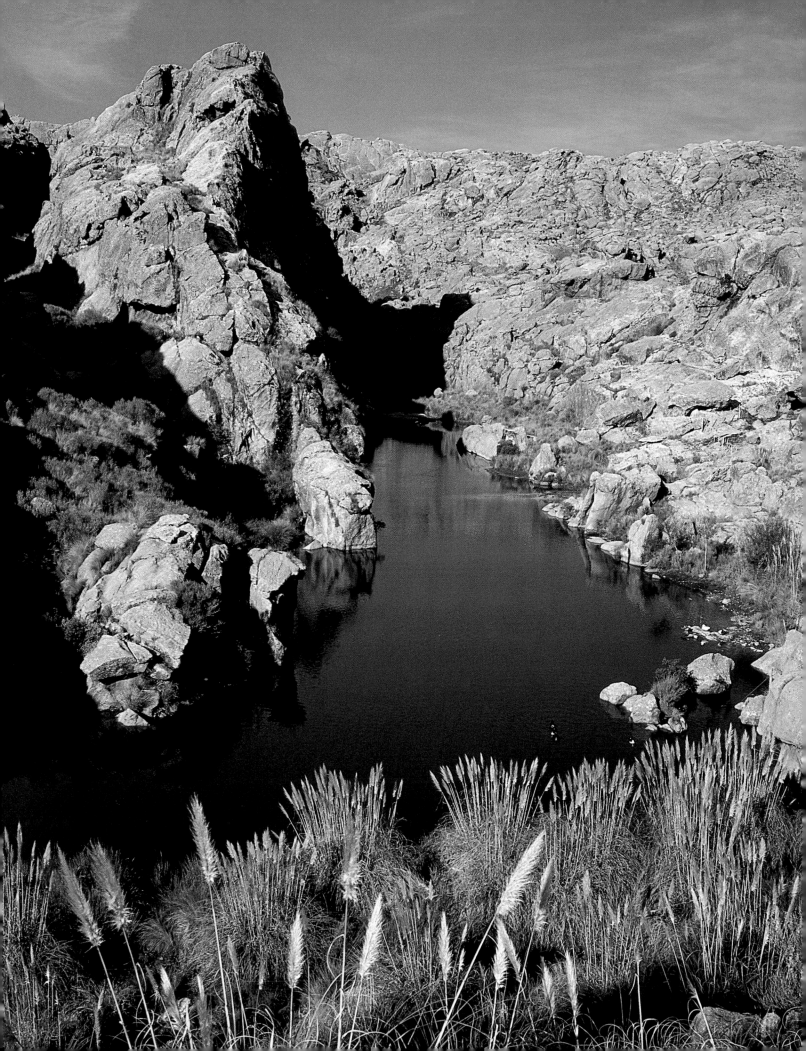

Patagonia, nature's last frontier

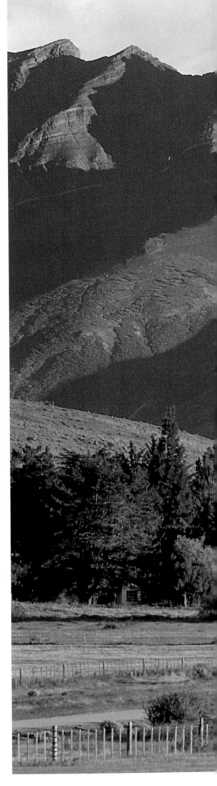

48 top *The south of the region of Patagonia, between the cities of Río Gallegos and El Calafate. Vast estancias developed in this area at the end of the 19th century and made Argentina one of the world's leading wool producers. In 1934 there were 93 farms here, between 5,000 and 50,000 acres in surface area, and they employed 800 people. Today Argentina boasts a national heritage of 40 million head of livestock.*

48 center *Baia Redonda, near the town of El Calafate, on Lake Argentino. Near this center, visited in summer by mountaineers and trekking enthusiasts, is Cueva del Gualicho, a cave with drawings dating from pre-Hispanic cultures, and the lovely Laguna de los Cisnes (lagoon of swans), frequented by several species of birds including flamingos, ducks and swans.*

48 bottom *A view of the famous Lake Argentino, 673 square miles in size and nearly 3,280 feet deep. Boats sail every day from Punta Bandera, 12 miles from El Calafate; the Río Santa Cruz flows out of this lake across Patagonia and into the Atlantic Ocean near the town of Santa Cruz.*

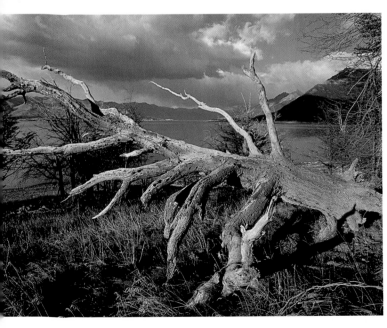

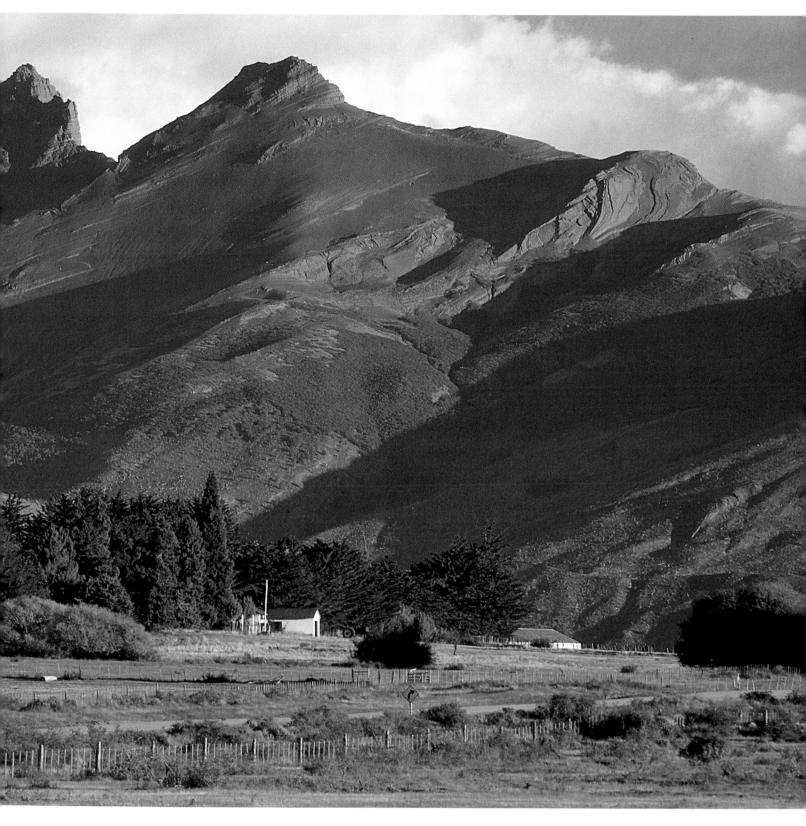

48-49 *Like most of Patagonia, the territory surrounding El Calafate, the main city in the southern lake region, sees the presence of the wild barberry* (Berberix buxifolia), *a thorny shrub with yellow flowers and fleshy blue berries, the symbol of the region's flora. According to the locals, those who eat its berries will be bewitched by the spirit of Patagonia and will never be able to forget it.*

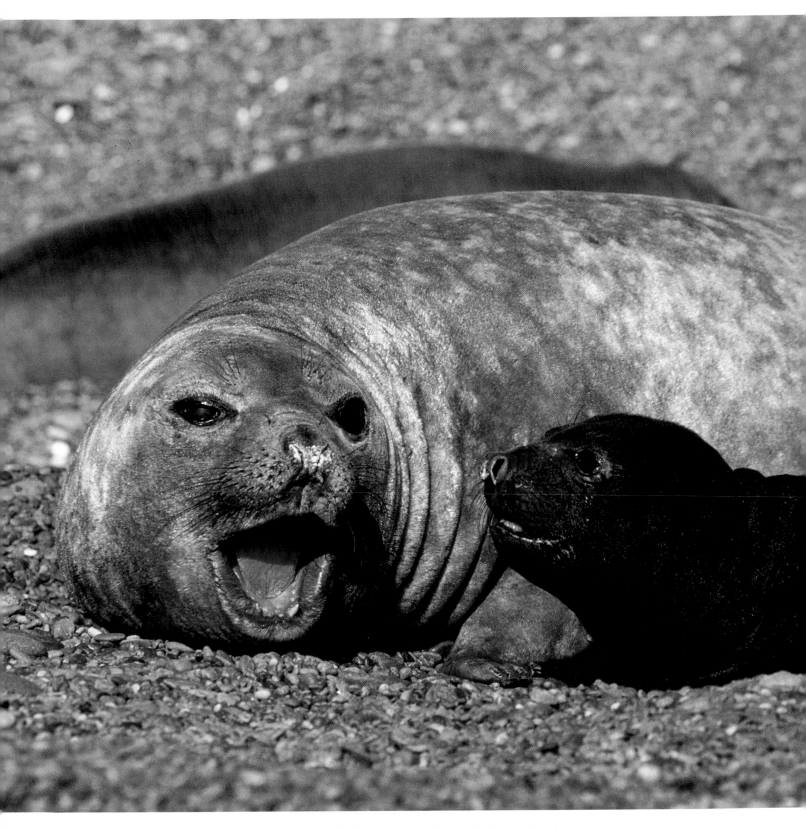

50-51 *Extending into the Atlantic Ocean, Península Valdés, a piece of land connected to the northern coast of Patagonia by a slender 22-mile isthmus, is one of the most important fauna sanctuaries in the world. Lying 131 feet beneath sea level it is considered the deepest hollow in South America; the peninsula is home to typical Antarctic animals such as elephant seals (the photograph shows a mother with her pup).*

51 left *The Patagonian animal-life, subjected to a cold desert climate with little rainfall, severe winters and strong westerly winds, comprises numerous species. Colonies of sea mammals such as sea-lions (Otaria flavescens), seals (Arctocephalus australis) and, in the photograph, elephant seals (Mirorunga leonina) live on Península Valdés as do numerous penguins.*

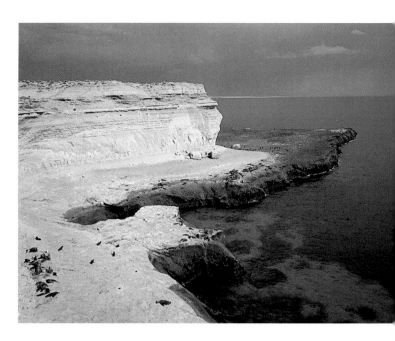

51 top right *Between January and March the southern seals gather at Puerto Pirámides (in the photograph) and Punta Norte, both on Península Valdés, to find new companions and mate. The adult bulls, which can weigh a few hundred kilos, confront each other in ferocious battle to defend their females, heedless of the pups, which are sometimes crushed.*

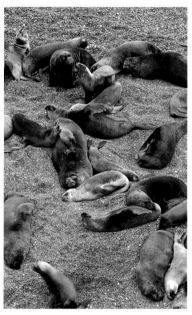

51 bottom right *The curious proboscis of the elephant seal bull.*
These creatures can grow to 20 feet in length and a weight of four tons; they meet on Península Valdés between August and October. Every bull tries to draw as many females as possible onto its territory and, to avoid possible intruders, never leaves them alone, not eating for up to two months.

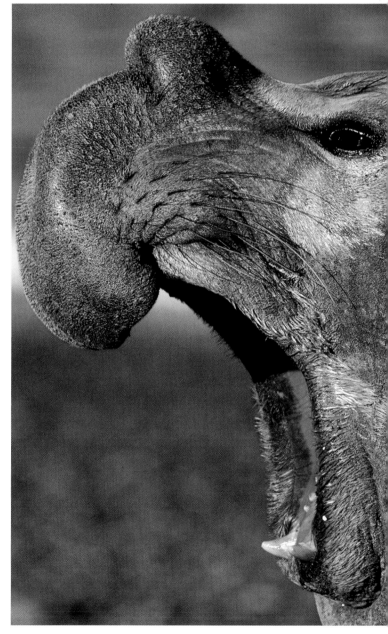

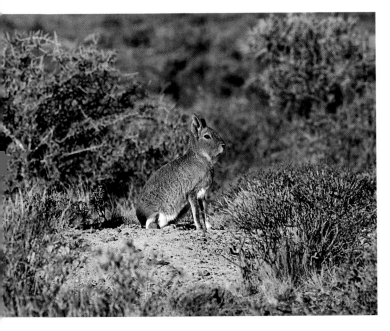

52 top right *A Dolichotis patagicum, the Patagonian hare or mara, which lives on the southern Argentine steppe together with the guanaco, Darwin's nandú, and the armadillo. The wild rabbit was introduced to Tierra del Fuego in the Fifties and has reproduced on an abnormal scale, causing the loss of vast areas of undergrowth.*

52 center left and bottom *The great ant-eater* (Myrmecophaga tridactyla) *and hairy armadillo, relative of the smaller Pichi Patagonian armadillo, are among the most curious members of Argentine fauna. Thanks to its humid subtropical climate, the province of Misiones is one of the Argentine regions with the richest flora and fauna, its forests fuelling a flourishing timber industry.*

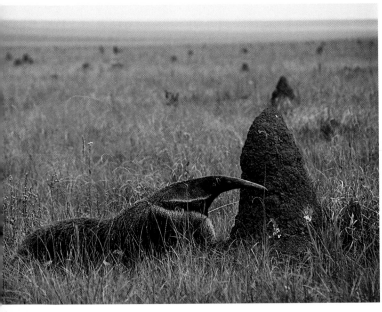

52 right and 52-53 *The vast Patagonian plains are the favorite habitat of the agile and graceful guanaco* (Lama guanicoae); *the photograph shows one of the two wild South American* Camelidae *with the Vicuña. Not many species can withstand the difficult climate of southern Argentina. Animals not original to Patagonia introduced by the Europeans and which, in the absence of predators, have multiplied disproportionately include the American beaver, brought in the Forties-Fifties and responsible for the destruction of large areas of woodland.*

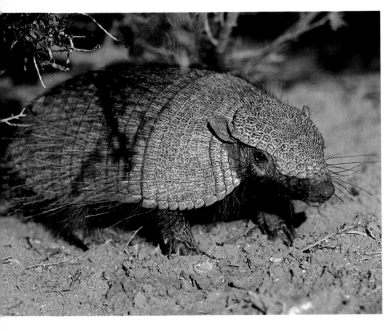

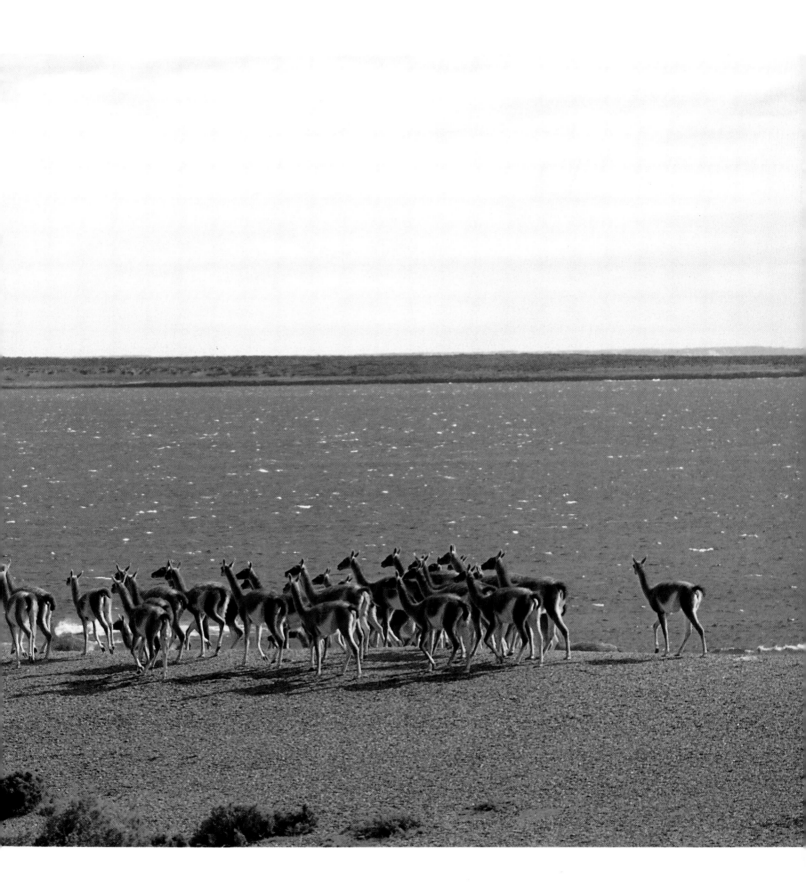

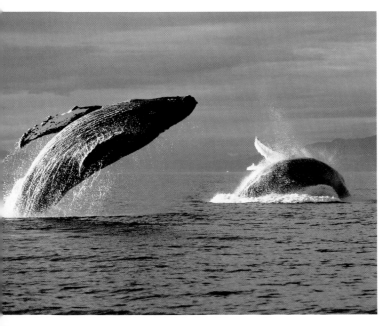

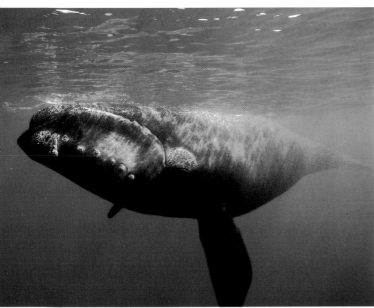

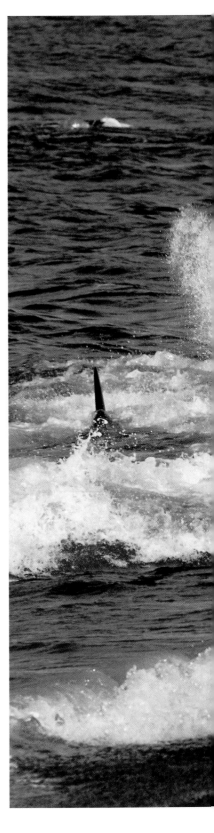

54 top left and center *Puerto Pirámides is a favorite haunt of whales, especially of the southern whale, the Eubalaena australis. This is a protected species with only 7000 surviving specimens, 2500 of which are in the Valdéz Peninsula. In June the females, which can grow to lengths of 40 feet, give birth to baby whales; at the moment of birth these weigh a ton and a half and are 13 feet long. Thanks to the nourishing milk they suck from their mothers at an average rate of 150 litres per day, the young grow by approximately 220 pounds a day or 11 pounds an hour. They will then abandon these waters in December, heading south in search of food.*

54 bottom left *Another visitor to Patagonia, found in two species: the Emperor penguin and the Magellanic penguin* (Spheniscus magellanicus). *Nearly three thousand pairs of penguins come in September to nest in the Punta Tombo Nature Reserve, along the Chabut coast, and remain until March. The first to spot what he called "strange ducks" was Antonio Pigafetta, Magellan's diarist, who arrived here in 1520.*

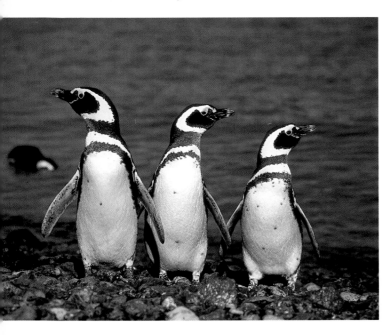

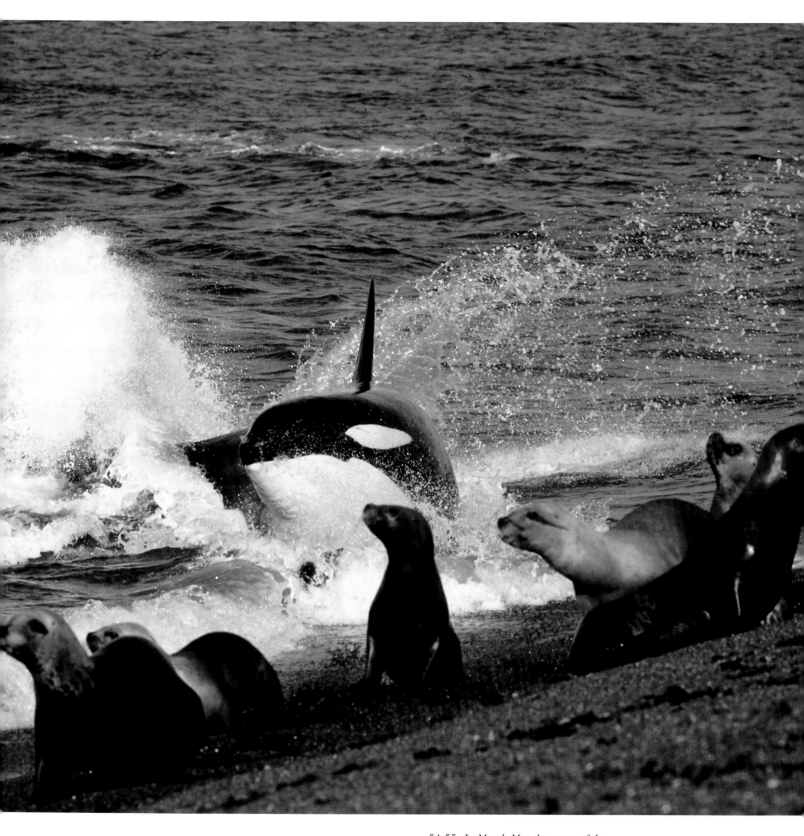

54-55 *In March-May the waters of the Punta Norte and Pirámides Nature Reserves, on Península Valdés, are scoured by a fearful and voracious predator, the killer whale (Orcinus orca) which ventures almost up to the beach hunting penguins and young sea-lions. If the opportunity arises, however, he will not scorn an adult sea-lion or elephant seal.*

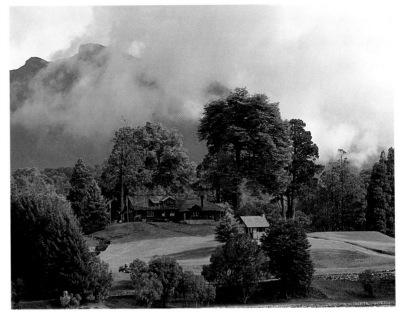

56 left *Two views of Lake Nahuel Huapi which, with the nature reserve of the same name, is one of the most visited places in the country. Situated on approximately 18,500 acres of land bequeathed to Argentina by Francisco Moreno to become the first Argentine Nature Park - an area later extended to the present 2,000,000 of Andean-Patagonian land - the lake offers many opportunities to practice nautical sports such as rafting, canoeing, water-skiing and windsurfing.*

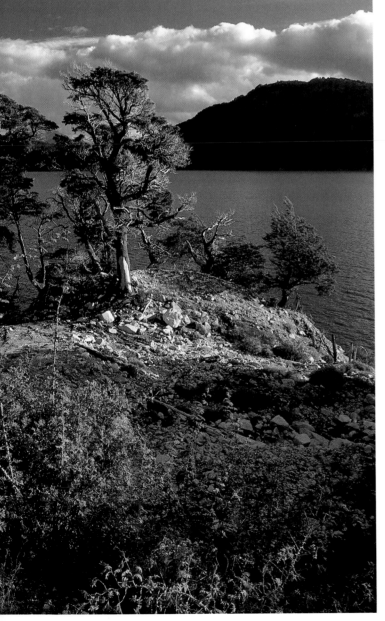

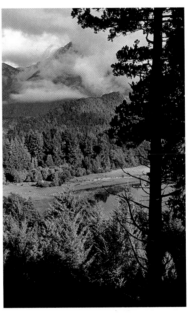

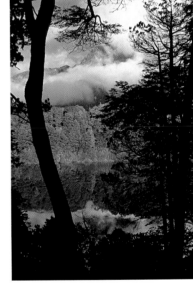

56 right and 57 *The city of San Carlos de Bariloche is a good base for a number of excursions into the Nahuel Huapi National Park. As well as the lake it is named after, seen in the photograph, this also comprises the Traful and Mascardi lakes. Many of these itineraries are on the so-called Grand Circuit, an imaginary ring more than 160 miles long which crosses the north of the reserve. The animal species living in the park, most native, are the javadlí,* the South American boar, the red fox, the puma, the huemul red deer, the Axis-Axis, a deer which originates from India, and the chinchilla; closer to Bariloche lives an animal at risk of extinction, the pudú, which at just 5 feet tall is the smallest American deer. Local birdlife is particularly rich and, depending on the particular system and ecoclimate present in the park, includes the hummingbird, common heron, condor and cormorant.*

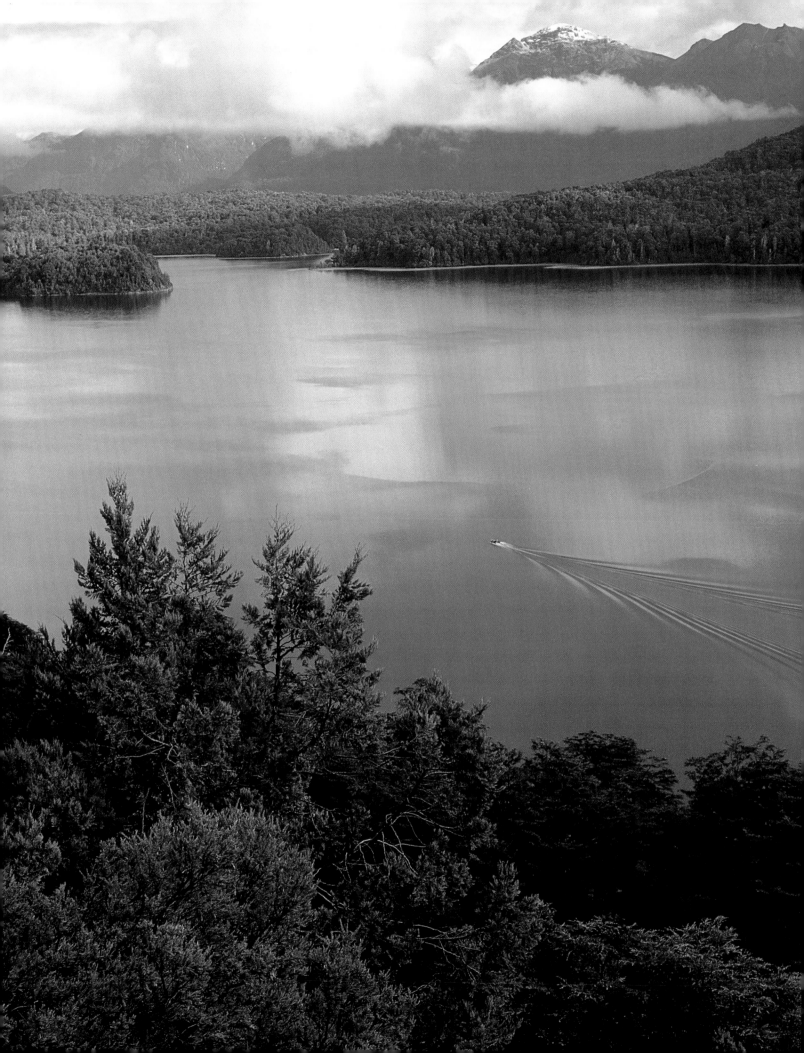

58 and 59 *Officially established on 8th April 1922, the Nahuel Huapi National Park lies along the border with Chile, in the extreme north-west of Argentine Patagonia. Its vast territory, which stretches from west to east, spans from the mountains and glaciers of the Andean Cordillera, such as Cerro Tronador (11,657 feet) to valleys blanketed with thick woods. It then extends to the area occupied by the great lakes, such as Nahuel Huapi which dates from 40 million years ago when, at the height of the Tertiary period, the waters of the Pacific ocean flooded the region's volcanoes.*

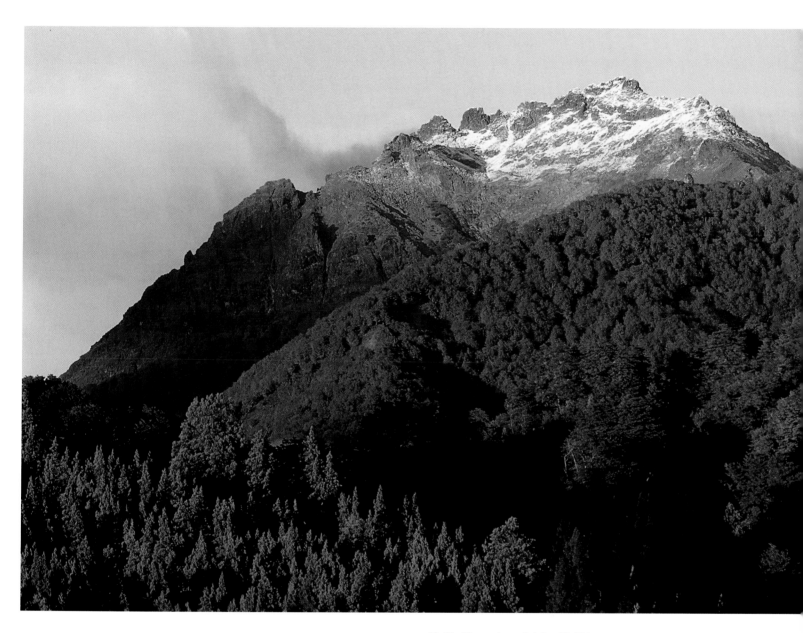

60-61 *Situated at a height of 2,624 feet, Lake Nahuel Huapi covers a surface area of 214 square miles, equal to just over three times that of Buenos Aires. 1,500 feet deep it is surrounded by Andean-Patagonian woods, rich in mayten, alerce and ñire. Isla Victoria has one of the reserve's many peculiarities, its arrayán wood, the only one left in the world; this myrtle with cinnamon-colored bark can grow to a height of 80 feet.*

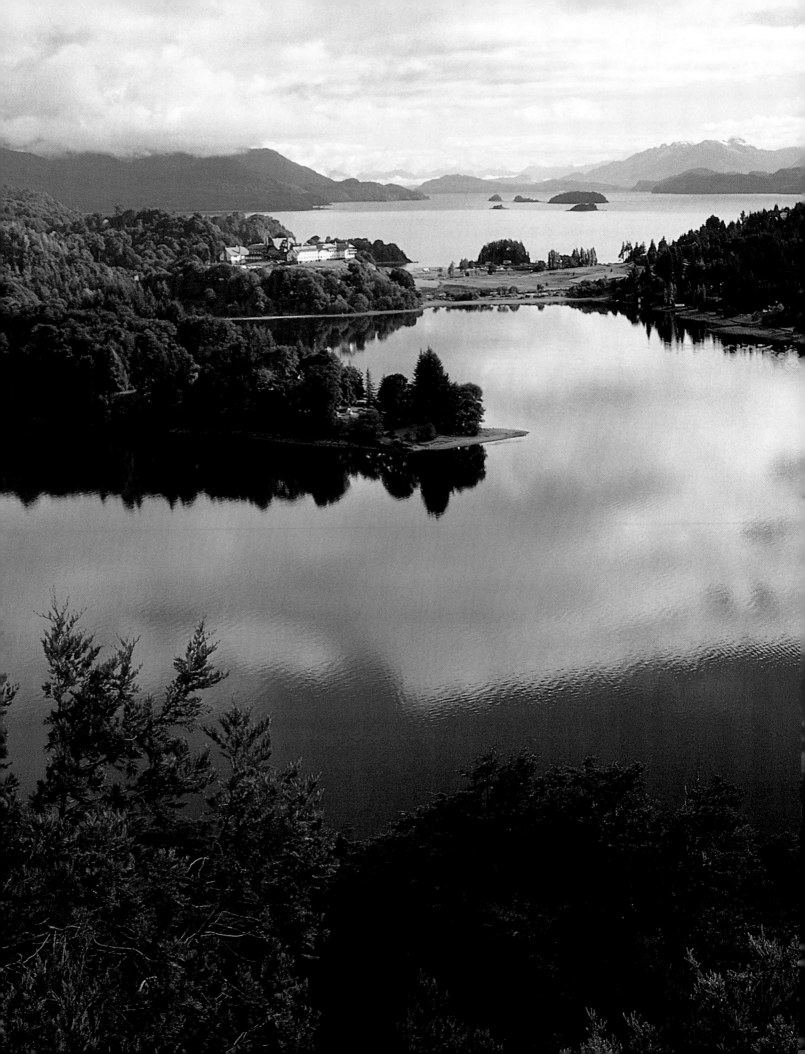

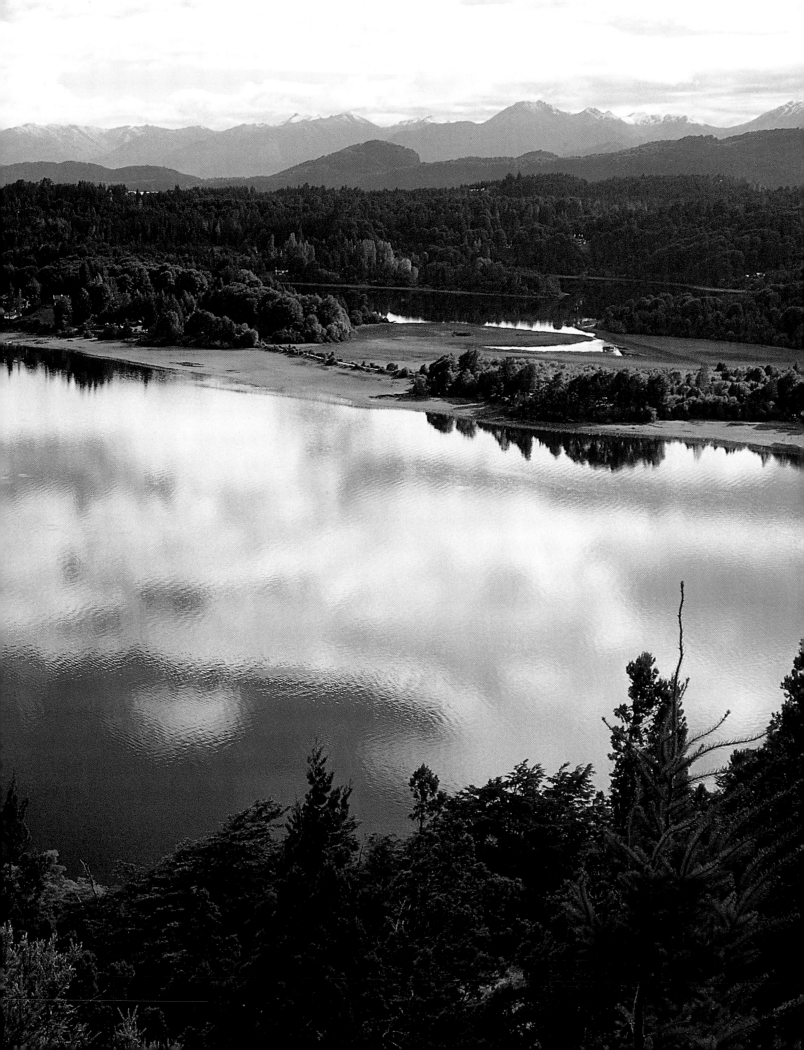

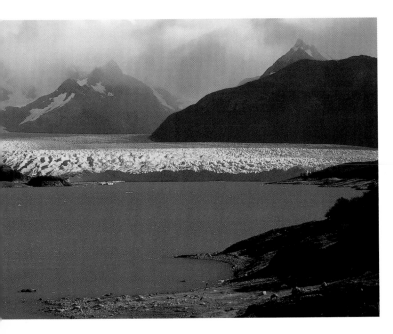

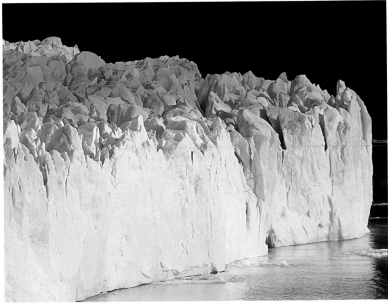

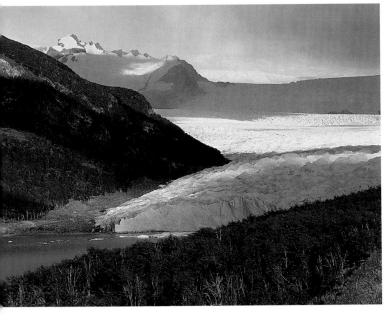

62 Three views of the Los Glaciares National Park which comprises Lake Argentino, partially occupied by the Perito Moreno glacier, in the south-west of the province of Santa Cruz. Created in 1937, with a surface area of 1,482,000 acres it is certainly one of the largest Argentine parks. The reserve, which also includes Lake Viedma, comprises, among others, the Uppsala glacier, the largest in the southern hemisphere (except for Antarctica) and the Cerro Torre and Fitz Roy peaks. Since 1981, the Perito Moreno glacier, which extends approximately 4 miles into Lake Argentino dividing it into two branches, has been a world heritage site. The climate of the Park is cold-damp with mean annual rainfalls of between 200 and 400 mm .

63 Fed by the glaciers around Lake Argentino, the Moreno Ventisquero (glacier), 22 miles long and nearly 330 feet high, periodically dams one of the branches of the lake, giving rise to a phenomenon of water compression which at a certain point causes the ice to break. Heralded by hollow cracking noises, the explosion of huge blocks of ice is one of the park's most thrilling spectacles.

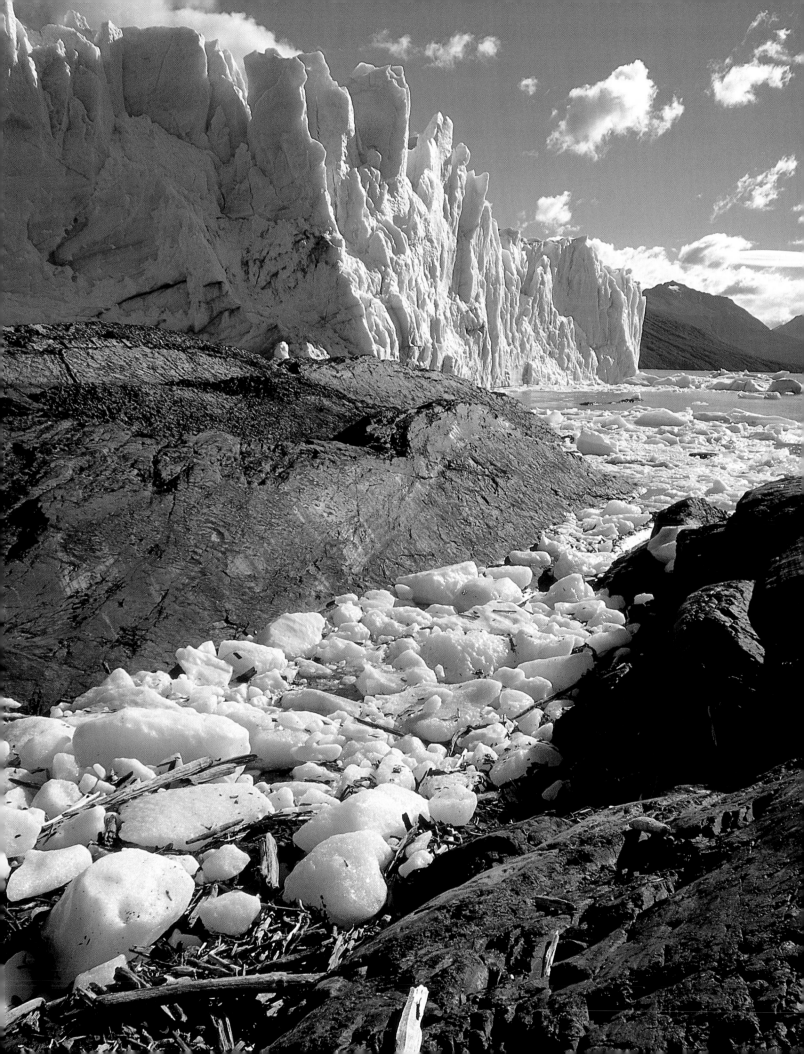

The Andes, the roof of America

64 top *The area around San Carlos de Bariloche, in Patagonia, known for its vast expanses and coniferous woods which rise to 4,000 feet close to Chile before yielding to the Selva Valdiviana, dominated by plants such as the coihue and lenga, which in autumn tinges the mountains around the city red.*

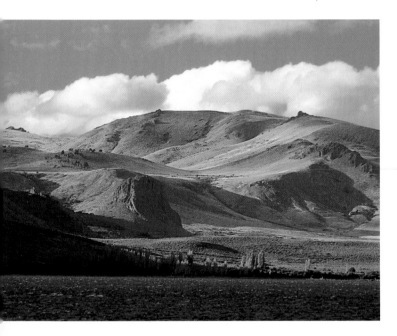

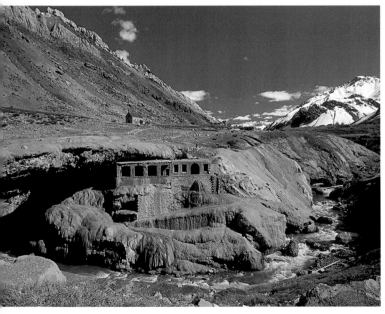

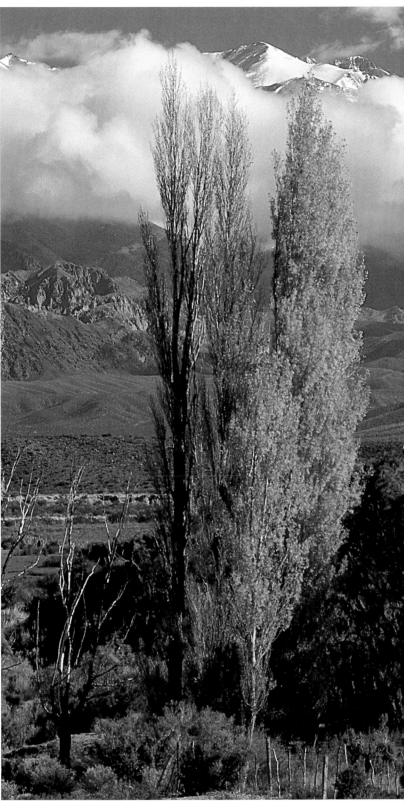

64 bottom *The so-called Puente del Inca in the province of Mendoza. At 8,856 feet this rock bridge nearly 165 feet long is the product of a mass of mineral deposits in bright tones of red and orange which envelop the remains of ancient warm water springs, already known during the time of the Incas.*

64-65 *The Andes at Uspallata, in the central-west Cuyo region, known for its vine-yards fed with the water from the glaciers of the Andes. The Andean Cordillera is relatively young, geologically speaking, the main peaks having formed in the Tertiary period.*

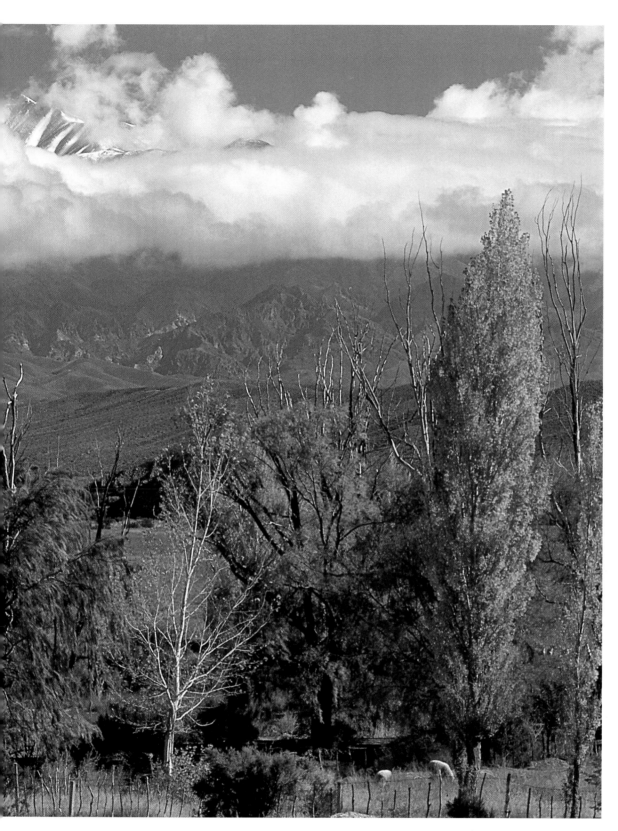

65 *The Río Negro, north of San Carlos de Bariloche. This river flows out of Lake Nahuel Huapi as the Río Limay and makes various areas fertile for intensive farming. After passing towns such as Carmen de Patagones and Viedma, it flows into the Pacific Ocean at a promontory full of sea-lions.*

66-67 *The peaks of the region of Aconcagua, in the province of Mendoza, between Chile and Argentina, are some of the highest in the entire Andean chain. A paradise for mountaineers and trekking enthusiasts, thanks to a large number of peaks between 16,000 and nearly 23,000 feet, they are bound to the south by the 34° parallel and to the north by the 28° parallel, namely Passo Alvarado and Passo de La Luna.*

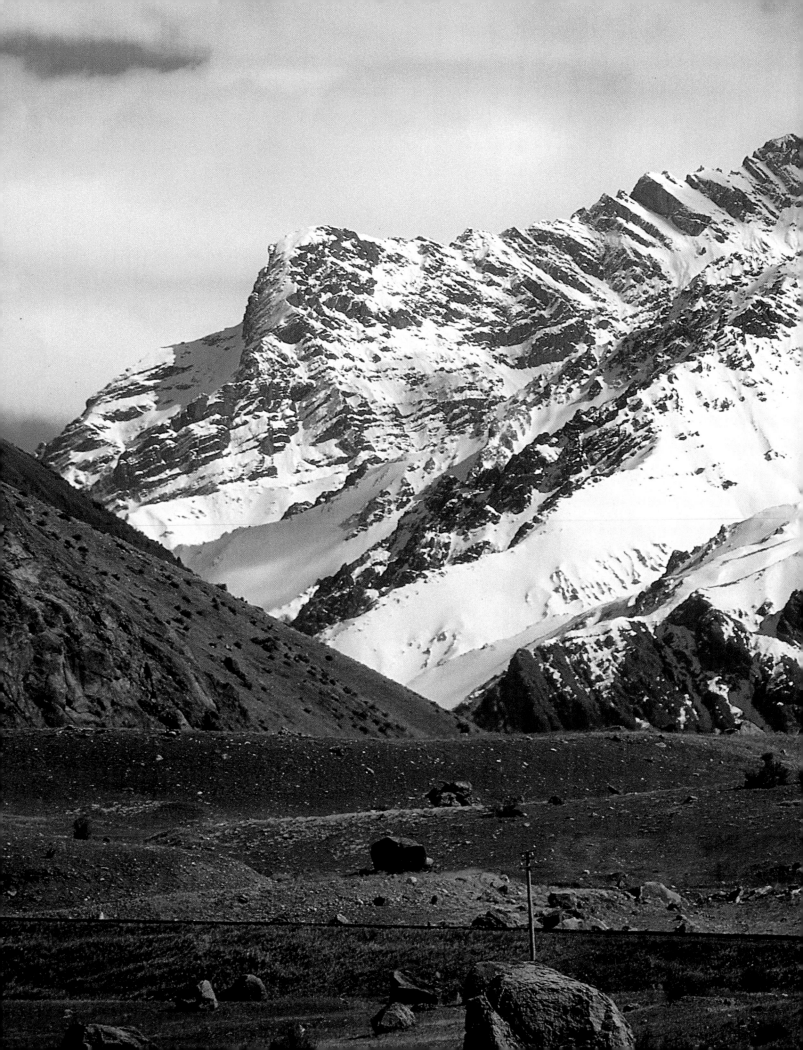

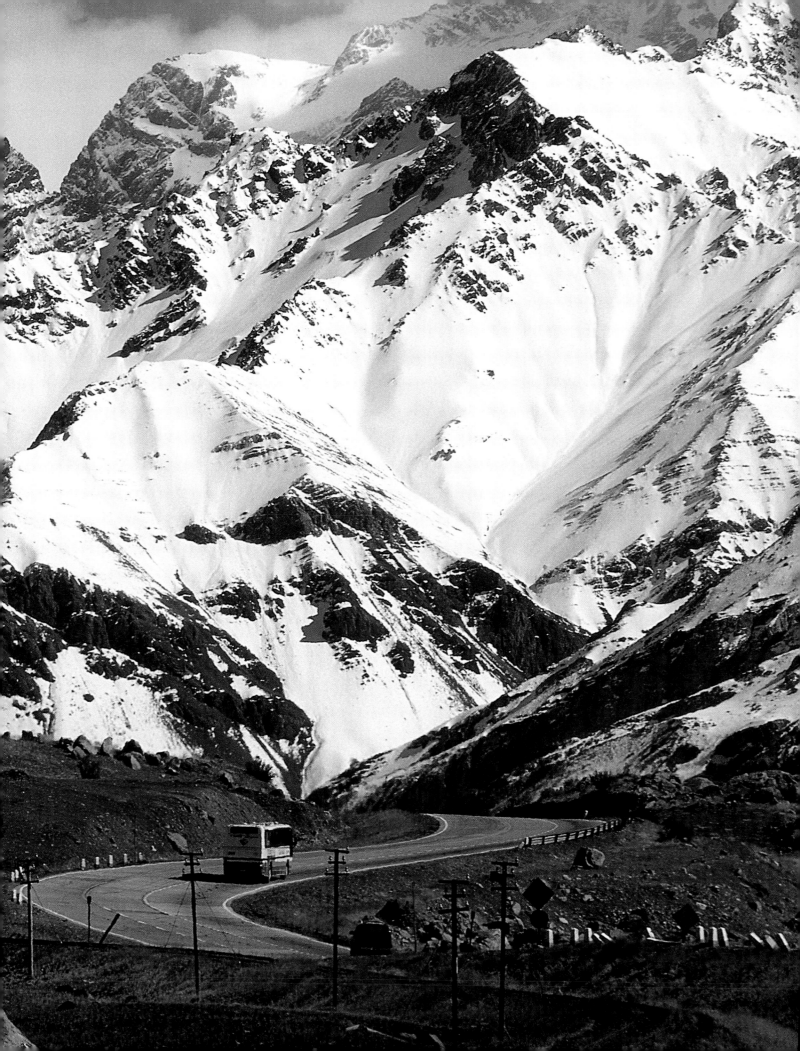

68 top left *The tourist resort of Las Leñas, approximately 90 miles from the town of Mendoza, in the south of the province, is one of Argentina's main skiing resorts. Visited by the pick of South American society, who meet here between June and October, it offers 30 miles of ski runs, modern lifts and first-class hotel amenities for more than 2,000 visitors.*

68 bottom left *The small cemetery that contains the remains of those who died in the attempt to conquer the peak of the nearby Cerro Aconcagua. This is near the ski resort of Los Penitentes, in the province of Mendoza; the Club Andinista Mendoza offers assistance to the mountaineering expeditions which, from mid-January to mid-February, tackle the difficult mountain, normally choosing to climb the north face.*

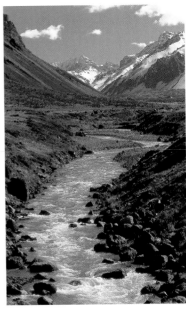

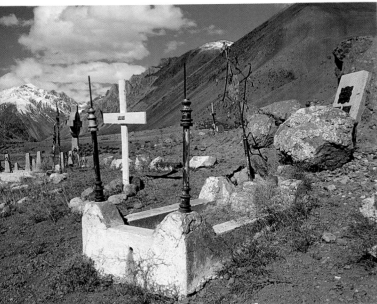

68 right *The Río Mendoza, near Las Cuevas, from where it is possible to reach the border with Chile. As well as a modern tunnel, reserved for vehicles, there is an old road that winds up to the La Cumbre pass, at a height of 13,776 feet; this was crowned in 1904 with a huge statue of Christ the Redeener, to which visitors attach small scraps of cloth to ask for grace.*

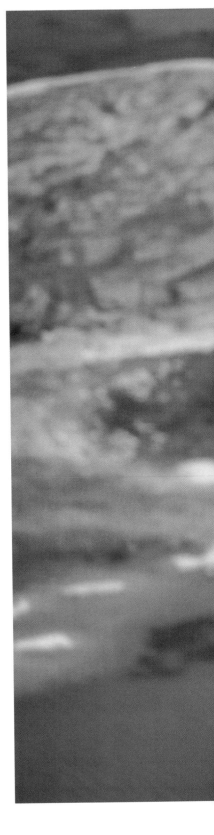

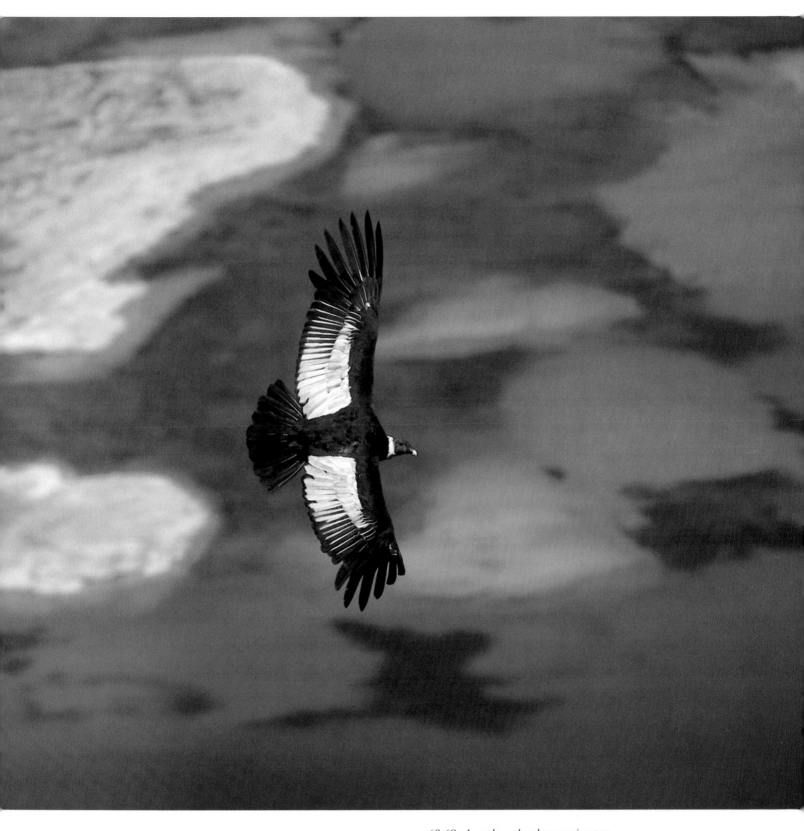

68-69 *A condor - these have a wingspan of up to 10 feet - flies over Lake Santa Cruz. An inhabitant of the Andean skies, this unmistakable but rarely sighted creature has a marine equivalent in size and flying ability in the wandering albatross. The woods of Patagonia are, on the other hand, the favorite hunting ground of the Chilean eagle.*

70 left *A sweeping view of the Andes at Uspallata, the pass of which, along the so-called Ruta Sanmartiniana which starts from the city of Mendoza, reaches a height of 5,746 feet. These peaks, on the boundary between Precordillera and Cordillera, witnessed the passage of the legendary army of the Andes, led by general San Martín, which in 1816 inflicted a* burning defeat on the Spanish militia. *The Andean Cordillera, approximately 4,300 miles long, constitutes the main divide of the South American continent and is the largest mountain range on the planet. The highest peak is Aconcagua, on Argentine territory, while between Peru and Bolivia it reaches its widest point, approximately 500 miles.*

70 right *The Cerro Tronador, towering above Lake Mascardi, near San Carlos de Bariloche, lies on the border with Chile. As well as for its three peaks - one Argentine (11,184 ft), one Chilean (11,250 ft) and one international (11,657 ft) - it is known for the so-called Ventisquero Negro, a glacier regrettably subject to fast recession, which owes its grey color to the layers of detritus that cover its face.*

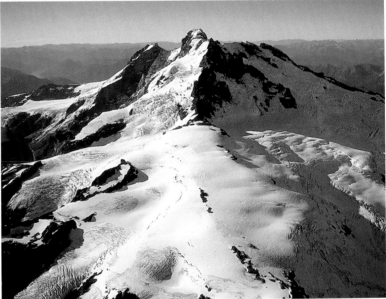

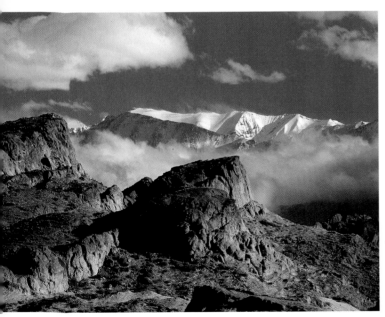

71 *A spectacular photograph of Cerro Torre (10,259 ft) in the Los Glaciares National Park, established in 1937. Situated in the South of Argentine Patagonia, approximately 36 miles from the town of El Calafate, the park contains some of the country's major natural attractions, from the Moreno glacier to the Cerro Torre and Fitzroy peaks, constantly assailed by mountaineering expeditions.*

72-73 *A sweeping view of the spectacular Aconcagua, the name of which in Indian is thought to mean the "stone sentinel". This great mountain in the province of Mendoza on the border between Argentina and Chile, has two peaks; the first, 22,825 feet, was conquered in 1897, the second 98 feet lower was not reached until 1947. The south face, a wall of rock and ice nearly 9,850 feet high, is particularly demanding.*

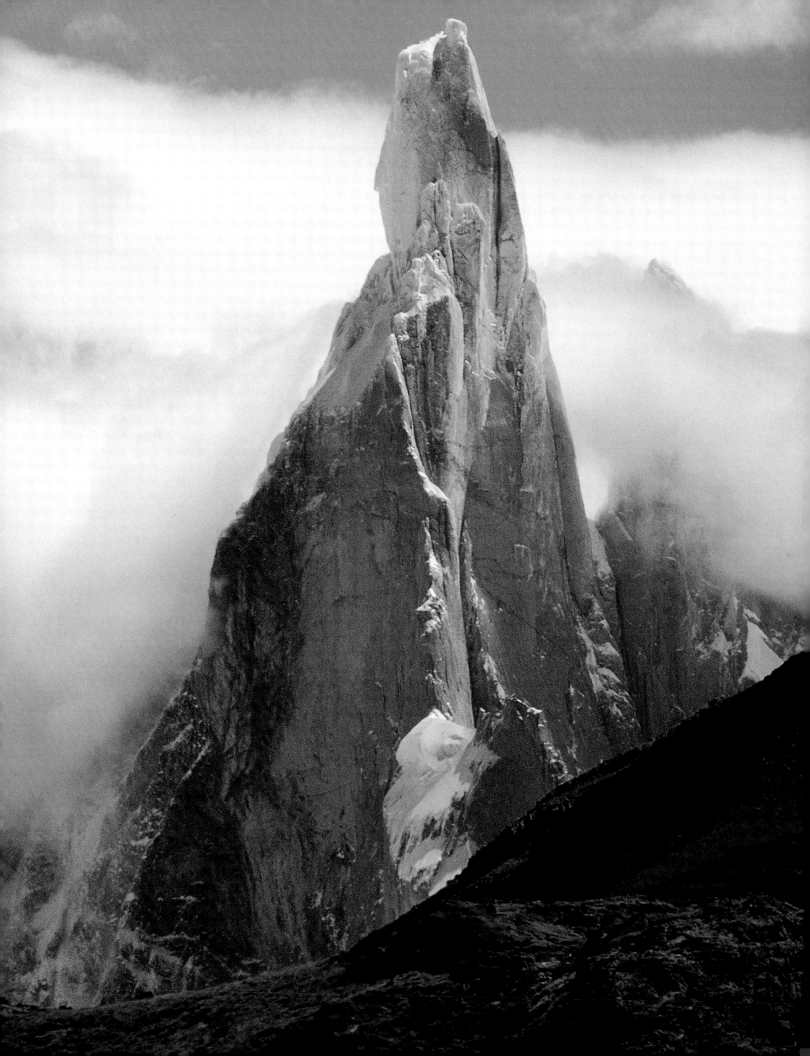

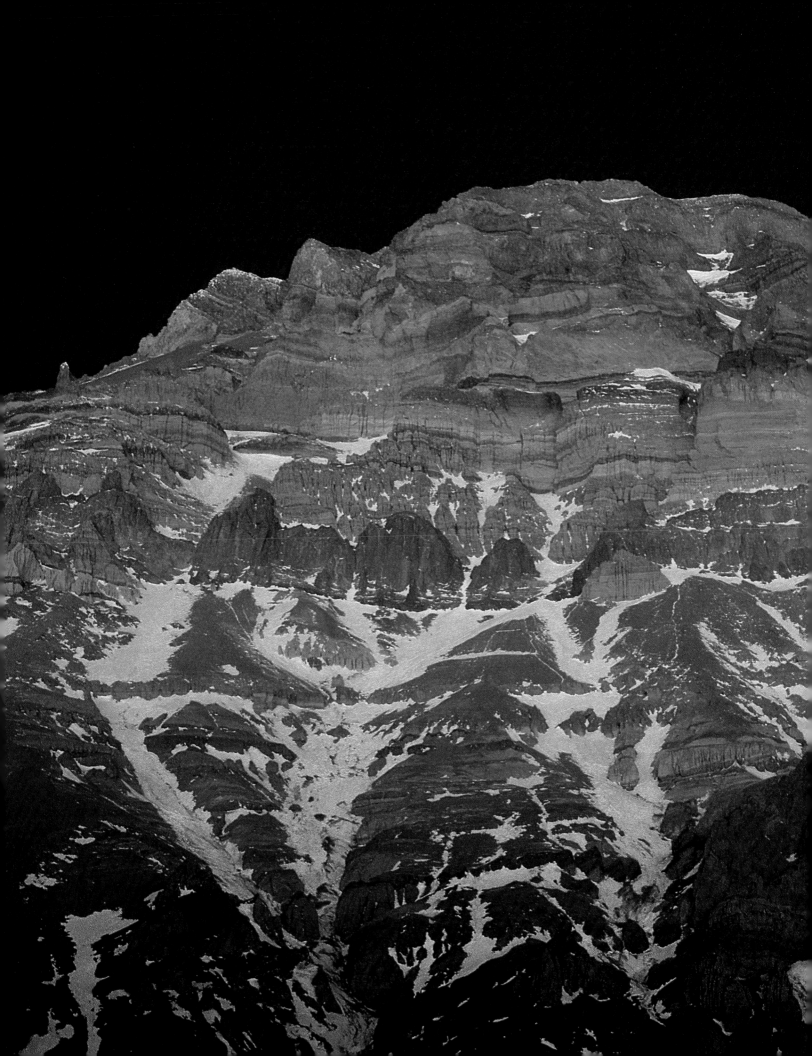

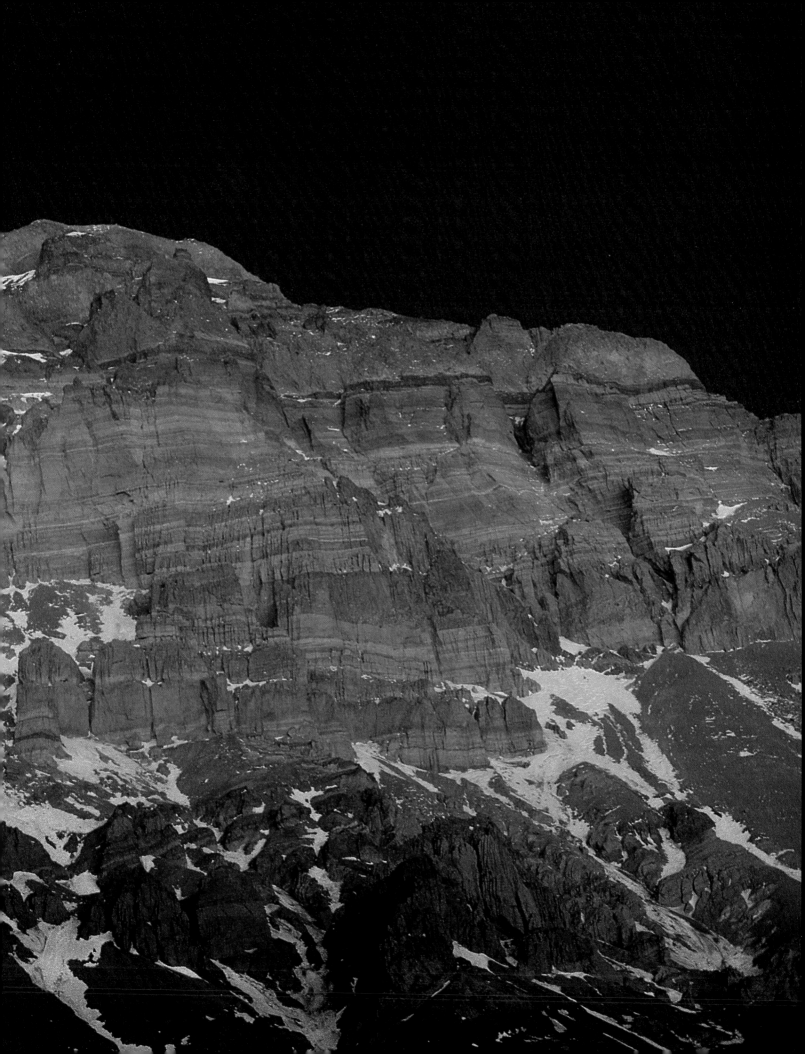

Tierra del Fuego, on the edge of the world

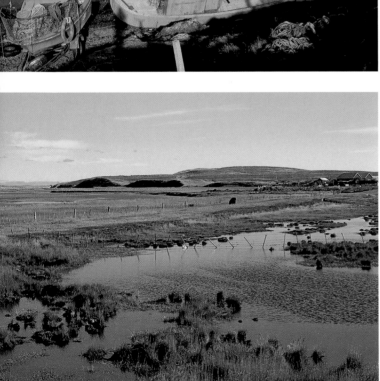

74 top left and center *Situated on the north shore of the Beagle Channel, latitude 55° south, Ushuaia is considered the southernmost city on the planet. The home, together with Puerto Madryn, of major scientific centers, it is the last Argentine outpost. Capital of Tierra del Fuego and Argentine*

Antarctica it stands at the foot of the Glaciar Martial. The abundant snowfalls, severe weather conditions, with mean temperatures of 8°C in January and 0°C in July, and the huge distances from other towns continue to make it a frontier city. The Fin del Mundo museum has been set up here with an exhibition on ancient Fuegian culture.

74 bottom left *The approximately 8,106 square miles of Tierra del Fuego, lying between the Strait of Magellan and the Beagle Channel, have a sub-Antarctic climate, made milder by the proximity of the Atlantic and Pacific Oceans. Despite the strong south-westerly winds the climate permits the growth of low, monotonous vegetation which features the calafate, a shrub that produces beautiful flowers and edible berries.*

74 right *The Hostería Kaikén, near the town of Tólhuin (founded in 1972) on the south-east tip of Lake Fagnano enjoys a beautiful view with the peaks on Chilean territory in the background. This is Tierra del Fuego, together with Patagonia the undisputed realm of sheep, the rearing on vast scale of which is, with oil and natural gas drilling and tentative torism, one of the main sources of income on the island.*

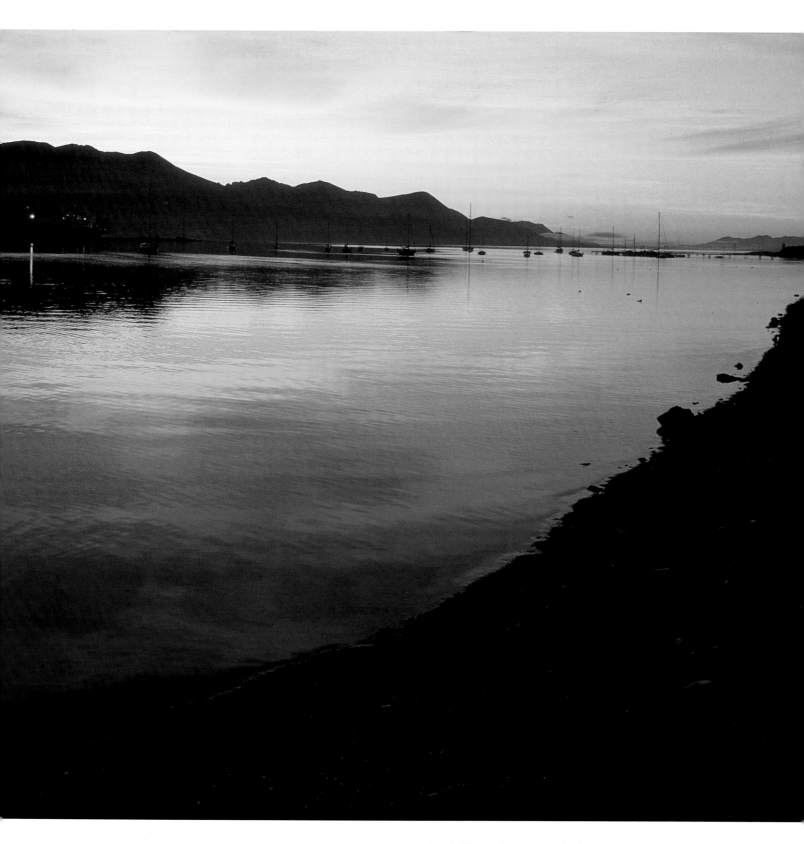

74-75 *The Beagle Channel takes its name from Darwin's ship, which touched these lands in 1833, after a five-year voyage. The oldest native coastal settlement of Tierra del Fuego was found on the Channel at Tunel. Only half-caste descendants remain of the island's old natives - the Ona, Alacaluf, Yaghan and Tehuelche - encountered by the first European explorers.*

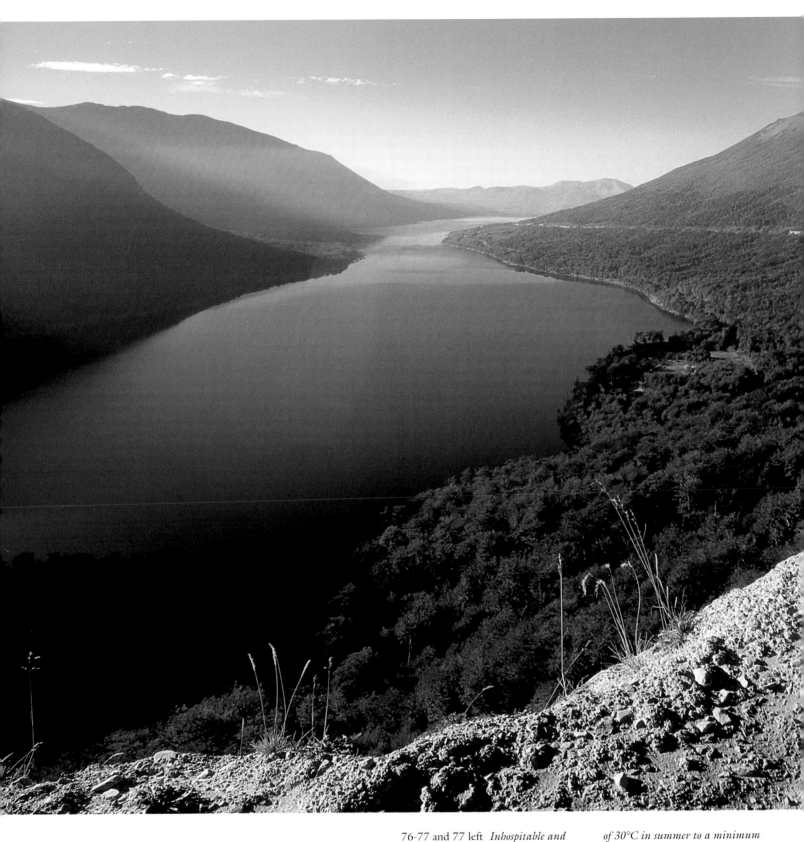

76-77 and 77 left *Inhospitable and mostly uninhabited, Tierra del Fuego is situated between latitudes 52°25' south and 56° south. The archipelago, on which lies the Andes chain, boasts a temperate subantarctic climate; save for the mountains that are battered by raging winds, it has mean annual temperatures, along the Beagle channel, ranging from a maximum of 30°C in summer to a minimum of -14° in winter. Between January and March the Tierra del Fuego National Park, set up in 1960 on a surface area of over 155,000 acres, is visited by thousands of people. Particularly rich is the birdlife with kingfishers, albatross, hawks and condors and the fish which include salmon and trout.*

77 top right *Just six species of the trees typical of the Andean-Patagonian zone are present in Tierra del Fuego. Predominant among these are the three that belong to the southern beech family (in the photograph one seen in autumn) resistant to the low temperature and found up to 2,000 feet above sea level. Of these only the ñire, with its unique orange leaves in autumn, and the leña are deciduous.*

77 center right *Lake Fagnano or Kami, partially included in the Tierra del Fuego National Park. This lake, of glacial origin and named after the missionary Giuseppe Fagnano, who in 1886 tried to oppose the extermination of the Indians, flow on to the west, on Chilean territory, discharging into the Seno Almirantago via the Río Azopardo. Exploration of this*

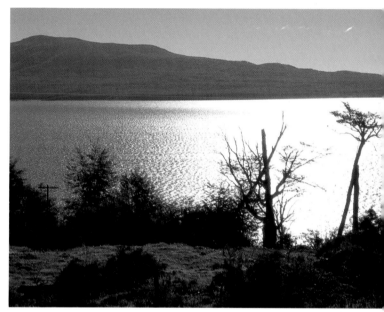

archipelago started in the 16th century with Magellan, who called it Tierra del Fuego because of the many natives' bonfires sighted on its coasts.

77 bottom right *From the 19th century on the vast* estancias *of Tierra del Fuego, sometimes extending over hundreds of thousands of acres, have been used for sheep-farming. The ports of San Julián, Puerto Deseado and Río Gallegos have exported thousands of tons of wool produced in Argentina all over the world, to Britain in particular. Now farms mostly keep Australian merinos sheep and Corriedales.*

Past and future combined

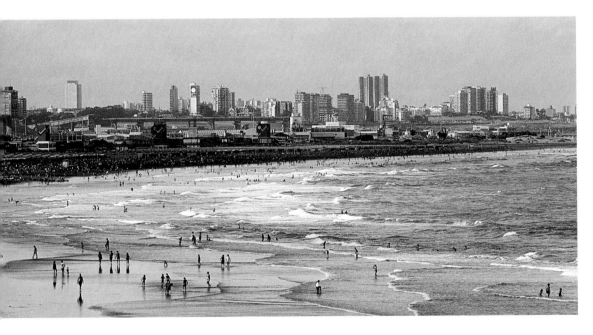

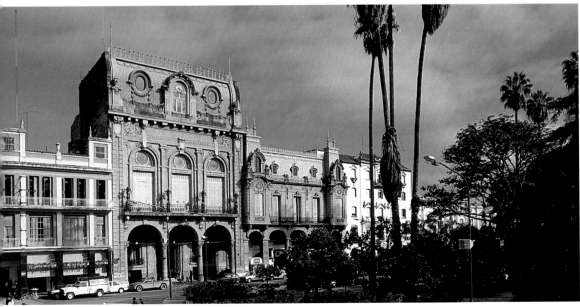

78 top *The beach and skyscrapers of Mar del Plata, the best-known and most fashionable Argentine seaside resort. Approximately 248 miles from Buenos Aires, it has a population of nearly 600,000 which in summer, between December and February, rises to more than 3 million. Its tourist development started in 1888 with the inauguration of the elegant Hotel Bristol, patronized by the cream of society, and continued with the construction of the railway, which brought a broader clientele.*

78 bottom *Plaza 9 de Julio in Salta, capital of the Argentine province of the same name. Situated in the Lerma valley the town is known for its vast tobacco plantations and their 865,000 acres of crops account for roughly one third of the national production. It is also known for its old buildings, reminiscent of the turbulent colonial times.*

79 *A detail of the famous Casa Rosada in Buenos Aires, the residence of the President of the Argentine Republic. The central arch is by the architect Tamburi and the building stands on the east side of Plaza de Mayo. It dates from 1894 and was built on the remains of a military fortress later turned by the president of the time, Sarmiento, into the Central Post Office.*

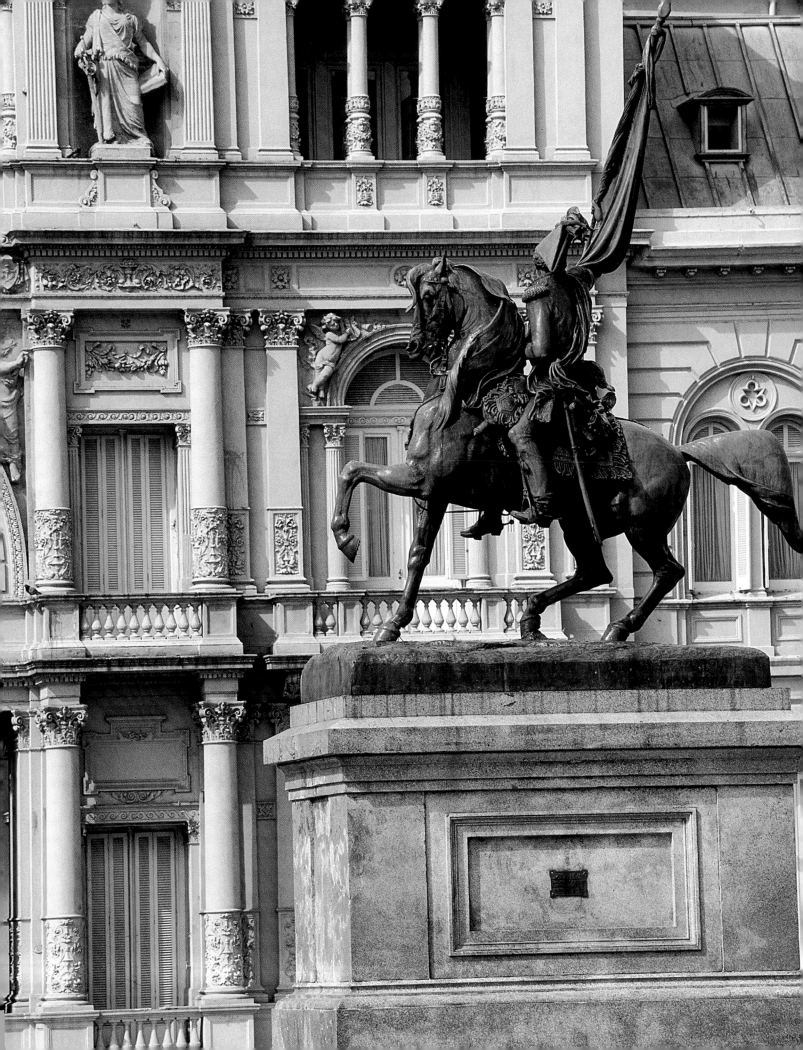

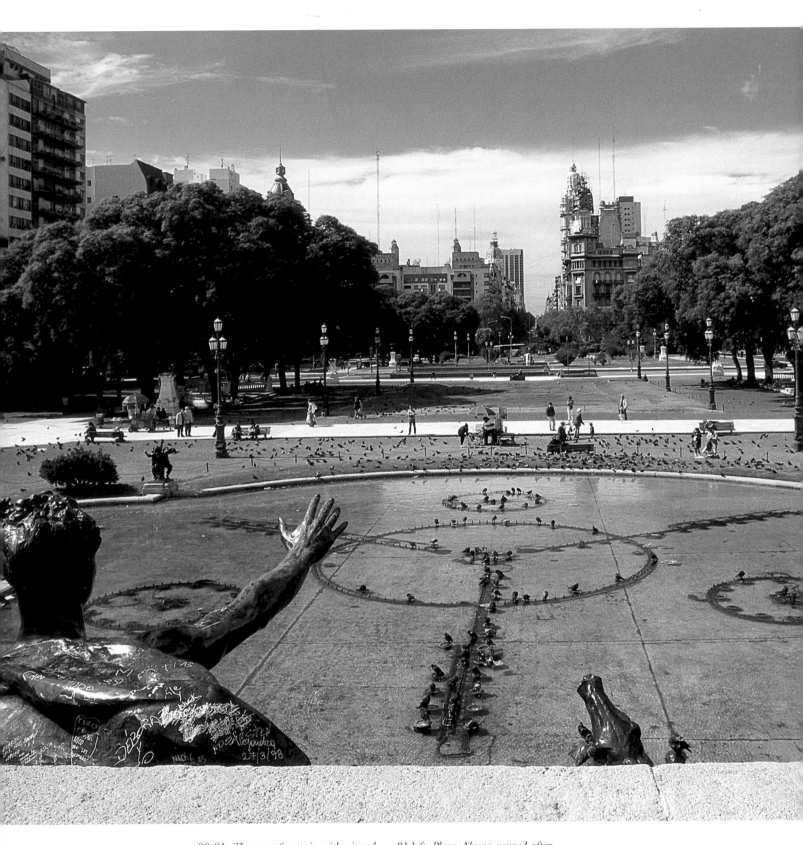

80-81 *The great fountain with winged horses and putti, situated on the huge square in front of the Palacio de los Dos Congresos in Buenos Aires, is one of the busiest places in the Argentine capital. Used as a point of reference for the distances on the road maps of all the country, it is topped with a monument to the two national Congresses.*

81 left *Plaza Alvear, named after Torcuato de Alvear, with to the rear, the bell-tower of the Iglesia de Nuestra Señora de Pilar, considered one of the prime examples of Argentine Baroque style and situated in the exclusive Recoleta district. This is one of the most refined barrios in the capital, known for its prestigious mansions and elegant boutiques, as too for its famous cemetery, where Evita Perón is buried.*

Buenos Aires, the great mother

81 top right *A squad of the grenadier regiment, the elite corps created by General San Martín during the war of independence and entrusted to protect the Casa Rosada, on Plaza de Mayo in Buenos Aires. The soldiers, who still wear the traditional red and blue uniform, also escort the President during his public appearances.*

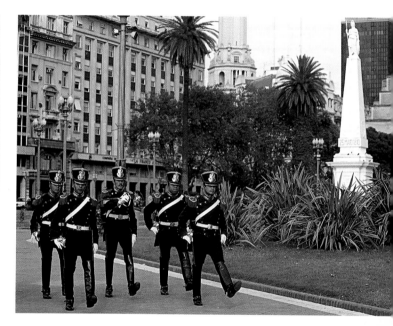

81 bottom right *One of the capital's main squares is dedicated to the famous General San Martín, a quartermaster from Cuyo and hero of national independence. Set on a hill, in the heart of one of the city's most elegant districts, Barrio del Norte, it is surrounded by extensive gardens, wide tree-lined avenues, stylish mansions and impressive skyscrapers such as the Kavanagh Building, constructed in 1936 and considered the first building of its type in Latin America.*

82-83 *Puerto Madero, the old dock area of Buenos Aires, has been transformed into a trendy residential area - which also includes skyscrapers and splendid office buildings - along the lines of the London docks. A breathtaking revolving bridge, designed by brilliant Argentine architect, Santiago Calatrava, is the symbolic entrance to this quarter.*

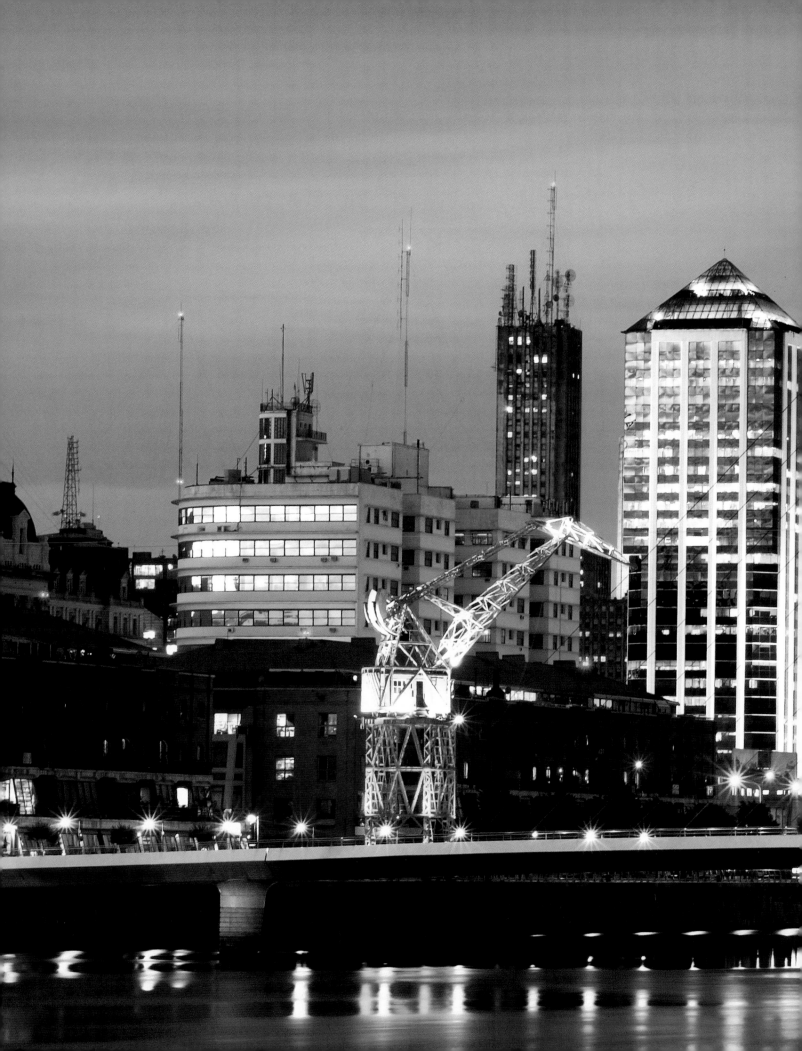

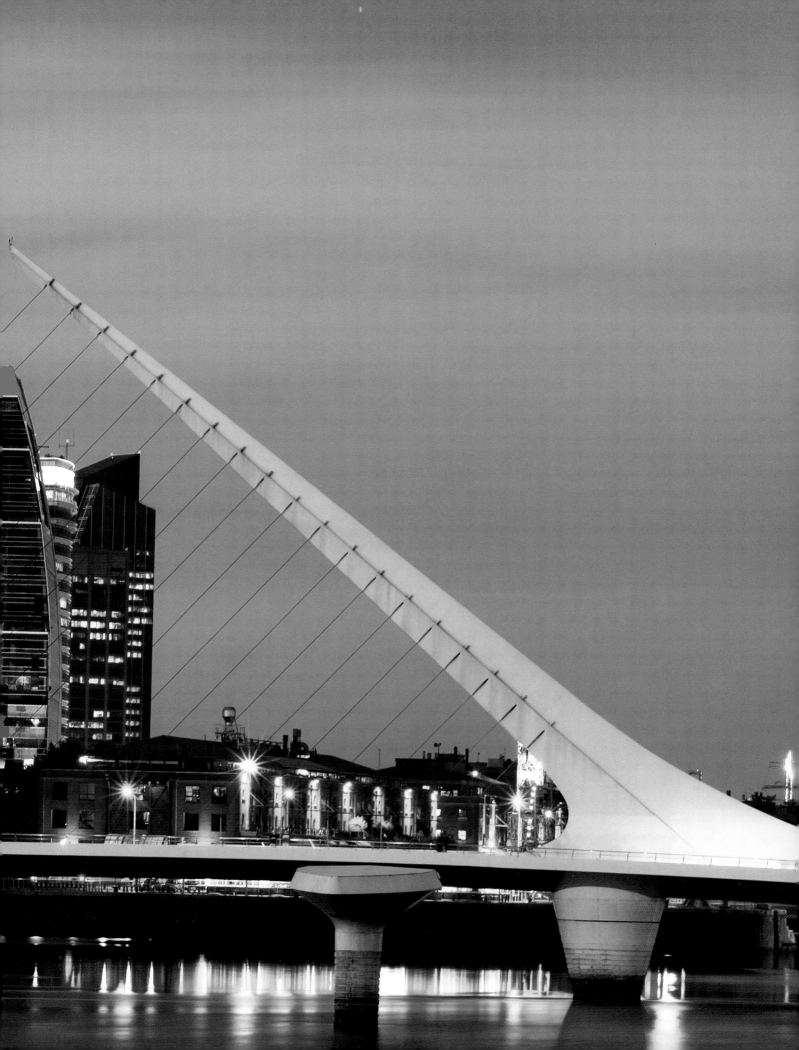

84 left *An expression of the Argentine imagination, El fileteado is a special decorative technique used for traders' signs invented at the turn of the century to provide street vendors' carts with brightly colored and patterned decoration that would catch the eye of passers-by; today they are mainly seen in the San Telmo quarter. Every day, in Plaza Dorrego, the fileteadores make personalized souvenirs for the tourists and exhibitions of old pieces are held in the Cornelio Savedra history museum in*

Buenos Aires. San Telmo quarter, the oldest in the city, was abandoned in 1870 by the middle and upper classes because it was considered unhealthy. Fearing that the winter fog, brought by the water, that enveloped the barrio would favor the spread of yellow fever, the noble citizens took refuge inland, founding the new districts of Recoleta and Barrio del Norte; that left by its old inhabitants was quickly occupied by the new immigrants.

84 right *A street artist performs in Calle Florida. This vast pedestrian area, full of shops, is spread over 11 blocks. The first part, which starts in Plaza de Mayo, is the 'City' of Buenos Aires. The central area is more commercial with shops and bars while the luxury boutiques and fashionable cafés are concentrated at its end.*

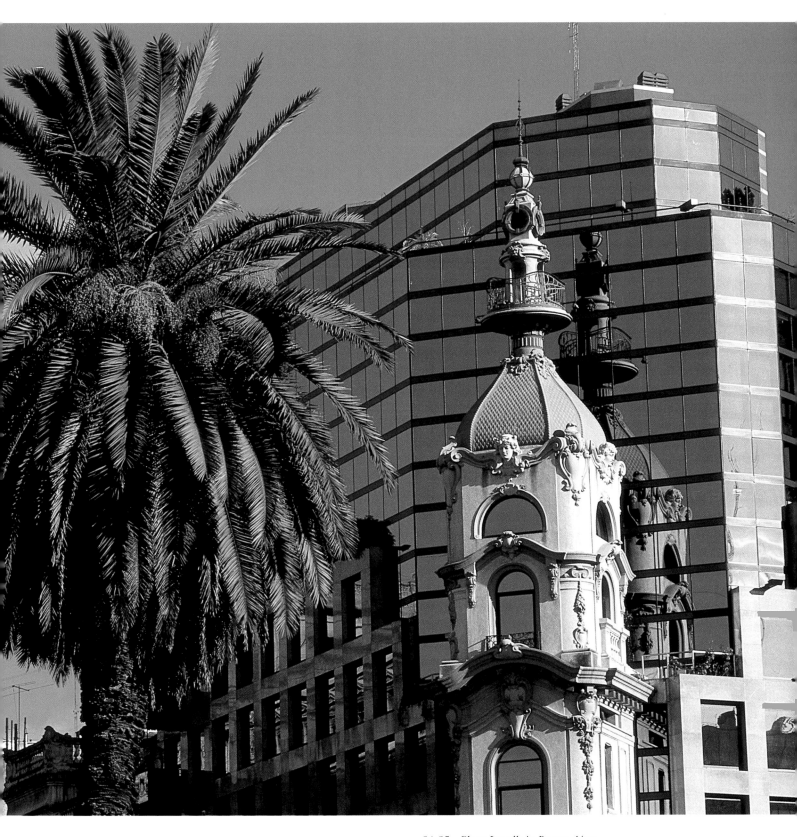

84-85 *Plaza Lavalle in Buenos Aires was previously used as a dump for the remains of animals killed and skinned for their hides, exported all over the world. At the end of the 19th century the city's first railway station was built here; today on one side is the building housing the Federal Law Courts and on the other the Teatro Colón, one of the best-known constructions in the capital.*

85

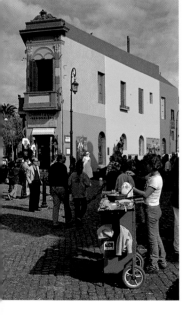

86 *The Caminito, in the La Boca barrio, is certainly one of the most picturesque parts of the well-known Genoese quarter, the haunt of tourists and artists alike. Made famous thanks to the tango of the same name by Juan de Dios Filiberto, it was originally a railway terminus, a shortcut between the rail tracks and the back of some houses. La Boca was born in the mid-19th century when Genoese and Neapolitan sailors and workers settled in this area at the mouth of the Riachuelo, a small waterway leading to the Río de la Plata. Mindful of Italian tradition, the new-arrivals started to color the humble dwellings, mostly built on piles using wood and corrugated iron, with the only paint available, the colorful shipyard leftovers.*

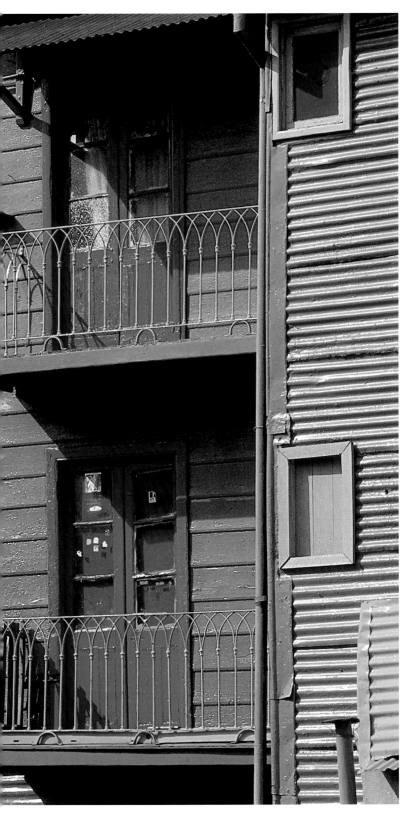

86-87 *The center of the port develement of the Argentine capital, the lively La Boca district, now an open-air art gallery, has not lost its attachment to the mother country. In 1882 its inhabitants even raised the flag of Genoa proclaiming an independent republic with Italian laws and invited the king of Italy to attend the event.*

87 *Some musicians and a mural dedicated to the tango in the La Boca quarter. This* barrio *is where the musical genre was born from the coming together of the Cuban habanera, African candombes and milonga, Andalusian tangos and Italian melody and now one of the national symbols. The Italians who provided the first musicians that played mainly from memory and the first self-taught writers gave it this unmistakably melancholic nature.*

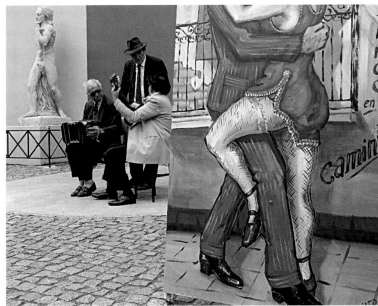

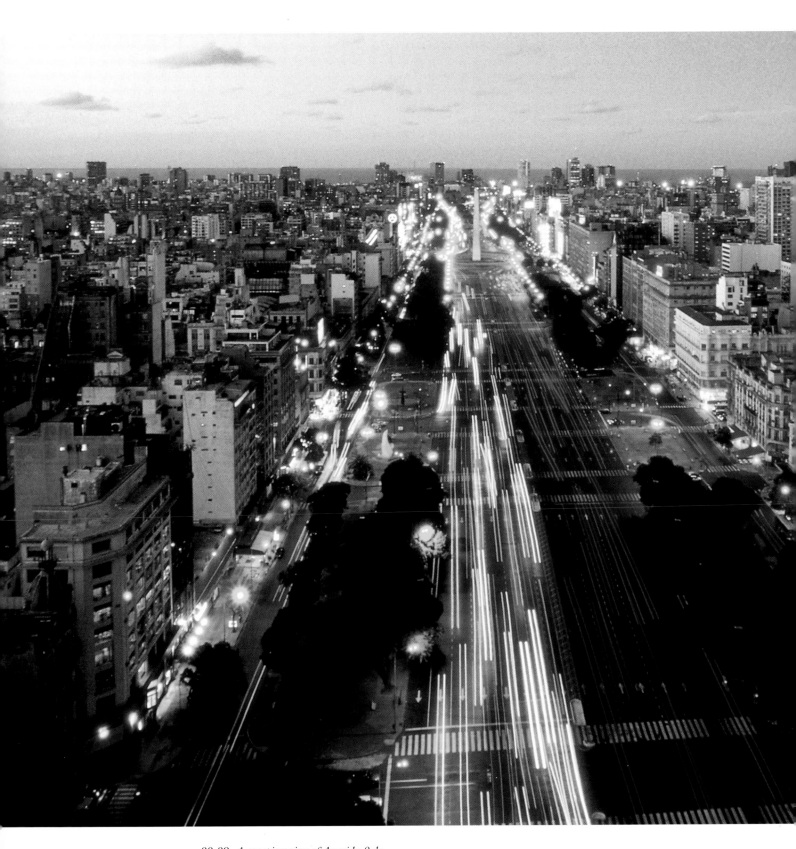

88-89 *A sweeping view of Avenida 9 de Julio at sunset. 460 feet wide, it is considered one of the broadest thoroughfares in the world. Embellished with large green flower-beds it is lined with private homes and public buildings in various styles, advertising posters and a number of* Palo Borracho, *or 'drunken woods, which in summer produce magnificent pink flowers.*

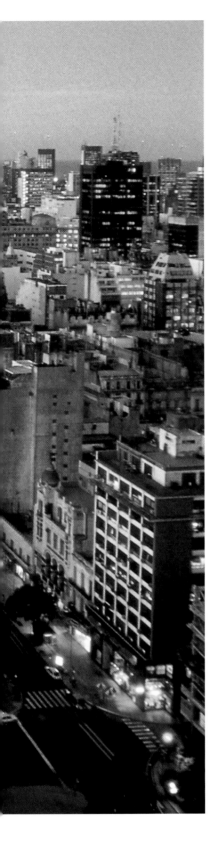

89 left *The Galerías Pacífico in Buenos Aires is home to a large shopping center and was recently declared a national monument by President Menem. Designed in 1889 by Emilio Alegro and Raus Le Vacher, who were inspired by the Vittorio Emanuele Gallery in Milan, in 1945-47 it was altered by the architects Aslam and Escurrà. The frescoes on the central dome are by Castagnino, Berni, Colmeiro, Urruchua and Spilimbergo.*

89 top right and center *Designed by three architects in Neoclassical style with some French influence and inaugurated in 1908 with* Aida *by Giuseppe Verdi, the Teatro Colón is considered one of the great temples of world opera. Occupying almost a whole street block, sumptuously furnished and with period decorations, its stage is 59 feet by 111 and the auditorium can accommodate up to 3,500 spectators. Enrico Caruso and*

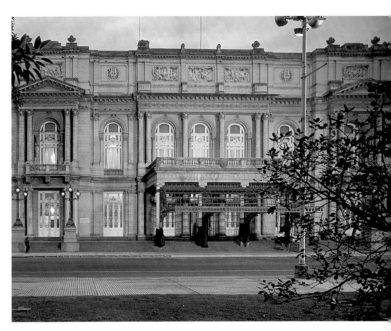

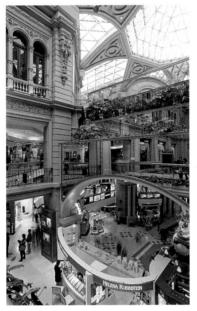

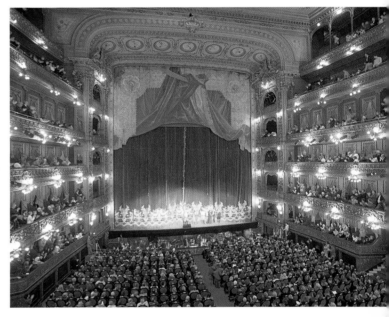

Eleonora Duse among others performed here and to engage the great singer Adelina Patti the management paid the astronomical sum of 30,000 francs per night. Home of the National Symphony Orchestra and the National Ballet Company, the theater season commences in May and ends in October.

89 bottom right *The Caffè Tortoni, in Avenida de Mayo, is certainly the most famous of the capital's many meeting places. Opened in 1858 by the Italian Oreste Tortoni, it is furnished with* boiseries, *oak and marble tables, Art Deco mirrors, old photographs and caricatures. It also has a large library and its clientele has included Borges, Pirandello, Ortega y Gasser, Lorca; Rubinstein, Carlos Gardel and Josephine Backer performed here.*

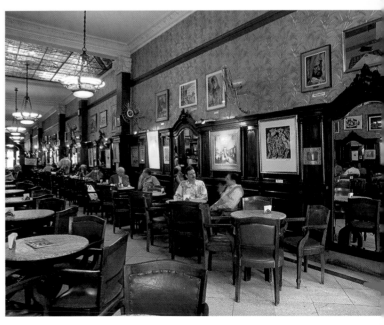

Rosario, the cereal port

90 *The port of Rosario, the Northeast Argentine town with many inhabitants that descend from the old Piedmontese immigrants who came in the last century to seek fortune and work. Not surprisingly, until 20 years ago, there were 37 Italian cultural clubs here, of which remain, among others, the* Famijia Piemonteisa *and the* J'amis del dialet.

91 top left and bottom *Two views of the Parque and Monumento de la Bandera in Rosario, one of the city's most important spots. Like the rest of the country, this city developed rapidly with the arrival of the new European settlers, attracted to this largely uninhabited land by the Argentine government.*

Indeed article 25 of the 1853 Constitution declared: "The Federal Government shall favor European immigration and shall not restrict, limit nor impose tax upon the entry to Argentine territory of foreigners intending to work the land, improve the manufacturing activities and introduce sciences and arts".

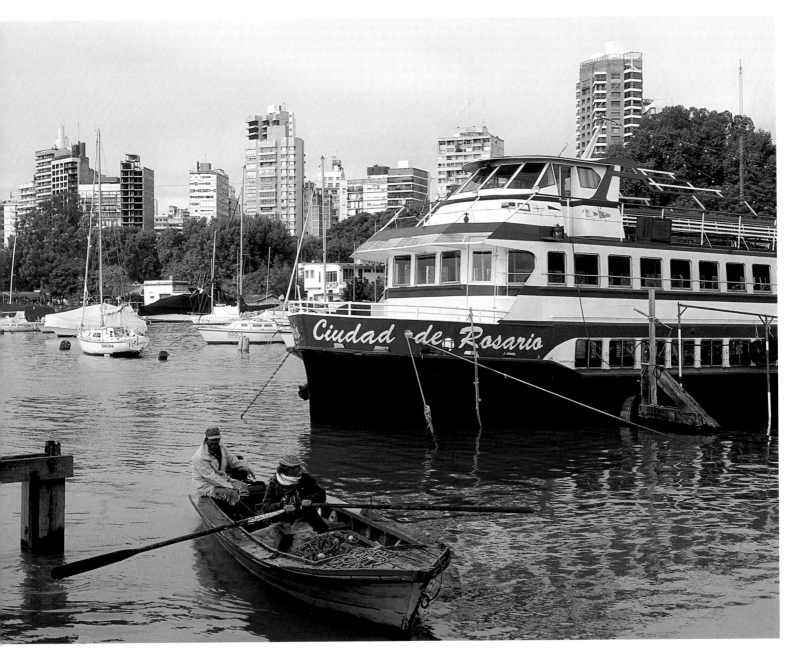

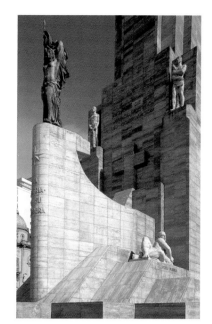

91 top right *The Río Paranà in the city of Rosario. For more than 350 years, roughly until 1920, this major and relatively safe waterway brought goods, explorers, settlers and visitors to the Noroeste region on the boats that sailed the country's rivers linking, among others, Buenos Aires to Iguazú.*

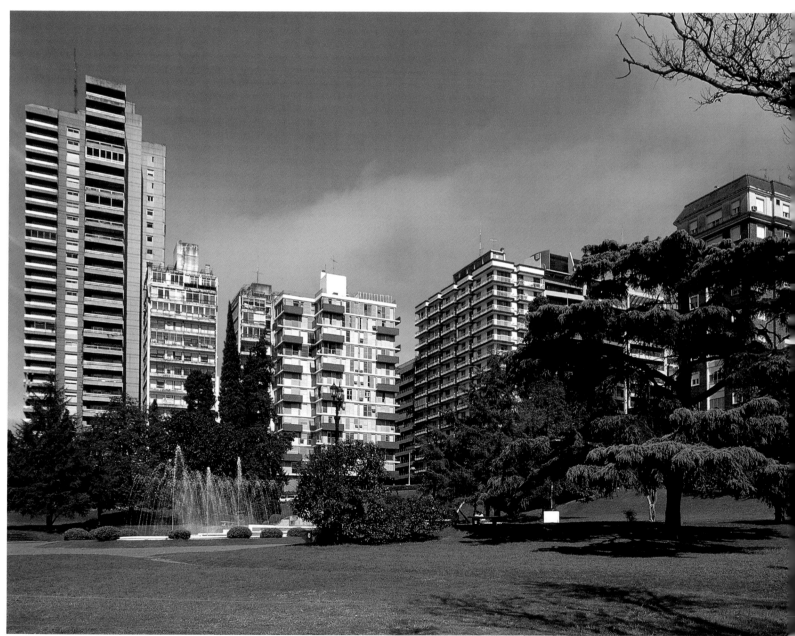

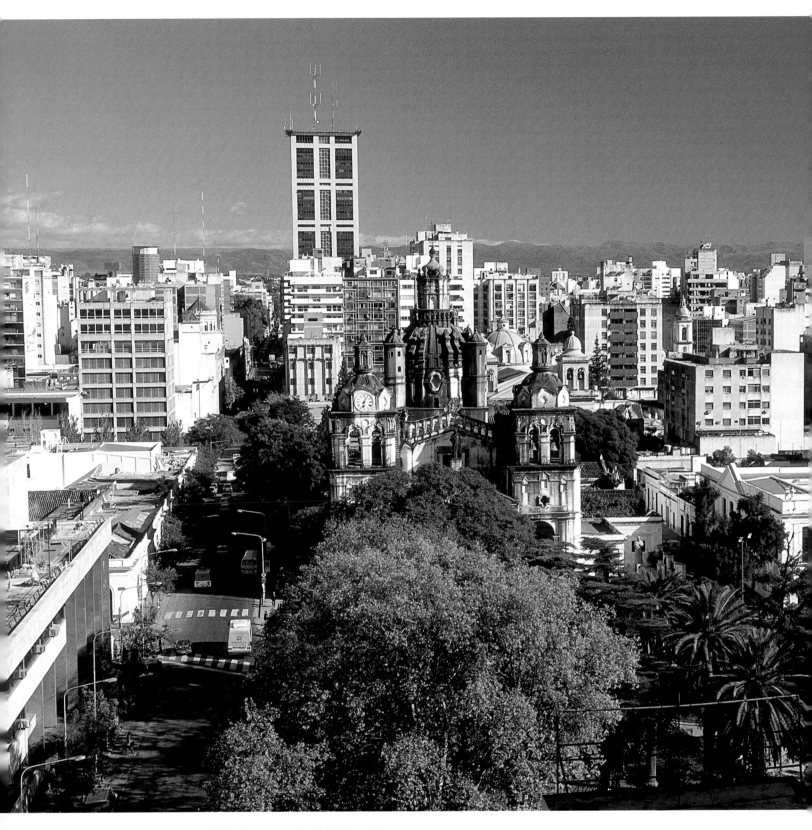

92-93 *A sweeping view of Córdoba, with at the center the ancient cathedral, considered one of the masterpieces of colonial style. This building, with a Baroque doorway, bell-tower and dome, has an interior with three aisles divided by great columns and a 19th-century silver altar. Commenced in the 17th century, after collapse and several interruptions it was not completed until 1784.*

Córdoba, the queen of the Sierras

93 top right *Considered one of Argentina's main financial and cultural centers after Buenos Aires, Córdoba and its province (the photograph shows life in Plaza San Martín) base most of their economy on cattle-rearing. A few miles from the town, Jesús María in January hosts a rodeo, the* Fiesta Nacional de la Doma, *which is extremely popular with enthusiasts; indeed this area witnesses a succession of trade fairs and shows throughout the year.*

93 center right *The Paseo Rivera Indarte of what at the time of its foundation was called Córdoba del Tucumán. When the first settlers arrived in the second half of the 16th century the area was inhabited by three groups of Indians. The Sanavirones were in the north-west, to the west the Comechingones lived in caves or mud huts surrounded by thorny bushes and the Pampas nomads stayed on the plain.*

93 left *The Iglesia de la Compania, in Córdoba, is a reminder of this Argentine city's colonial past. Constructed in the 17th century it formed part of the larger complex, comprising the private chapel of the order and the members' quarters and was erected by the Jesuits on the older site of a late 16th-century sanctuary. Of great interest is the interior built in the form of an inverted ship's hull in Paraguayan cedar-wood.*

93 bottom right *A view of Plaza San Martín, in Córdoba, the imaginary heart of this city with 1,300,000 inhabitants that lives mainly on agriculture, stock-rearing, conducted with innovatory techniques and more recently the automobile industry and production of nuclear energy, the country's second reactor having been installed here in 1983.*

Salta, in the heart of the north-west

94 top left *Born in 1582 as San Felipe di Lerma, the town of Salta - the photograph shows the traditional Plaza 9 de Julio - presents the customary grid plan with at the center the main church and the Cabildo. Full of colonial buildings dating from the Baroque period, it borders to the west on the barren Puna de Atacama plateau lying between Argentina and Bolivia.*

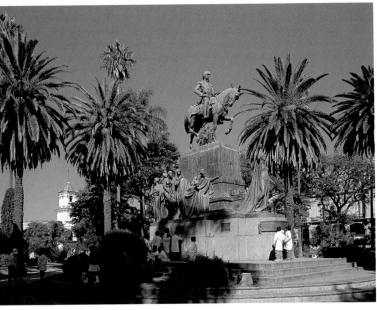

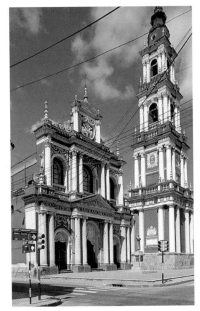

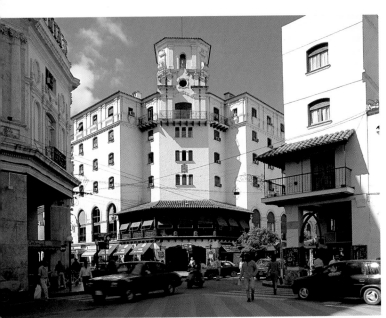

94 bottom left *From 1921 until just a few years ago, every Saturday between April and November saw the departure of the 'Train to the Clouds' from Salta railway station. This followed the route at nearly 13,000 feet to the mining town of San Antonio de los Cobres, in the heart of the Andes.*

94 top right *The pedestrian Alberdi mall crosses the center of Salta with plenty of colonial buildings dating back to the baroque period. Salta, approximately 3,900 feet above sea level and with more than half a million inhabitants, is an excellent base for excursions and treks.*

94 center left *The Iglesia San Francisco in Salta displays decorative exuberance and is one of the most typical examples of colonial Baroque style in Argentina. Construction commenced in 1806, when the town was raised to the status of episcopal see.*

94 center right *The town's archaeological museum has pre-Incaic and Incaic finds from the region and a provincial exhibition of Fine Arts includes paintings and sculptures ranging from colonial to modern times.*

95 *The old municipal building of Salta, the Cabildo, austere and simple in form, houses the History Museum, containing regional material and records. The present construction, although not greatly altered, dates from 1676.*

96-97 *Situated in the Cuyo region, Salta, together with Mendoza, Córdoba and Tucumán, developed along the supply route to the Spanish settlements in Peru and Bolivia. The first town in the area was Santiago del Estero, founded in 1553 by Francisco de Aguirre in the name of the Spanish viceroy of Lima.*

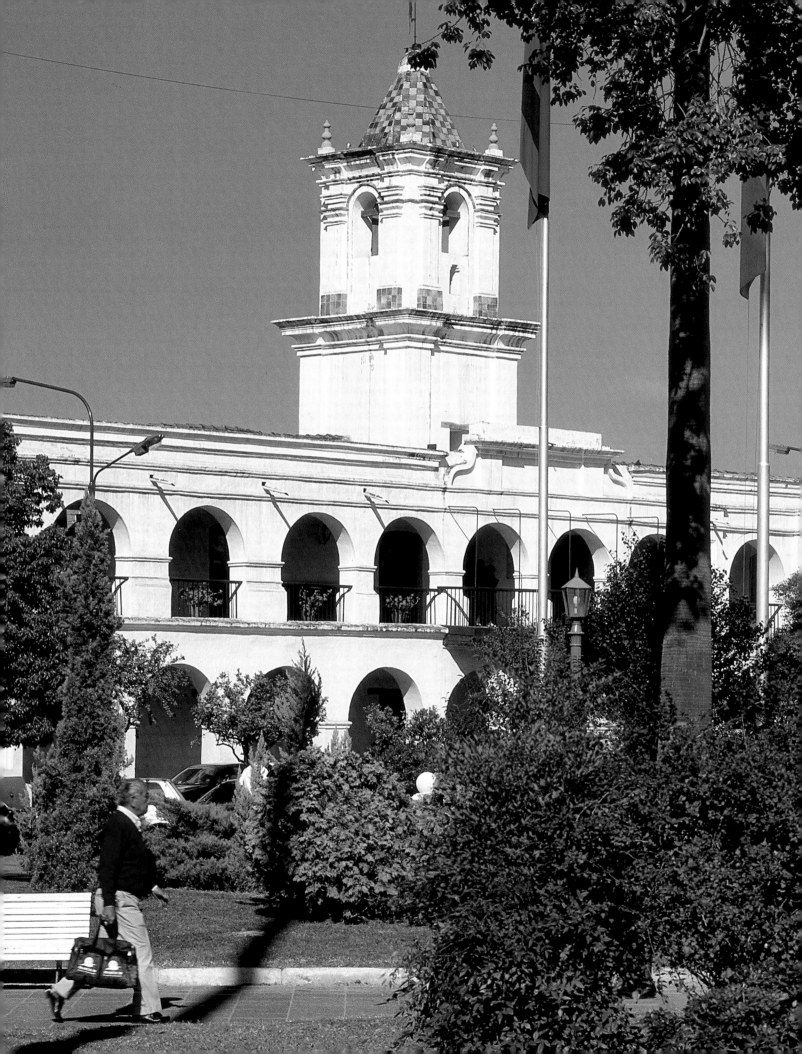

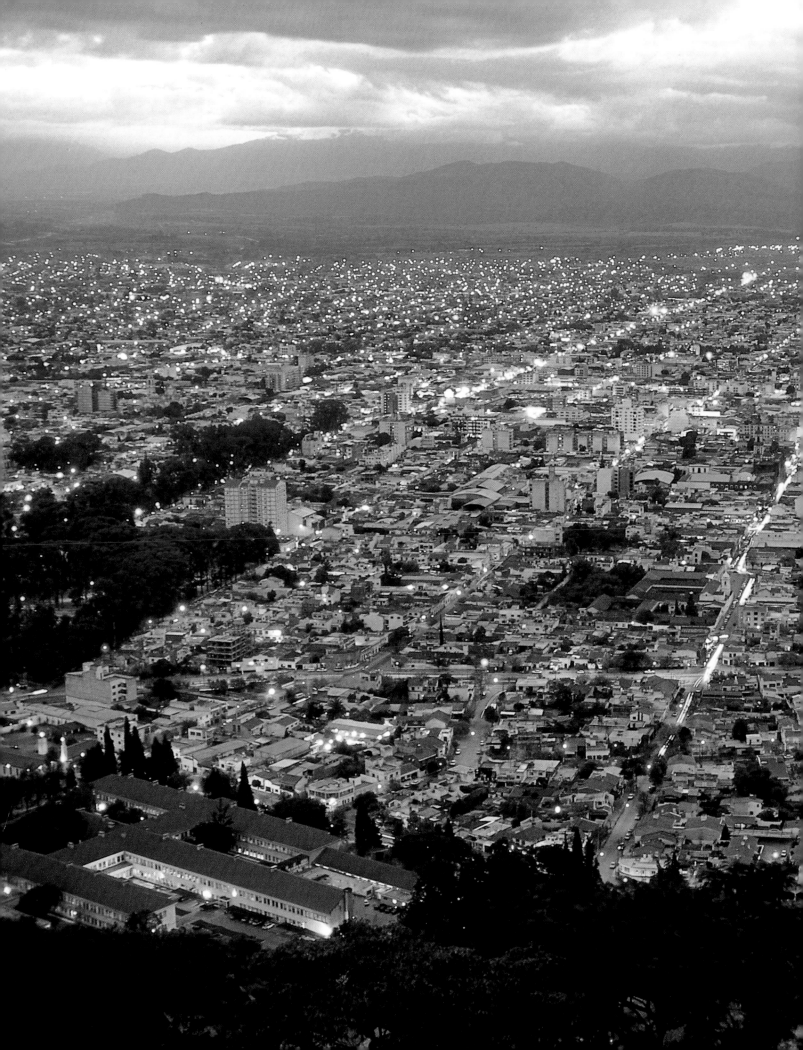

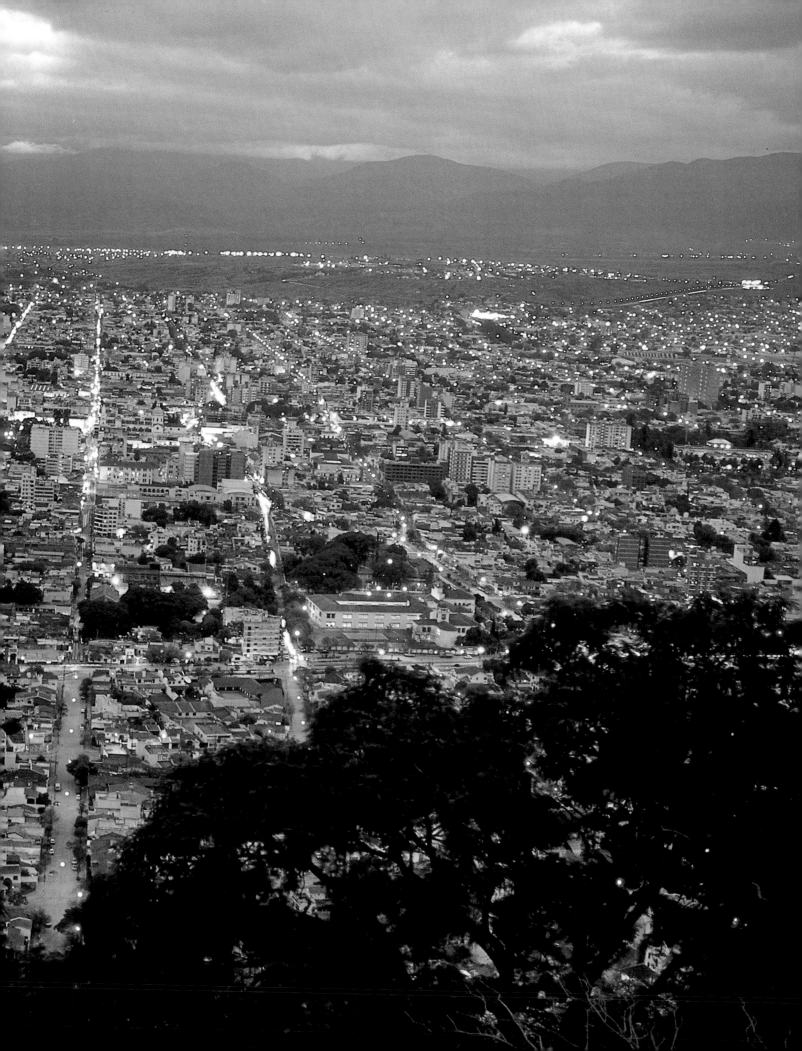

Mendoza, at the foot of Aconcagua

98 top left *Two views of the Plaza España in Mendoza, its fountain surrounded by a number of panels made with majolica tiles that illustrate various episodes from Argentine and South American history. The most striking are those inspired by Christopher Columbus' discovery of the New World and those commemorating the teachings of the gaucho Martín Fierro to his children*

and indirectly to the nation itself: "Let the brothers be united / because this is the first law / let their unity be true / on all occasions. / Because if they fight each other / the foreigners will devour them." An essential junction for trade with Chile, thanks to its strategic position at the foot of the Andes, among all the Argentine metropolises, Mendoza is one of the liveliest and most bustling cities.

98 center *The Paseo Sarmiento in Mendoza. Capital of the province of the same name, of the Cuyo region and its first permanent settlement, the city was founded in 1561 by Pedro de Castillo and named after the then Governor of Chile, Hurtado de Mendoza. Almost totally destroyed by the earthquake which in 1861 caused the death of 10,000 people, in 1985 it suffered a second one which produced many homeless but few victims.*

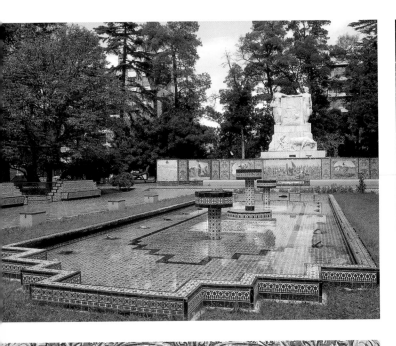 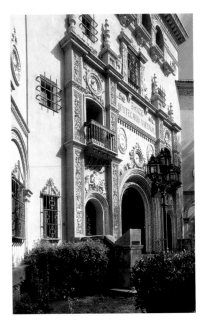

98 right *Mendoza - the photograph shows the elaborate façade of the Banco Ipotecario building - like San Juan, is known for its wine production. Although the first vine-yards were planted in the 16th century by the Jesuits, the sector really took off with the arrival of French and Italian immigrants towards the mid-19th century, bringing economic prosperity to the city. This affluence increased in the 1950s when the local petroleum industry was set up.*

99 *Plaza Independencia and its fountain, in Mendoza, are one of the reminders that this is where the march of General San Martín and his troops set off to cross the Andes and free Chile and Peru from Spanish rule. The city also has a history museum dedicated to the Argentine hero and his military campaigns, commemorated with a bronze monument on the top of the Cerro de la Gloria.*

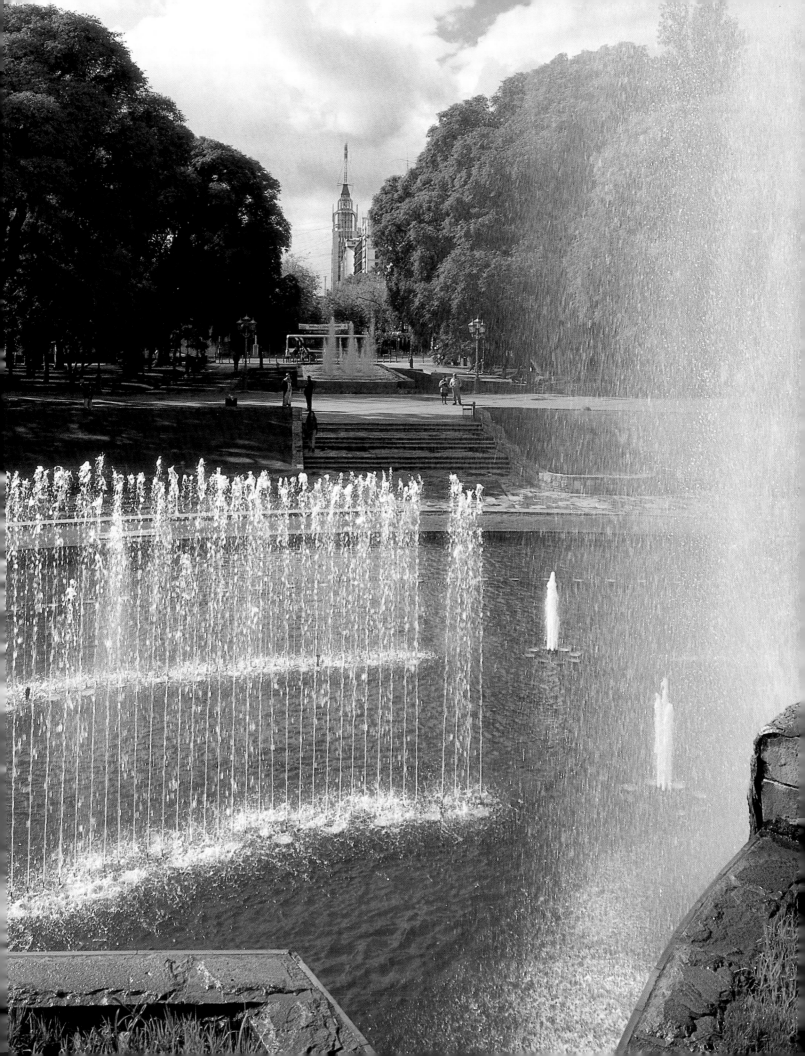

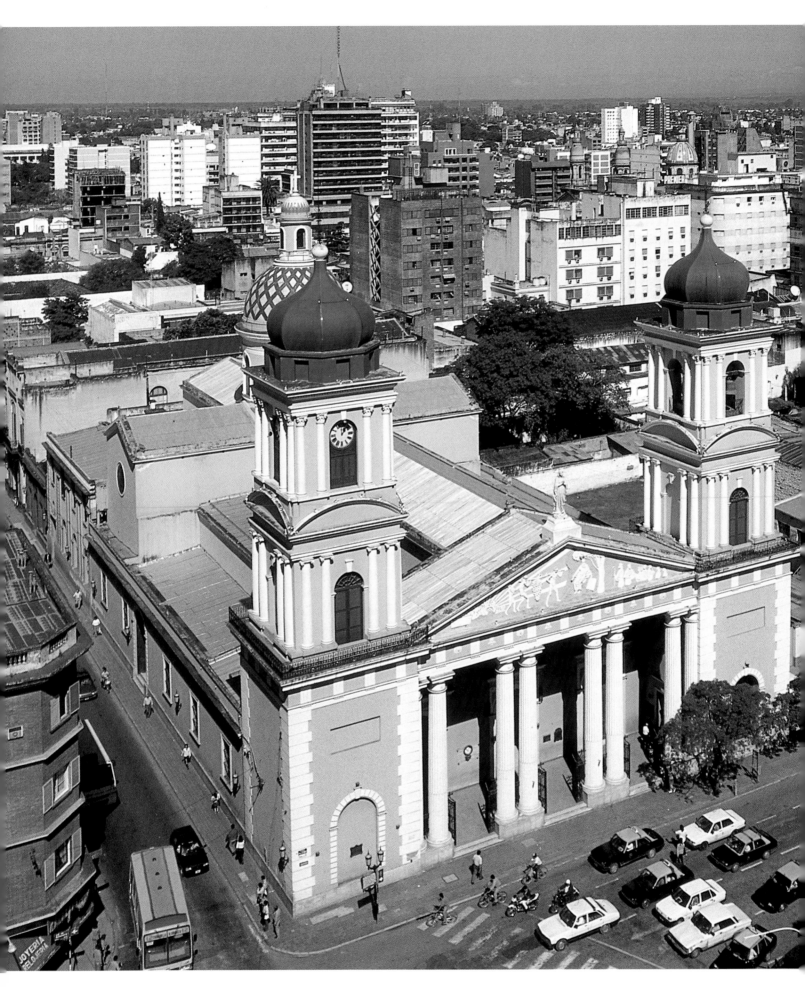

Tucumán, the Baroque capital

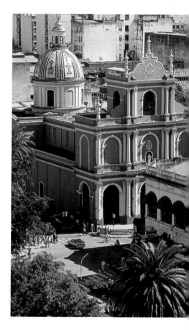

100-101 *A view of Tucumán with to the fore the elegant pink cathedral, its façade adorned with neo-classical columns and tympanums. Capital of Tucumán province (which with 156 inhabitants per square mile is one of the country's most densely populated) the city is reasonably well-off thanks to farming, sugar works and a number of industries created in the second half of the Sixties.*

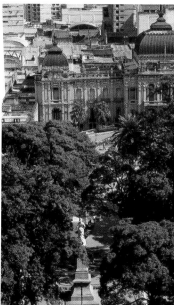

101 left and center right *Plaza Independencia, in front of the Casa de Gobierno in Tucumán. This square is named after one of the city's main monuments, the Casa de la Independencia. On 9th July 1816 the independence of the Argentine Republic was declared in one of the rooms in this partially reconstructed building.*

101 top right and bottom *Founded in 1565 as San Miguel de Tucumán, the city conserves much of its colonial past, particularly religious buildings, mostly in Baroque style, as is the church of San Francisco and the Casa de Gobierno in Tucumámn, shown here.*

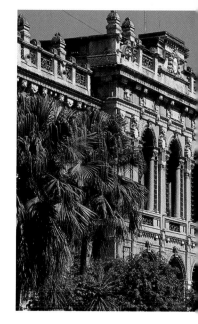

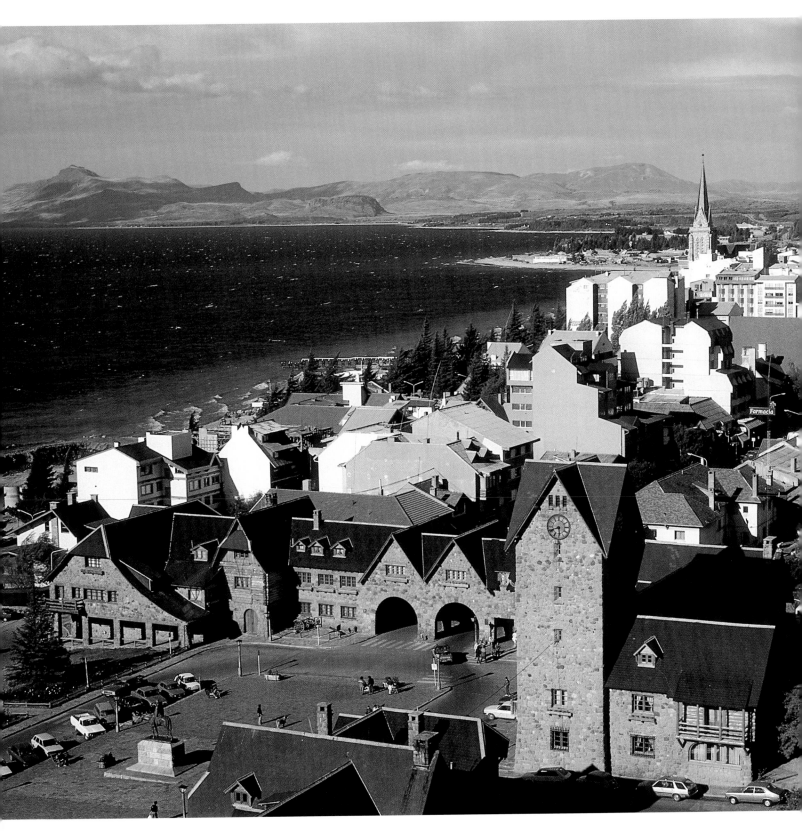

102-103 *Bariloche, on the shore of Lake Nahuel Huapi, is a fashionable tourist resort, patronized in summer by lovers of sailing, fishing and water sports; in winter it becomes a paradise for mountaineers and skiers as well as a favorite choice for honeymoons and school trips. Abundant use of grey-green stone and cypress wood has brought it the nickname of the "South American Switzerland". Although Bariloche derives from the ancient name Vuriloche (which in the native tongue meant "people that live beyond the Cordillera") the town got its present name thanks to an error. A letter addressed to the emporium founded in 1895 by one of the first pioneers in the area, Carlos Wiederhold was mistakenly addressed to San Carlos instead of Don Carlos, hence San Carlos de Bariloche.*

Bariloche, a miniature Switzerland

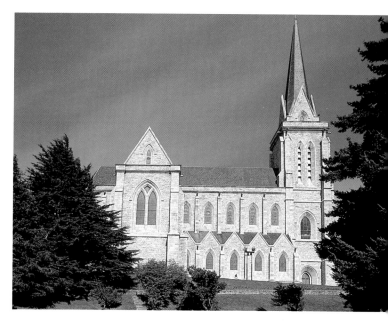

103 top right *The cathedral of Bariloche. A few miles from the town is the Colonia Suiza, a village founded in 1899 by some families from Switzerland. The first settlers to reach these parts were German and Swiss who arrived in 1889 to devote themselves to horse and sheep farming and the timber trade. Not surprisingly perhaps chocolate is one of Bariloche's main products.*

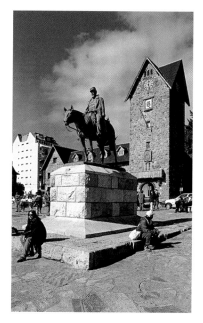

103 left, center and bottom *With nearly 500,000 visitors a year, Bariloche lives mainly off tourism, an important economic resource that developed at the beginning of the century when the first hotels were built after the creation of the Nahuel Huapi National Park, in 1935-44. The town has an interesting Museum of Patagonia, with period photographs, displays of local flora and fauna and an exhibition on the local pre-Hispanic civilisations. A number of excursions can be made from the town, the main ones being to Isla Victoria, Puerto Blest, the Los Cantaros falls and the Cerro Leones caves, with their remarkable rock drawings. In winter the nearby Cerro Catedral, at 7,832 feet, provides enthusiasts with more than 40 miles of ski runs.*

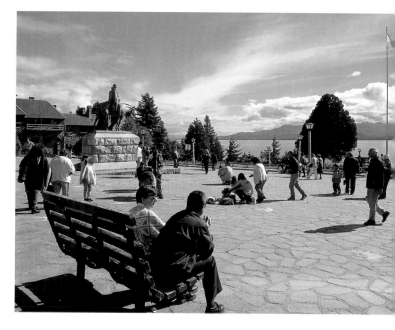

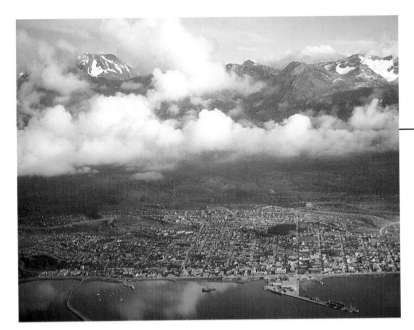

Ushuaia, en route to Antarctica

104 *The main city in the Argentine extreme south, Tierra del Fuego, Ushuaia will be a free port until 2003 and this, together with many other benefits, has encouraged a large number of multinational companies to establish their head offices here. Today Ushuaia is home to a large naval base and its economy is founded on oil and natural gas drilling, timber production and television/radio manufacturing.*

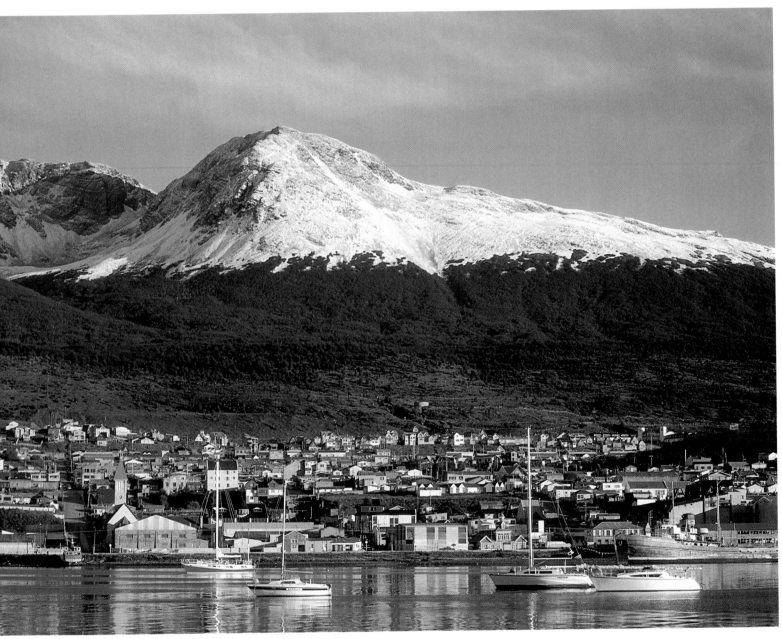

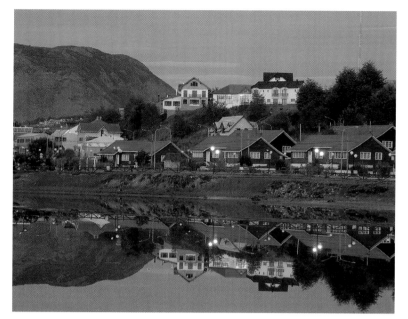

105 *Ushuaia was started to develop as an Anglican mission in 1869 but was officially founded 15 years later. The missionaries were the first to settle in the area and came to convert the Yaghan Indians. Today the city is mainly populated with soldiers, engineers and scientists of the CADIC research centre* (Centro Austral de Investigaciones Científicas) *plus skilled workers who here earn three times what they would elsewhere in the country.*

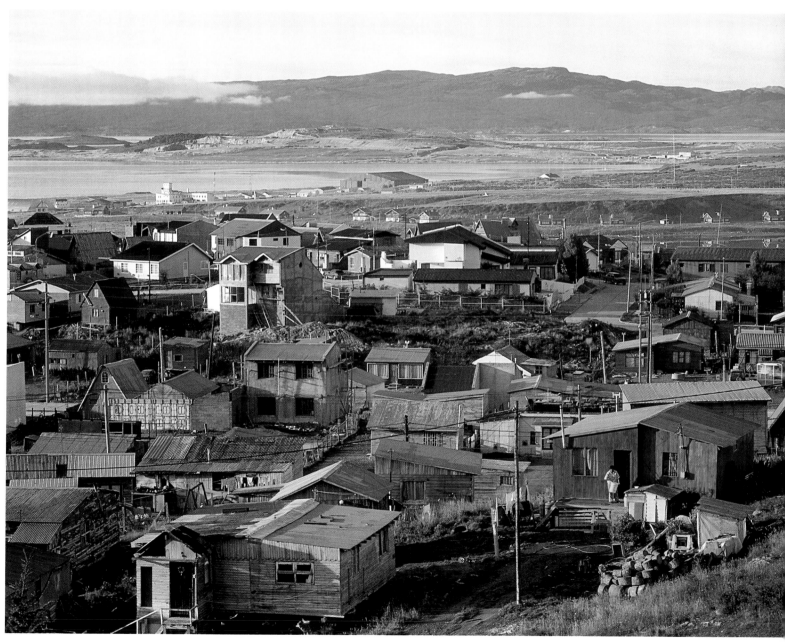

The gauchos of
the new millennium

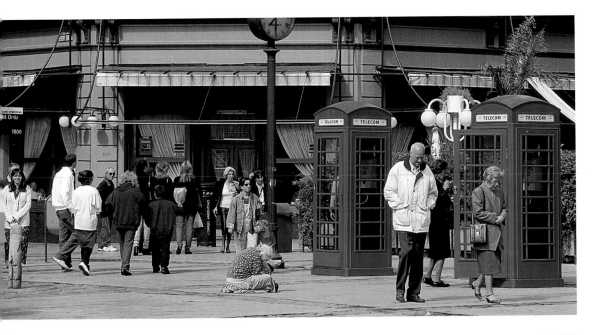

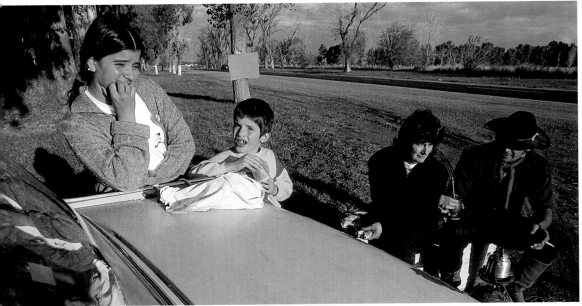

106 top *The streets of Recoleta which, as well as Retiro and Palermo, is considered one of the capital's most exclusive residential districts. Until 1870 the home of a large slaughterhouse, the notables of the city moved here from the southern* barrio *of San Telmo after a yellow fever epidemic and built elegant mansions and sumptuous villas. Today this neighbourhood conserves all the past charm made of elegance and good taste.*

106 bottom *A gaucho and his family seen during one of Argentina's most traditional rituals, drinking* yerba mate, *an infusion of* Ilex paraguayensis *leaves which contains a small quantity of caffeine. This drink, a major part of the Argentine day, is made and served in a small gourd and sipped by all present from a single* bombilla. *In olden times this metal straw was always silver, as the use of this material was thought to prevent the transfer of infection.*

107 *Dancers at a gaucho celebration near Salta. Every year these old lords of the pampas meet at San Antonio de Areco, 70 miles from Buenos Aires. In November this town hosts the Fiesta de la Tradición with tests of horsemanship and folk events. All Argentines, even the many descendants of European immigrants, identify with the gauchos and passionately defend the old ways.*

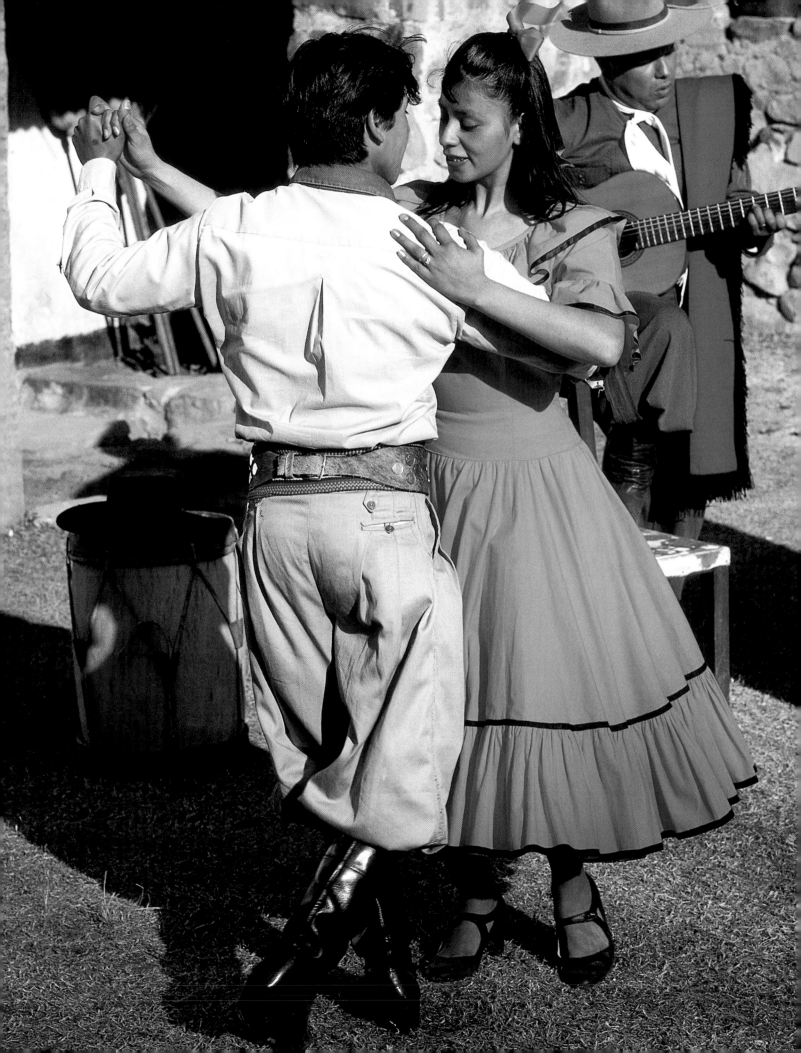

108-109 *The interior of an* estancia, *near El Calafate, one of the vast estates that dot Argentine territory. Although modern conveniences have helped to ease the harsh living conditions of the past, it is not easy to live with the sense of isolation created by properties on which the entrance may be 60 miles or more from the master's house.*

109 top left and bottom *Musically speaking Argentina is a product of Europe and of the New World. Through its veins flows the blood of the ancient pre-Hispanic and Andean peoples, as too that of the thousands of Europeans who populated its immense lands. Even the* bandoneón, *the instrument resembling an accordion which helped to make the tango an agonising and melancholic dance was brought by a sailor from Hamburg.*
The prince of bandoneón *players was Astor Piazzolla who towards the end of the Sixties, after many dark years, gave new life to this musical genre, introducing it to all the world. Thanks to this innovatory musician, famous with the public at large for his* Ballata per un Pazzo, *the tango underwent a profound rhythmical and contrapuntist transformation.*

109 right *The problem of seeking a national identity is deeply felt in a country such as this, born of the coming together of different peoples and cultures. A famous saying by Carlo Fuentes reads: "The Mexicans descend from the Aztecs, the Peruvians from the Incas, the Argentines from the ships". From the birth of the Republic the Government sought in all manners to favor the arrival of new settlers, such that the number of inhabitants rose from 405,000 in 1810 to 7,885,237 in 1914. Although the past generations never completely severed their bonds with the mother country, today's youth no longer consider themselves heirs of Old Europe, but fully masters of their destiny as Argentines.*

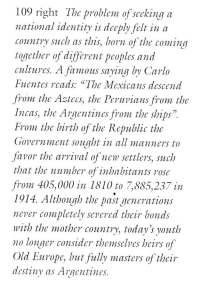

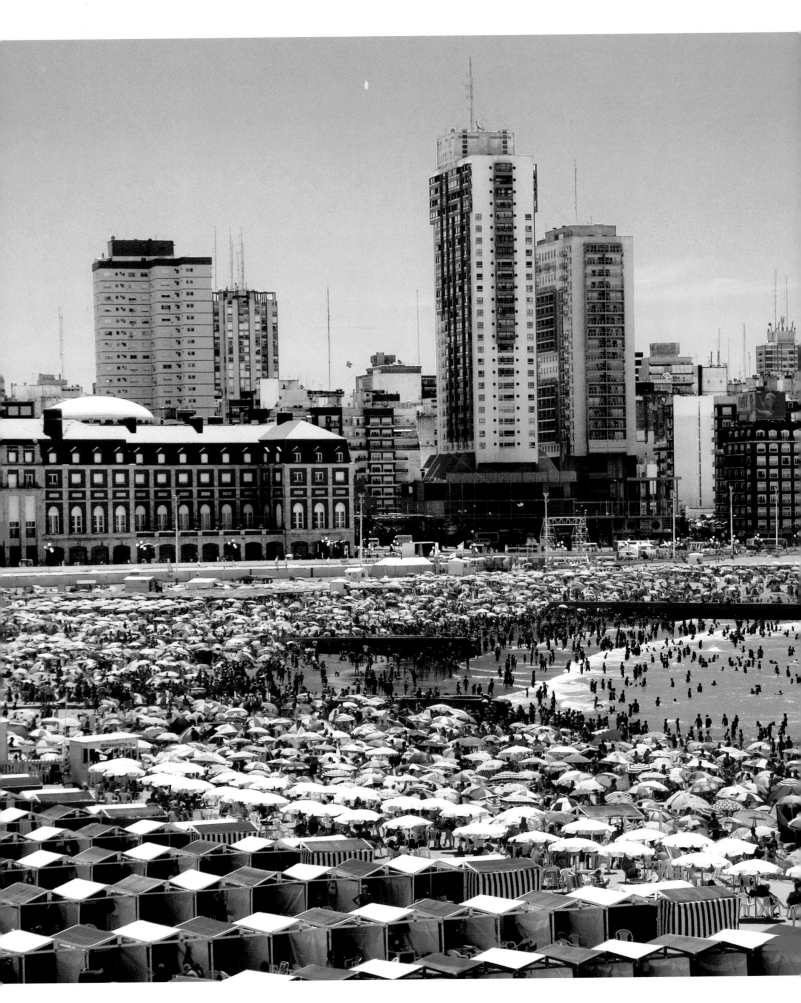

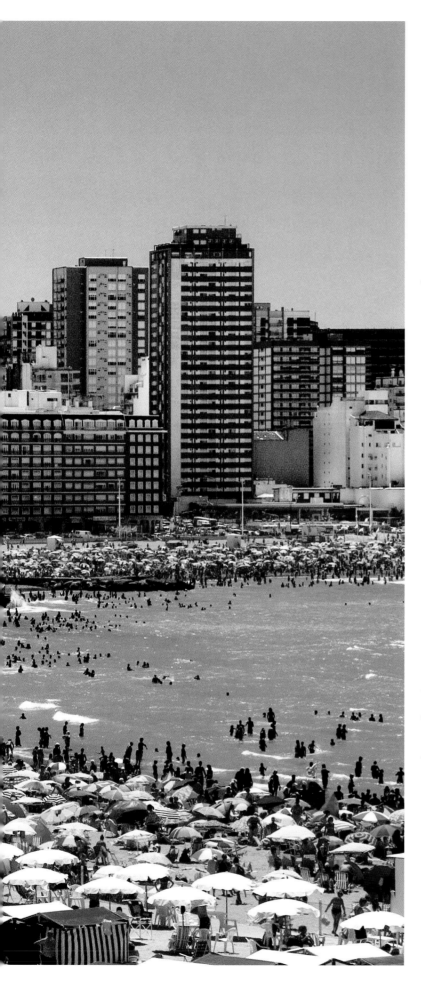

110 and 111 *Fun in the resort of Mar del Plata, a favorite summer holiday destination of the inhabitants of Buenos Aires, is the same as everywhere else in the world. Year after year, groups of young and not so young meet on the long beaches, washed by the Atlantic. Swimming, evenings in the disco, walks and games of golf or beach*

volley-ball liven up the days of a host of people bent on enjoying themselves and relaxing in the sun, bent on forgetting their everyday problems and anxieties. Ever attentive to new trends, those who visit this lively town flaunt fashionable clothes and dark suntans.

112 *Buenos Aires is a cosmopolitan metropolis, product of a multi-ethnic society, and visitors can choose from a large number of restaurants, generally marked by excellent service, and many national cuisines. From Italian - Piedmontese, Ligurian and Neapolitan in particular (the three regions from which originated most of the immigrants who settled in the capital) - to French, Spanish and Chinese, there is a wide choice. Local gastronomy is also excellent and based mainly on the renowned Argentine meat, the essential ingredient, together with onions, eggs and a "shell" of flaky pastry that is fried or baked, for one of Argentina's most typical dishes,* empanadas.

113 *Cafés are certainly the most common places to encounter the Argentines, who love to spend much of their time talking politics and culture in these comfortable places with a glorious past. Full of charm, and often marked by a nostalgic Retro atmosphere, until recently the cafés of Buenos Aires had somehow managed to resist the onslaught of fast food restaurants which have in recent years started to force their gaudy windows on the city center. The main cafés in the capital include the legendary* Tortoni, Molino, La Biela *and* Café La Paz, *patronized by intellectuals and artists.*

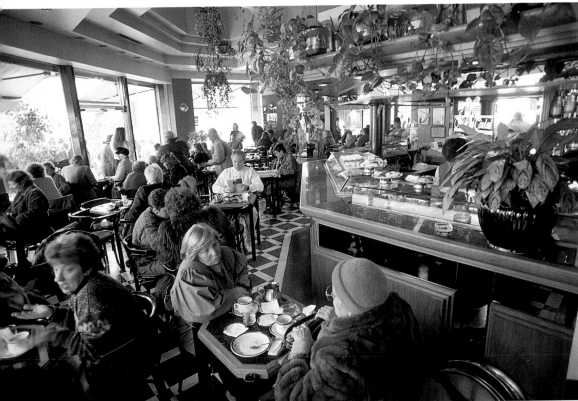

Tango, almost a religion

114 and 115 *Although now more listened to than danced to, tango continues to fire the Argentine soul. Born and developed in the sordid bars on the outskirts of Buenos Aires, this musical genre had to wait a long time before being admitted to the bourgeois parlors, on its return from Europe where it had been the object of an overwhelming craze. A true legend and*

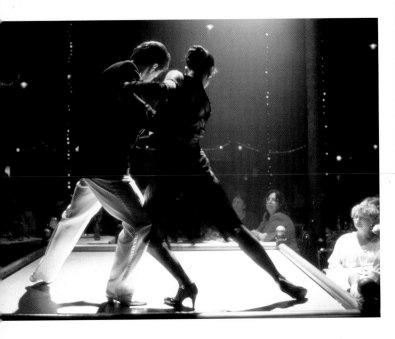

its leading interpreter was Carlos Gardel, the singer/actor who died young in 1935 although he did not disappear from the national music charts. His records are played frequently on the radio and visitors leave a lit cigarette in the fingers of the statue on his funeral monument.

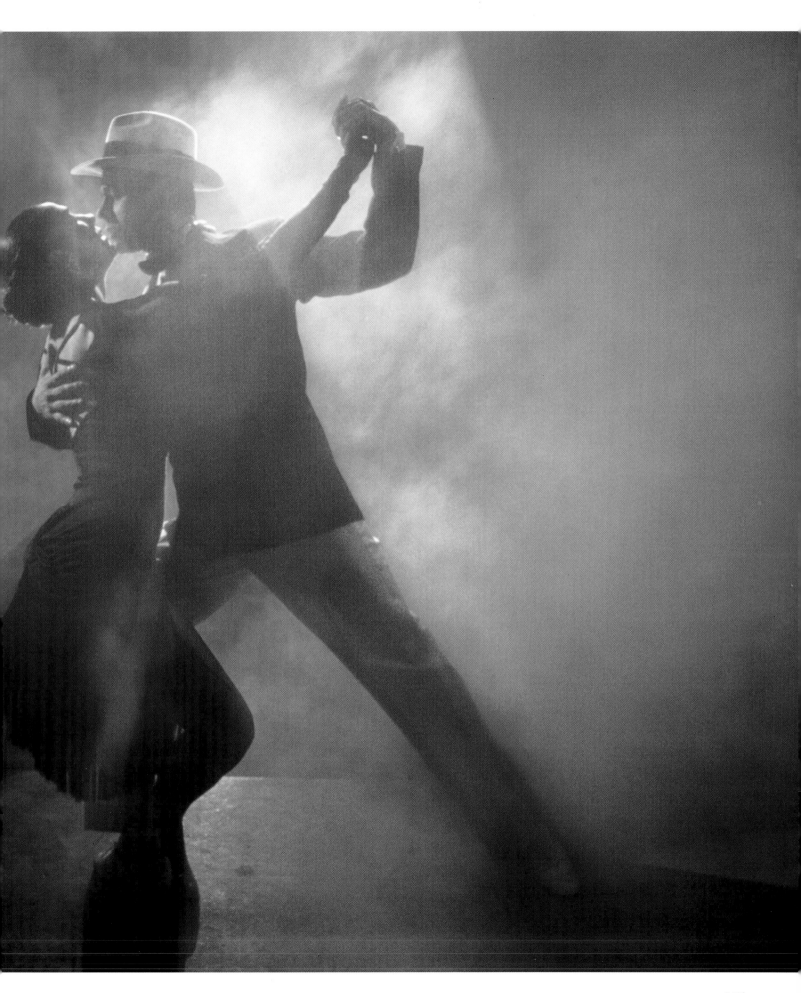

Not just football

116 top left *Initially reserved for the wealthier classes, skiing has gained many converts among the Argentines, who visit the major resorts such as Las Leñas (in the photograph) and Los Penitentes, both in the province of Mendoza. Particularly popular is the Cerro Catedral ski complex, close to Bariloche. The season generally starts in June and ends in October.*

116 bottom left *A match between Buenos Aires' two main teams: Boca Juniors (founded in 1905) and River Plate (1901). Football is one of Argentina's best-loved national sports. Introduced in 1860 by English sailors, it was not played regularly until 1891, when the subjects of Her British Majesty received balls, nets and posts, passed unofficially through Argentine customs as "some nonsense for the mad English".*

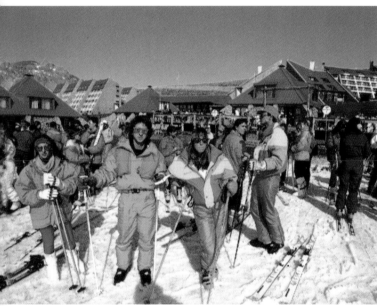

116 right *The English were also responsible for the arrival of another rather popular sport in Argentina, golf. Thanks to a generally mild climate and the presence of vast stretches of flat land, this sport spread quickly among the Argentine aristocracy. The best national courses include the prestigious Buenos Aires Jockey Club and the Sierra de los Padres Golf Club of Mar del Plata (in the photograph).*

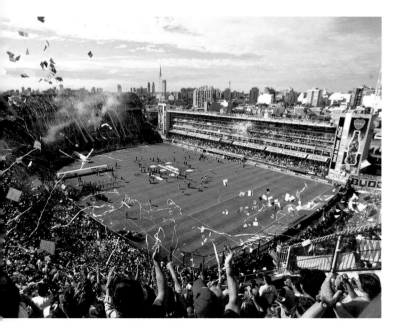

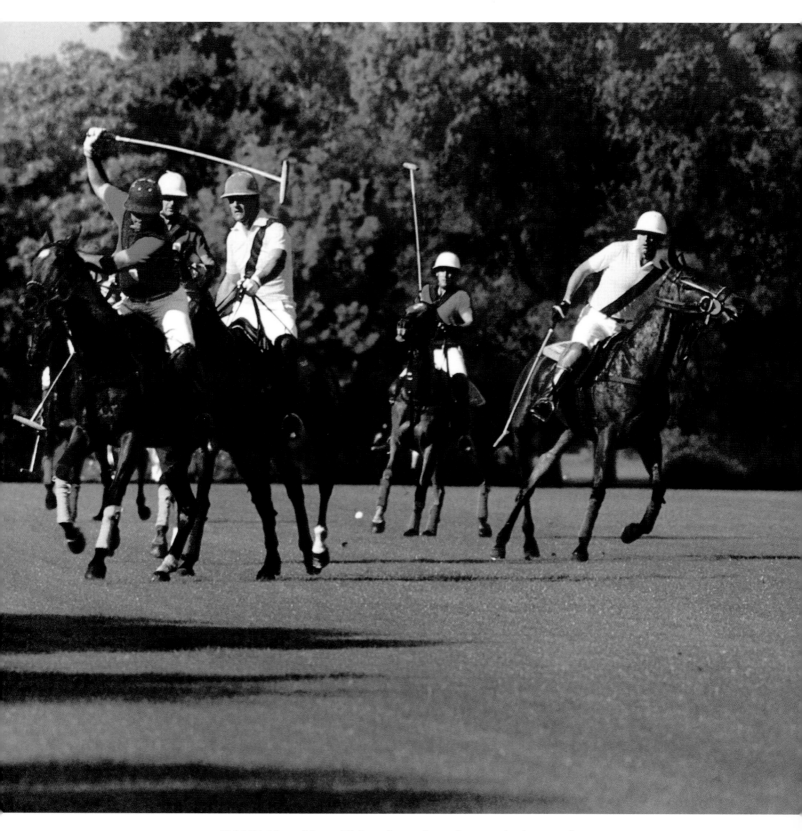

116-117 *Many of the world's best polo players come from Argentina. The national championship matches have been played in Buenos Aires, which has one of the most important international teams, every year in November since 1893.*

Just as famous as the players are the polo horses bred in this country, not excessively tall but strong and fast. The temple of this sport, imported by the English, is the polo ground of Palermo, the capital's exclusive district.

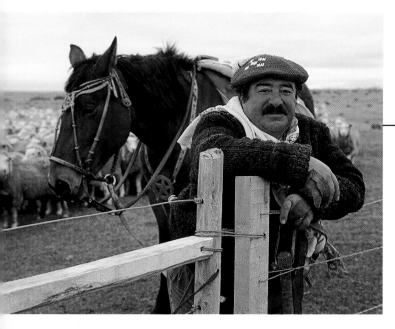

Gaucho, half man and half horse

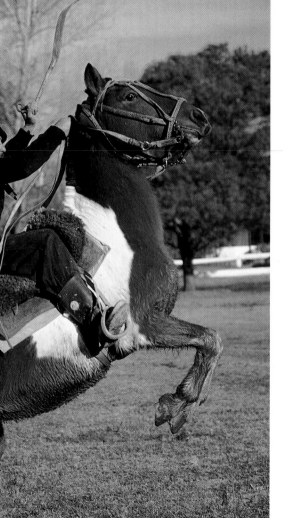

118 left *According to Atahualpa Yupanqui, the great Argentine musician: "the gaucho, sitting high on his horse, dominates a landscape of sheer horizons. He is not afraid because he sees everything coming from afar". Indeed, until the introduction of barbed wire, which enclosed the plains around Buenos Aires, and the discovery of the principle of refrigeration, which led to the birth of the frozen meat trade and made seasonal work on the estancias needless, these untamed horsemen constantly roamed the pampas, living off its resources and only stopping in the farms for seasonal work, such as branding. Innovation changed their lives but did not tame their wild spirit or their function. Nor could it have been otherwise in a country with nearly 60 million head of livestock.*

118 right and 118-119 *The various gaucho gatherings and fiestas particularly common in the province of Córdoba, Santa Fe and Entre Ríos give those participating an excuse to wear their best clothes and most elaborate accessories, inherited from their parents and kept for grand occasions. During these celebrations, which may last several days, they wear baggy trousers, sombreros and broad leather belts decorated with rows of coins or silver chains, which served to hold the long knife normally carried across their backs.*

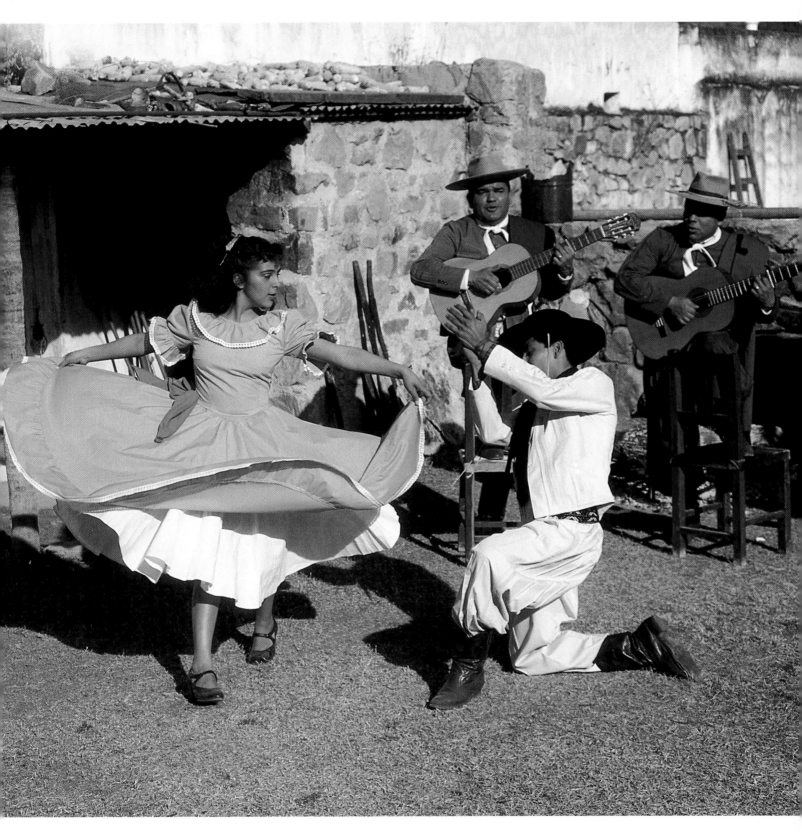

120-121 *The excellent meat from their farms, obtained from a long process of breed selection started in 1826 thanks to the* estanciero *Juan Miller, who imported some head from Europe to improve the local wild species, is certainly the highlight of the local diet and cuisine. The* parrilla *(barbecued meat) the* achuras *(sweetbreads) and the* asado *(roast meat) appear on all the menus of this nation in which the people eat nearly 220 pounds of meat per year compared with the 35 of the Americans.*

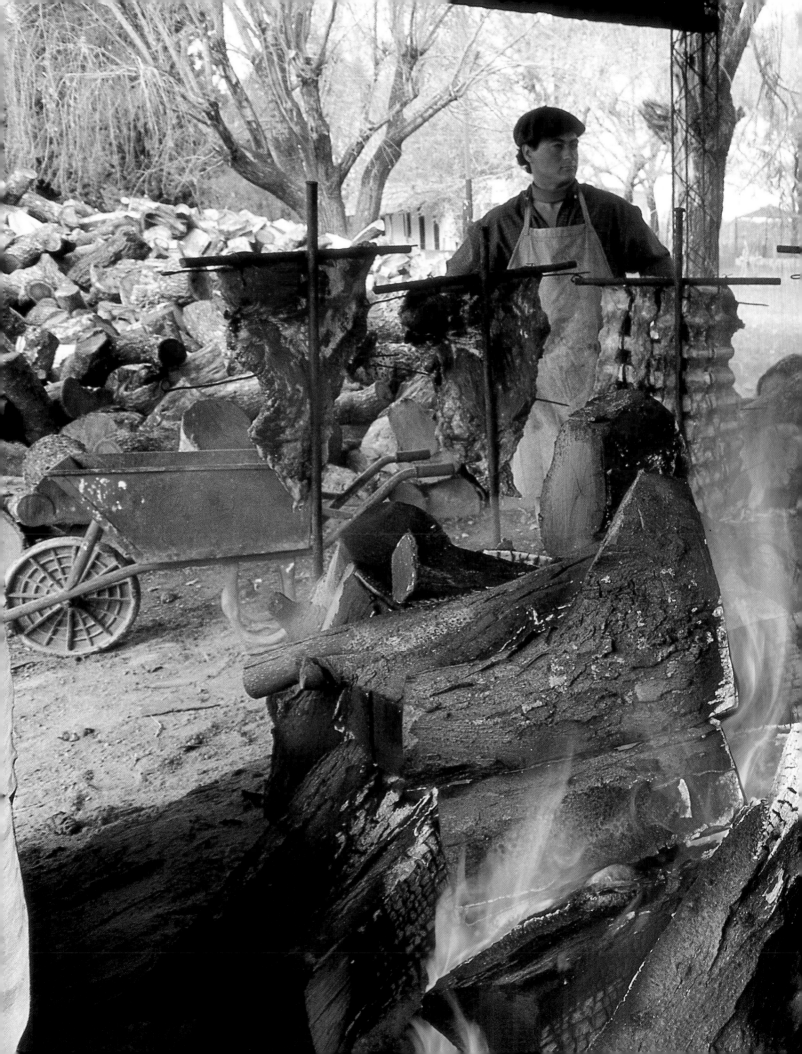

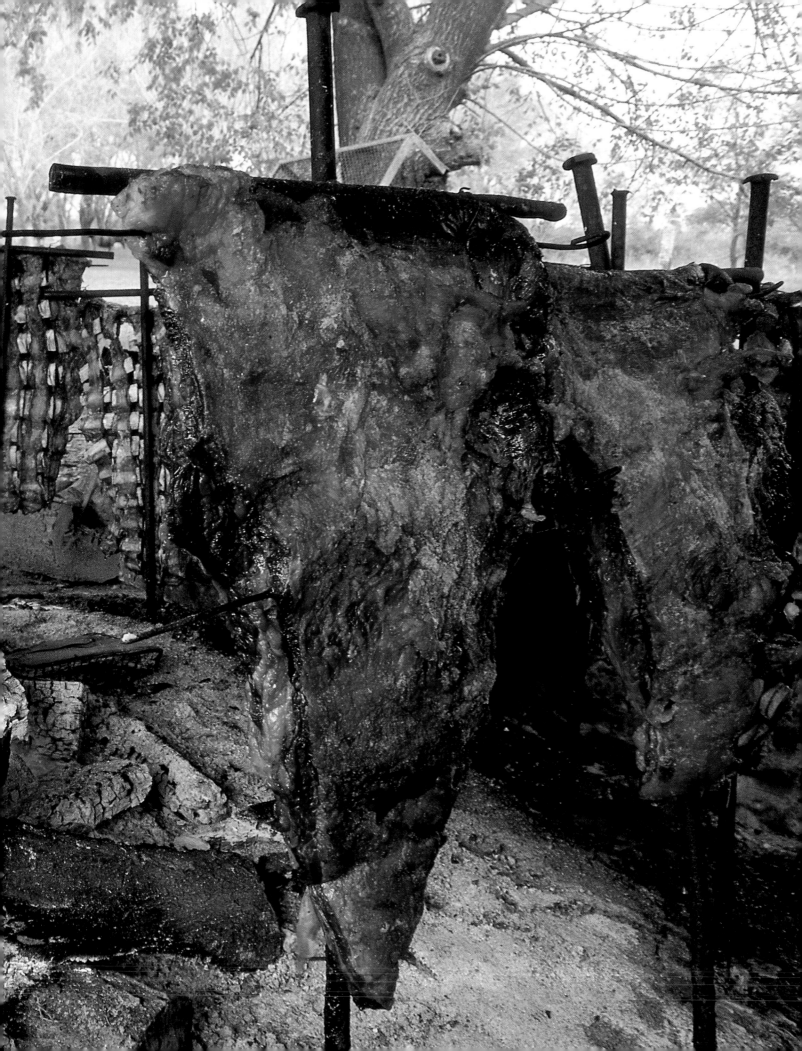

122-123 and 123 left *Together with his trusty horse, lasso and* boleadora, *weighted thongs approximately 3 feet long - both used to facilitate the capture of animals such as the fast* nandú *on the* pampas *- are part of the essential gaucho kit. As described by Borges, one of the leading Argentine writers, "being a gaucho was fate. There is no point in seeking an ethnic definition: accidental son of forgotten conquistadores or settlers, he was an Indian or sometimes a Negro half caste or he was white. His poverty had a luxury: courage. He learned the art of the desert and its rigours". The epic deeds of these proud vagabonds of an eternal frontier land started when, in 1536, the Spanish abandoned a few dozen horses and some head of cattle on the plains around Buenos Aires and these bred beyond measure.*

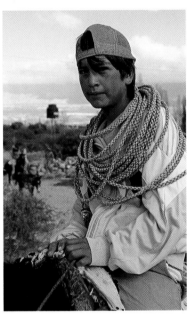

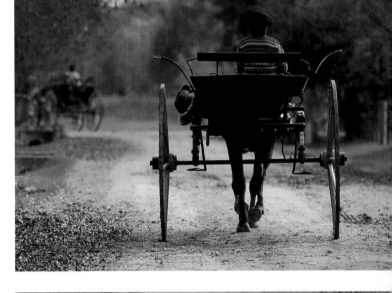

123 top right *Two park rangers riding in the mountains of the Aconcagua Provincial Park in the province of Mendoza, where the Andes become a single chain and peaks rise to 20,000 feet. With more than 40 nature reserves, Argentina is the only country in the world to have a school for park rangers.*

123 center right and bottom *As well as in* Martín Fierro *the figure of the gaucho has been immortalized in other literary masterpieces such as* Facundo *and* Don Segundo Sombra, *published in 1926. All the works highlight the proud rebellious spirit of this legendary character - his name is probably derived from the Quechua tongue and means "motherless" - who lived in wide open spaces with no master nor boundaries. He scorned the peasants and preferred the freedom of the prairies to the bonds of civilisation.*

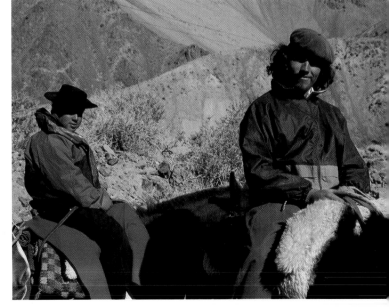

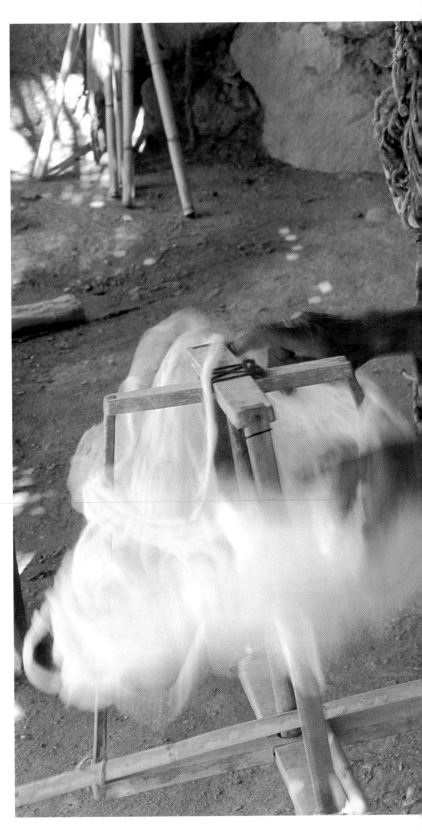

124 top and 124-125 *A carpet weaver at Molinos and a woman spinning wool. Only a few groups remain of the original population that inhabited these lands before the arrival of the Spanish, and they are mainly concentrated in the northern and southern extremes of the country. The ethnic groups of Tierra del Fuego such as the Yamana and the Ona in particular were exterminated by mass deportation and the diseases introduced by the Europeans. Now almost no trace of these aboriginal ethnic groups is left.*

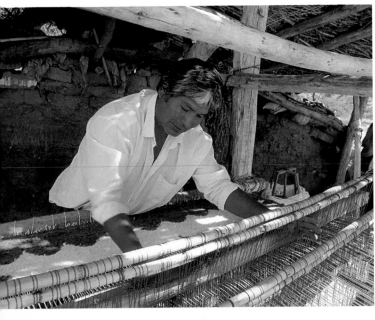

124 bottom *A child smiling, the sun warming up his Cachi. At present Argentine Indians make up no more than 15 per cent of the total population. Generally settled outside the main towns, they live in small isolated groups, far from the country's main roadways.*

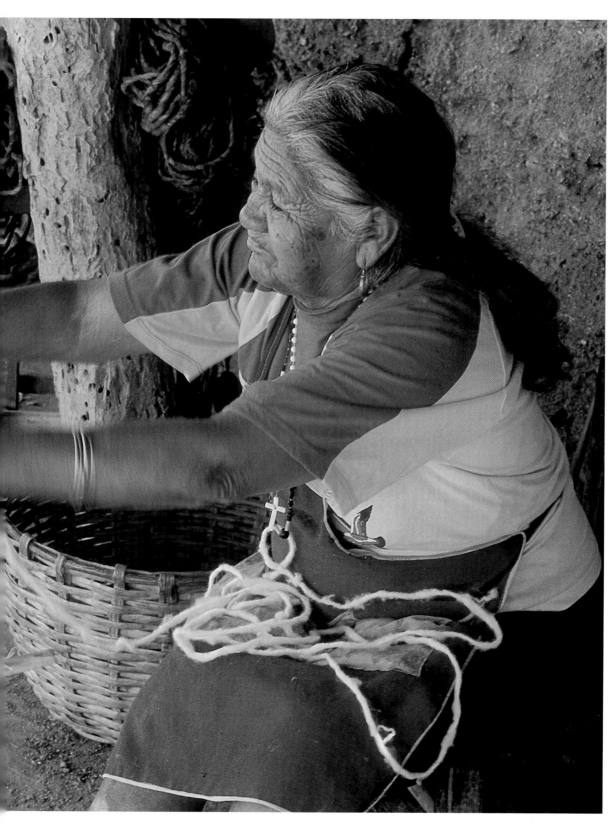

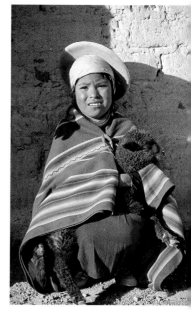

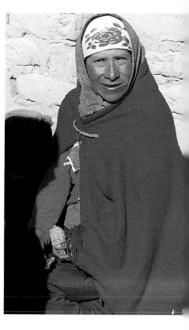

125 *These are pictures of the festival of Pachamana, held at the beginning of August on the high plateaux of the province of Salta. This celebration, which is one of the most important festivities in Quechua culture, is a propiatory rite designed to obtain* healthy animals and a fertile motherland, Pacha-mama, *with offerings of various kinds. During the ceremony food and drinks are placed in a small hole dug in the ground, along with the ever present coca leaves.*

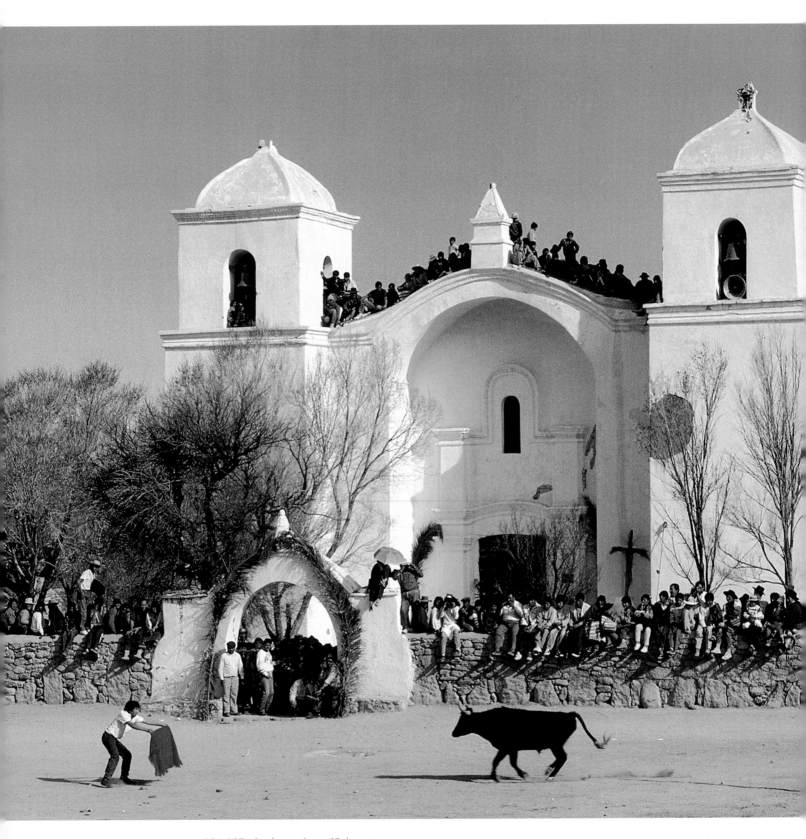

126-127 *In the province of Jujuy, at Casabindo, every 15th June they hold the traditional* Toreo de la Vincha, *the only bullfight in Argentina, a legacy from Spanish rule. The event starts when a bull is freed in front of the church with some silver coins hanging on a red band from the poles; these are for he who manages to conquer it.*

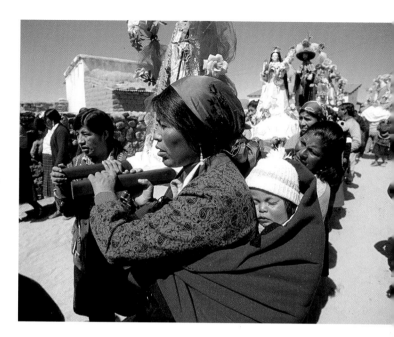

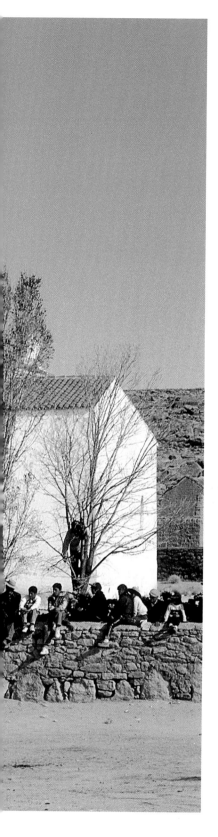

127 left *At Casabindo, a number of religious celebrations held on the same day as the* Toreo de la Vincha *are a mixture of rites introduced by the Spanish and those that existed before colonisation. The photograph shows some bird-men covered with suri feathers who, after dancing in front of the church, join the religious procession that starts the festival. This is one of the most heartfelt and liveliest celebrations in the whole Jujuy province, known for its ancient traditions.*

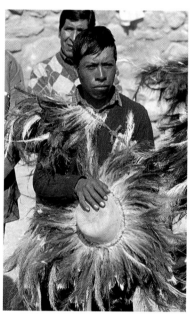

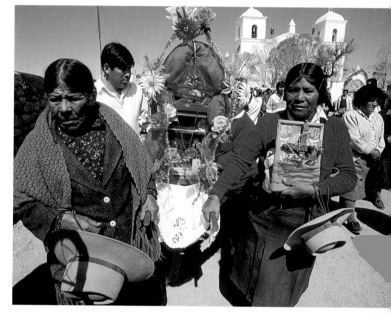

127 right *Before the* Toreo de la Vincha *a colorful religious procession winds through the streets of the village of Casabindo, celebrating the patron saint. As on other similar occasions this provides the inhabitants of the scattered villages of the puna valleys an opportunity to break out of their normal isolation to meet, sell their wares or farm produce and exchange news.*

128 *The* gaucho *is surely one of the most characteristic and best-loved Argentine figures. Ancient lord of the vast pampas, the fertile alluvial lands surrounding Buenos Aires, this legendary character was inseparable from his horse and is immortalized in what is considered the first true literary expression of Latin America,* Martín Fierro *by José Hernández.*

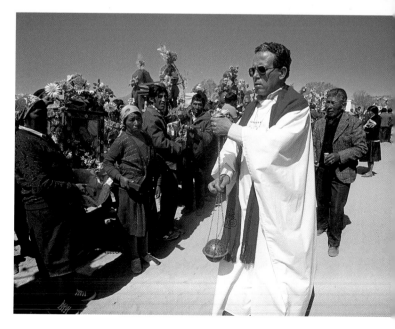

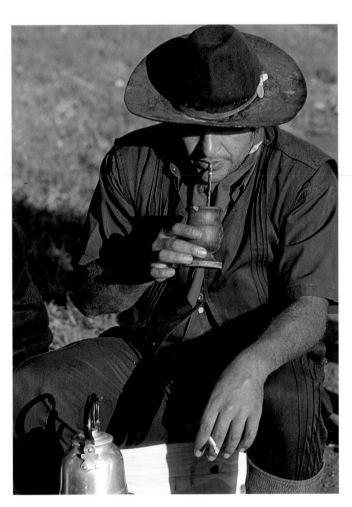

All the pictures inside the book are by Alfio Garozzo/Archivio White Star except for the following:

Alamy Images: pages 110-111.

Giulio Andreini: pages 22, 23, 51 top right , 68 top left, 70 bottom, 72-73, 78 top, 89 center, 102-103, 104 top and bottom, 107, 108-109, 111 top and bottom, 112 in basso, 116 top left and right, 118 bottom left and right, 118-119, 125 top and bottom, 126-127.

Stefano Ardito: pages 6-7, 11 top right, 70 top left.

Marco Brindicci/Reuters/Contrasto: page 116 bottom.

Patricio Estay/Icône/Ag. Franca Speranza: pages 114, 114-115.

Jeff Foot/Bruce Coleman: page 54 center. *François Gohier/Ardea London:* page 54 top.

Alex Ocampo/Ag. Franca Speranza: pages 116-117.

T. Ozonas/Masterfile/Sie: pages 12-13, 82-83.

D. Parer & E. Parer-Cook/Ardea London: pages 54-55.

Vittorio Sciosia/Focus Team: pages 88-89.

John Waters/Planet Earth Pictures: pages 52-53.

Martin Wendler/N.H.P.A.: page 71.

Gunter Ziesler: pages 24-25, 32 bottom, 50-51, 51 bottom right 52, 54 bottom, 68-69.

Map by Cristina Franco.